Calvin Albert's
FIGURE DRAWING
COMES TO LIFE

Second Edition

Calvin Albert's
FIGURE DRAWING COMES TO LIFE

Second Edition

A series of experiments in drawing the figure conducted by
CALVIN ALBERT

Interpreted in a text by
DOROTHY GEES SECKLER

Revised by
MARTHA NEFF ALBERT

PRENTICE HALL PRESS • New York

The quotation on pages 14–15 is from "East Coker" in *Four Quartets* by T. S. Eliot, copyright 1943 by T. S. Eliot: renewed 1971 by Esme Valerie Eliot. Reprinted by permission of Harcourt Brace Jovanovich, Inc.

First Edition 1957 by Van Nostrand Reinhold Company, Inc.

Published by Prentice Hall Press
A Division of Simon & Schuster, Inc.
Gulf + Western Building
One Gulf + Western Plaza
New York, NY 10023

PRENTICE HALL PRESS is a trademark of Simon & Schuster, Inc.

Library of Congress Cataloging-in-Publication Data

Albert, Calvin
 Calvin Albert's figure drawing comes to life.

 1. Figure drawing—Technique. I. Seckler, Dorothy
Gees, 1910- . II. Albert, Martha Neff. III. Title.
IV. Title: Figure drawing comes to life.
NC765.A43 1987 743′.4 86-12236
ISBN 0-671-61255-7

Manufactured in the United States of America

10 9 8 7 6 5 4 3 2 1

First Prentice Hall Press Edition

To E.J.

Acknowledgments

Our deepest thanks go to the students whose interest and cooperation made this book possible. We are grateful to the many whose work, generously offered, could not be included for lack of space, as well as to all those whose drawings are reproduced (their names are listed at the end of this book, except for those whose names were missing from their drawings). We are indebted to the museums and private collectors here and abroad who responded unfailingly to our requests for photographs, and granted permission to reproduce works in their collections. We would like particularly to mention the gracious assistance of Dorothy C. Miller and William S. Lieberman of The Museum of Modern Art, Henri Marceau formerly of the Philadelphia Museum of Art and the staffs of The Metropolitan Museum of Art, The New York Public Library, The Whitney Museum of American Art, The Art Institute of Chicago, The Brooklyn Museum, and The British Museum. Among those to whom we owe a special debt of thanks for the important material they supplied, are artists Henry Moore, Mark Tobey, Saul Steinberg, John Little, Fritz Bultman and Elaine de Kooning. Finally, we wish to acknowledge the encouragement given by György Kepes at an early stage of the book, the help and advice given by Gerald M. Monroe, and also the devoted interest of Robert Iglehart, former Chairman of the Department of Art at the University of Michigan, whose efforts on behalf of the book led us to believe that it would have a special usefulness to educators.

Contents

Foreword to
Second Edition

When Calvin Albert was teaching sculpture at the Institute of Design in Chicago, he was convinced that drawing was the weakest part of the curriculum. He suggested to the director, Laszlo Moholy-Nagy, that even in this avant-garde school, based on the Bauhaus, drawing from the human figure would be helpful to the students. He proposed an experimental life class where figure drawing would be explored, similar to the Bauhaus-based workshops exploring possibilities of tools, materials and light. Moholy-Nagy gave him permission to try his ideas in a non-credit evening class. At the end of the school year the director was convinced by the students' progress that figure drawing was a valid discipline, and it became part of the curriculum. Some of the drawings in this book were made during that first year; the first edition of *Figure Drawing Comes to Life* developed naturally from the subsequent years of Albert's teaching and learning with his students. He has found that, in each group of students, different problems appear. He presents such exercises as are appropriate to the needs of most of the class, and devises new ones when necessary. Thus the "Building With Blocks" section is new to the second edition because he has found that many students lack an understanding of how the volumes of the figure relate to one another.

When Wendy Lochner proposed a new edition, Albert had collected many drawings made in his foundation and graduate classes since publication of the first edition, and new ideas based on student needs that had become apparent. But with teaching and working on his own drawing and sculpture, he lacked time to do more than act as consultant on the book. Dorothy Seckler was involved with her own painting. I had been interested in the drawing classes from the beginning; some of the first exercises were based on the ideas of a teacher I had studied with at the Art Institute of Chicago, and I assisted Calvin Albert and Dorothy Seckler with the first edition. I volunteered to take over the revision, with much help from Albert.

In the 1950s, when the first edition was being developed, the human figure in art and illustration was mostly used in simplified or stylized form, while abstract artists ignored it entirely. Now in the '80s, art galleries, books and magazines are full of works showing experimental approaches to the figure, some similar to exercises in Albert's classes, sometimes by artists who had studied with him. It was decided to include examples of these in the new edition, as well as some drawings made by Calvin Albert at various times since 1951, showing how his own work has influenced his teaching.

MARTHA NEFF ALBERT, 1984

Introduction to the First Edition

The authors

Calvin Albert, the teacher who has stimulated and guided these explorations in drawing, is a psychologist only in the sense that poets are—through a habit of attention to the actions and reactions of people. He has no theories, at least none to which one could attach labels or apply to all cases. Rather the series of experiments illustrated here have grown out of ways and means improvised on the spot as a stimulus or fresh point of departure for someone who had reached an obstacle in the struggle for expression. When a personal way of teaching works so well over a period of fifteen years, it probably operates in relation to some rather universal facts of human sensibility.

He would not have become the particular kind of teacher that he is without being the particular kind of sculptor that he is: preoccupied with fantasy, dream and nightmare, one with a passion for materials—this is seen in his charcoal drawings as well. Through the insights gained in his own work with molten metals, his habit of assigning to them an almost magical significance, he has been able to convey to his students a sense of materials as a means of self-revelation. Because he is as much "at home" with images as he is uncomfortable with words (used didactically) he has found ways of using words to communicate images and images to focus the visual attention and imagination of his students. His sculptor's sense of solid volumes has had a great deal to do with the kind of images he has used in this "picture-language" of teaching.

Against any kind of classroom dictatorship or assumption of God-like superiority, he insists that the teacher's aims as well as the students' be put up for discussion. This attitude stems only in part from natural disposition—in fact it is the opposite of the kind of sympathy extended by teachers who are merely over-impressionable. Its source, I believe, is in his conviction that a sense of freedom is a prerequisite for creative work. If a teacher's success depends on his ability in certain problems to drive students under extreme pressure of time, to prod and provoke them out of habitual ways of seeing, to proceed by surprising and apparently illogical attacks on work—then he must have the confidence of his students.

In those "life classes" where the student is required to make a factual inventory of the model, the teacher is the absolute repository of all knowledge. He is above the class and dictates its every move. His real or implied directive to the class will be: "Digest all this information about the model first; later you can add your own feeling. Be objective first; subjective last."

"I do not believe it," says Calvin Albert. "There can be no postponement of feeling. As the twig is bent so grows the tree. The student is potentially a creator every time he sits down to his drawing board or he is nothing at all."

Some teachers want their students to achieve a free style, but Calvin Albert wants them to enjoy a freedom of spirit that goes beyond style. The teacher does not inspire this kind of freedom by saying, "be free," any more than he can secure an expression of feeling by saying, "be emotional." He has to set the example of freedom by giving value to what is freely expressed. He has insisted that the students keep one half of each class period to pursue whatever aims they may have, even if those aims are opposed in spirit to the explorations that comprise the second half.

Instead of trying to develop a systematic course of study he has envisioned a kind of obstacle course in which his role is to define certain kinds of challenges that lie ahead, to distinguish one from the other and to assist in whatever way presents itself as the particular point is reached. Because he has been over the obstacle course before and is familiar with its hazards he may be able to help by offering an image, a material, an exercise, a joke or a "bravo."

The consuming interest in the creative process shared by the authors is the basis for our collaboration. Whatever interpretation I have been able to give these experiments in the text derives from my own teaching experience and from my working contacts with contemporary American painters. Observing and reporting the step-by-step developments of paintings in progress in the course of numerous articles I have written for art magazines, I have noted the primary role played by intuition. I found that, especially in dealing with the figure, many artists have had to unlearn mechanical and literal habits of drawing instilled in student days.

The creative process does not unfold evenly and systematically; but it often develops by sudden changes, even reversals of direction and at an uneven pace. Picasso is not the only one for whom the picture can be "a sum of destructions." In spite of all the mess, indecision, backtracking and frustration involved, we are never so alive as when we are facing the challenges that creation offers. Calvin Albert suggests that what T. S. Eliot said about the creation of poetry applies also to drawing:

> *"Trying to use words, and every attempt*
> *Is a wholly new start, and a different kind of failure*
> *Because one has only learnt to get the better of words*
> *For the thing one no longer has to say, or the way in which*
> *One is no longer disposed to say it. And so each venture*
> *Is a new beginning, a raid on the inarticulate*

14

With shabby equipment always deteriorating
In the general mess of imprecision of feeling,
Undisciplined squads of emotion. And what there is to conquer
By strength and submission, has already been discovered
Once or twice or several times, by men whom one cannot hope
To emulate—but there is no competition—
There is only the fight to recover what has been lost
And found and lost again and again: and now under conditions
That seem unpropitious. But perhaps neither gain nor loss.
For us, there is only the trying. The rest is not our business.

Intuitive drawing

Most people have a set evaluation on their ability to draw. They are "talented" if they can produce a likeness or a graceful rendering of a subject; "untalented" if their efforts in this direction are frustrated or clumsy. Friends and neighbors are on hand to support these judgments.

As a student of art history, I have noticed that such evaluations are often upset in the long run. The individual whose skill was dazzling may turn out to be the one most easily forgotten, while the clumsy fellows, like the young Van Gogh or Cézanne, hold our attention with drawings that seem to have a deeper grasp of reality. The artist who moves us is usually working not out of his factual knowledge or self-consciously contrived techniques, but out of intuitive feeling and identification with the subject.

I am interested in the drawings which make up this book, not because they are skillful, not because they are modern—many are not particularly— but because they are spontaneous and alive. They constitute a pictorial record of a teacher's effort to put people in touch with a more intuitive part of themselves, and with a remarkable degree of success. Compared with most student "life drawings" they are fresh and uncontrived; compared with the work of the same individuals before the experiments, they show a real liberation.

These drawings were made by students just entering art school, with few exceptions, in the first year of study. In the range of their abilities they are no different from the average first-year group in any art school. The difference in what they produced, as compared with the labored, clinically impersonal or vacuously slick renderings of the figure that come so often from such classes, is not in the capacities of these individuals, but in the fact that a different level of these capacities has been tapped.

The results obtained in these experiments suggest that the conception of "talent" is not a useful one. Many more people than ordinarily suspected have innate capacities to express themselves in esthetic form. Most individuals, if helped to explore materials spontaneously, if freed from wrong notions of what drawing is, are capable of originality—not in the sense of producing self-consciously novel expressions, but because their handling of materials reveals re-

actions, their lines and shapes, perceptions personal to each one and in some way unique. The gulf that separates genius from the rest of us may be located in the differences in drive and urgency. Self-consciousness is the barrier in the way of expressive drawing for many people. It often seems that the more conscious and determined the scrutiny of the model, the less one actually sees that is the material of art, the more one is alienated from the kind of attention that dwells with wonder and awakens association. To make a sensitive drawing of an apple, a landscape or a figure one must fall in love with it. This does not mean being captivated by the thing itself but with some aspect of it that finds a resonance in the spirit—the mistiness or ruggedness of a landscape; the apple in a certain light and setting. It is not the model as an individual who moves us —the same model can be expressive in one pose, dull in another. It is a single aspect of the model seen at one time that supplies the theme and stimulus.

The student drawings reproduced show that the individual gains in his ability to see intuitively when his conscious attention is engaged in the manipulation of materials, through a visual image held in the mind, most of all when the pressure of speed makes it impossible to rely on self-conscious and preconceived ways of drawing. Seeing is something that we do as naturally as breathing but, in both cases, to have our conscious attention called to the operation is to interfere with the process.

What is "real" in a drawing?

The problem of drawing the figure is attacked in an order that reverses the ordinary one: instead of learning first what a body is and then eventually to make a drawing of it, one learns first what a drawing is and then gradually discovers how aspects of the figure can become the material for expressive drawing. A drawing of a girl, one discovers, is a very different thing from the girl herself. The appreciation of that difference is the beginning of progress. This is not a difference that the teacher imposes. It was as true for the old masters as for the moderns. Does anyone believe that one could see in the market place of 16th-century Florence or Nuremberg individuals who appear in the drawings of Michelangelo or Dürer? As we differentiate between the real figure, which can never be set down on paper as it is, and the image on the two-dimensional surface before us we are more free to deal with our materials and with the lines and shapes they make available to the imagination. We are more conscious of the movement of the hand and the constant shaping with darks and lights, less conscious in our scrutiny of the model.

The model presents many aspects of reality: the reality of weight and volume, the reality of structure, the reality of appearance in atmospheric light, the reality of movement. Working with ink, crayon or charcoal, we discover that each of these materials conditions what we perceive, each accents a particular aspect of reality more than others. This selection enables us to use

materials with boldness and assurance. Indecision is overcome by isolating and concentrating on the single aspect of the model that the materials—the kind of manipulation appropriate to each—help to reveal.

The drawings themselves point up an interesting paradox: the more the student is willing to give up his intention to produce "a realistic figure" (all aspects at once), the more he is able to project the quality of life into his drawing.

The first and most important experiment—"Scribble Drawing" makes clear the difference between a drawing which aims at copying the externals of the figure and one that reveals the underlying reality. The scribble drawings differ from similar quick action sketches as utilized by other teachers not only in the degree of the pressure of time—the experience of making dozens of ten- or fifteen-second drawings rather than a few five-minute drawings—but also in the emphasis on seeing the total figure, and on the element of "unconscious" response in this experiment.

The "forest," not the "trees"

The student comes to class expecting to learn the anatomy of a figure and he first learns the anatomy of line, the anatomy of form. In a ten-second drawing one cannot put down details or even contours. The lines that are set down tell what is *happening* in the figure. One discovers that this is telling the truth about the model—it describes the reality more than a rendering of its detailed appearance would have described it. The reality that appears in the drawings is not a distortion—although it departs from what the camera would record. The swift line and "unconscious" response have captured what is essential to the figure.

In ordinary drawing such as the students practice in their free period, the attention is first on the model and then on the lines set down on the paper. In the scribble drawings the attention seems suspended somewhere between the two, as if the two images meet and fuse, becoming exactly identified each with the other. Thus the student has his first experience with the power of empathy —the ability to project into a subject or identify with it.

The discovery that one can penetrate superficial appearances to the basic, underlying reality of forms by a quick, spontaneous and total image, rather than through a labored and piecemeal one, serves the student not only in this problem but throughout the rest of the experiments. Even those which are of long duration, like "straight line" or "yarn" could hardly be successful without this introduction. Through it he is prepared for the intensive concentration on certain kinds of line, and armed with the understanding that emphasis on the forms of drawing will add to, not detract from, his ability to represent the model. The ability to perceive the subject as a whole and to concentrate on essentials serves one in any kind of drawing.

Why the figure?

Why deal with the figure at all, if we are learning techniques equally applicable to any kind of drawing? This question brings us to the issue of the value of the figure itself—a unique, an irreplaceable subject. Anyone who has mastered drawing the human figure is equipped to draw other subjects. As the experience of interpreting the human figure is more complex, it is also more rewarding as a preparation for expression in landscape or still-life subjects or for abstract expression. The mobility of the human figure makes it a subject of great range of feeling: a slight shift of balance creates a whole new harmony and meaning in mood, a whole new complex of structural tensions, a new revelation of the engineering of the body. The sensuousness of the figure challenges us to match it with the sensuousness of materials. The individual who can express the changing and varied surfaces of the body in their wholeness and interrelationship is dealing with the most complex kind of "landscape" possible. Unlike the person whose training accustoms him to thinking of the figure simply mechanically as the same two legs, two arms, etc. in assorted positions, the student whose approach is through expressive drawing, feels the figure as a completely different kind of "landscape" each time—now rugged, now cavernous, mountainous and so on.

The "abstract" artist as well as the realist needs to sensitize himself to the subtle play of tensions and balances in a dynamic form and to its extension into space. Whether or not an artist wants to represent the appearances of the world of nature, he must be aware of the way nature operates and familiar with its laws.

Identifying with the subject

The word "empathy" meaning "identification with" has become a part of the present-day art vocabulary. Artists immediately recognized under the label of this word a familiar way of getting in contact with a form—being it. Art educators appropriated empathy—but only for the inanimate part of the curriculum. Students who were drawing or painting landscape were supposed to be able to identify themselves with trees, rock and sky forms or with apples on a plate. But on the other side of the corridor behind doors marked, "life drawing," a different process was invoked: analysis, inventory of bones and muscles. Objective analysis was the rule here, with the subjective postponed until the "facts" were mastered, proportions memorized, etc.

The results of the "objective first, subjective later" approach were so depressing that a good many teachers and some schools decided to drop the "life classes" altogether, substituting abstractions with taut lines and tonic clarity. A drastic step, but one that had some eventual good consequences: it made a clean sweep of the old clichés and the annual harvest of "nudes." But when it became clear that something valuable had been lost in this catharsis, a few

people were stirred into exploring new approaches, among them, Calvin Albert, whose first life classes were inaugurated at an advanced school, as an attempt to restore a course that had been dropped.

Drawing with intuition need not have anything to do with unloading one's complexes or giving form to one's fixations. It is not therapy in this sense. Therapeutic drawing is a helpful technique in the treatment of insane or disturbed persons, one that often produces unforgettable images. But the achievement of esthetically satisfying forms is not the aim nor is it often attained. The insane person, intent on his fantasy, is seldom sensitive to the materials he uses or to the forms they can develop. Teachers who have encouraged "normal" students to an undisciplined excess of such "self expression" without developing the language of forms, the qualities of materials, have cheated the students of the broader therapy that serves us all in a fully realized art form.

New ways of seeing

Generally one does not arrive at his own intuitive perception until he is challenged, provoked and nudged out of habitual clichés of seeing. "Creation begins typically with a vague, even a confused excitement, some sort of yearning or hunch, or other preverbal intimation of potential resolution," says Brewster Ghiselin in "The Creative Process," University of California Press. ". . . Before any new order can be realized," he says in a different passage, "the absolute power of the established, the hold upon us of what we know and are, must be broken."

In several of these experiments speed is the element that helps break "the power of the established" and allows the individual to be catapulted into his own fantasy. In "Scribble the Figure" and "Handwriting the Figure," working under extreme pressure of time forces one to rely on reflexes and to gamble everything on a single impulse. The rhythmic character of the line produced at this pace reveals at a flash secrets of drawing that could not be gained in

years of patient analysis. In the experiments with improvised tools and mediums the very struggle to control materials for whose management there are no rules shakes one loose from moorings in fixed habits of perception. Similarly in the charcoal problem, the need to reconcile two different images, charcoal areas and the pose of the model, throws the artist back on the resources of his feeling rather than what he knows or has absorbed from others.

The time element is reversed in the "straight line" and "yarn" experiments. Here duration rather than speed assists in the release from habitual ways of seeing. The student-artist is literally saturated in a single element of drawing. Over a period of weeks, hand, eye and medium are brought into a free coordination, as attention is focussed exclusively on this single aspect of drawing. With the passage of time this attention is less and less a conscious concentration on tech-

nique, more and more a heightened sensitivity to certain aspects of the subject. If at first, the use of straight lines exclusively seems like a stylization, toward the end of this period of concentration, one is seeing in a new way, penetrating past the slackness of certain surfaces to the structural engineering of the subject. Yet this penetration is accomplished, not through intellectual analysis but through a projection of the artist's unconscious awareness of structural elements in nature. He brings into play what he has understood about pressures, weights and balances since he was a child playing with building blocks. In this experience of literally building the figure, one is set free of all the preconceived notions that persist as long as we are simply imitating outer appearance.

The imagination experiences a completely different kind of liberation with the irrational and fantastic elements introduced with such experiments as "Ant's-Eye View" and "Mechanical Man." The drawings show how much repressed energy is tapped, how readily the student can accomplish marvels of precise articulation of forms once the restrictions of his rationalizing mind are set aside.

These fantastic problems are not included simply for the sake of fantasy but rather to offer another approach to more sensitive and penetrating expression, whether realistic or otherwise. When the student is asked to consider the figure as a more or less workable system of mechanics, he must contemplate the operation and interrelationship of parts in the figure, yet he does this in the very act of drawing and with a freedom and audacity that would be very difficult indeed were he dealing with the actual nerves, bones and muscles rather than with their imaginative replacements. This ability to transpose, invent and compose all at once is both rare and valuable in drawing. It is an example of that "breaking the power of the established, the hold upon us of what we know and are," yet at the same time making use of what we imagine, to illuminate and reveal what comes from life experience.

Similarly the "ants" problem, although it makes use of a *tour de force* of perspective, succeeds just because this slowed down exploration of the eye (real and imaginary at once) traverses and transcribes the actual forms of the model—an example of what Picasso probably meant when he spoke of drawing and painting as "a lie that makes us realize the truth."

Materials devalued; materials elevated

Materials play a central role in all of these experiments. But before they are elevated to a leading role in expression they are first devaluated. As beginners we are all intimidated by materials and tools. An unsullied sheet of white paper, a row of shining tubes or jars of paint reduces us to near paralysis. But with a torn envelope, a sheet rescued from the wastepaper basket, ideas flow and overflow. Calvin Albert asked his students to deliberately devaluate the materials—in this case charcoal paper and charcoal. They were not to

draw until they had smudged and crumpled a clean sheet of paper and stamped on it savagely. This was not a matter of creating an interesting pattern or surface texture but of a direct release of feeling. So successful, in terms of freedom gained in the drawing that followed, was this explosive experiment that it has been repeated every year. In a number of other experiments, too, the student continues and repeats this experience of dominating his materials. In "collage" he cuts, pastes and juxtaposes fragments snipped from assorted newspaper and magazine pages. In finger painting he tastes the freedom of using hands and arms instead of traditional tools. He works with mediums and implements borrowed from every department except that of art until he loses all awe of materials. With the relaxed handling possible once he is sure of his command, he can let materials play a leading part in forming a conception.

Visual thinking and forming

In an article by Professor T. H. Pear quoted by Herbert Read in his book, "Education Through Art," the psychologist speaks of a fact, "more familiar to artists than to psychologists," namely that, in certain stages of thought, "arriving at truth along visual routes may be uniquely efficient."

Kurt Roesch, well-known painter and teacher at Sarah Lawrence, has also emphasized visual thinking. In his article in "Essays in Teaching," he says, "Visual thinking happens in forms, color, space and line, and it should be clear that such thinking can only come about through the forming process in one of its materials. The hand does not do something that has already been formulated in the mind before, but the combined doing of hand-eye-mind-emotion produces, in an indivisible process, a thought."

The visualization of the ball of yarn (in drawing with white and black crayon on grey) and all of its subsequently evolved forms of threading backward and forward in space, seems to me to offer an interesting example of visual thinking. Simultaneously it exercises the muscles of memory, involves the sensuous manipulation of a material, and introduces progressively complex conceptions of space. As the images of "threading" are developed, they are connected with associations of mood. By the time the drawing is directed to the model, the streams of fantasy are flowing, the hand and materials are working in a free and rhythmic coordination and various structural aspects of the figure are vividly in mind.

The images visualized in the "ants," multiple contour and charcoal tones experiments all make demands on memory, forcing us to create the new out of an interplay of elements recalled in the light of new association. The model herself may provide the image, as when one is asked to first study the model, then draw without looking at her. In these "memory drawings," unimportant details drop out; the image retains the aspects of strongest association.

No indoctrination of style

The styles of the twentieth century, in so far as they reflect the experience of living in this more dynamic environment should, logically, reveal to the student some aspects of his own thinking, seeing and feeling. But he has to find his own way to such points of view through the experience of drawing, and through an emotional identification with present-day artists to whom he feels close, not through a cerebral acquaintance with styles. To be indoctrinated with the mannerisms of a modern style could be just as bad as being indoctrinated with those of an academic style, as far as finding one's own intuitive way of thinking and working is concerned.

After intensive work with "straight line" one may be interested equally in the visual parallels offered by Cubist painters and sculptors and by the paintings of Lyonel Feininger and the angular drawings of the early Renaissance artist, Cambiaso. At the close of explorations with charcoal tones, one studies with renewed interest the handling of lights and shadows in works by Rembrandt and Goya or the contemporary, Jacques Villon (Calvin Albert shows examples from old and modern masters after the work on a certain problem—never before). A new open-mindedness toward unfamiliar means of expression may lead to further study, but it does not mean adopting a style. The same student whose fantastic drawings may suggest Surrealism, will, in another experiment, adopt a severely structural point of view that is its exact opposite. Gradually he makes his way toward his own synthesis of these varied extremes.

Because the student is intent on growth and change, he does not consistently emphasize "finished" presentation in his drawings. "A drawing is finished when it is done," says Calvin Albert. What he means by this is evident in the work. The finish of a drawing grows out of a progressively better solution to the problem, a more complete grasp of what is essential to the form. One does not stop halfway in this process to noodle up edges and accent details.

From subjective to objective

The stage of spontaneous exploration is followed by work directed to specific ends in most experimental problems. Thus the free scribble drawings provide the inspiration for a precise three-dimensional geometrical analysis; the "straight line" work involves analysis as well as invention and culminates in disciplined structural compositions; and the pen and ink problem, where the preliminary emphasis is all on the free play of rhythms, ends in the most sensitively observed and precisely characterized drawings.

The artist who feels free and confident does not balk at disciplines but welcomes whatever new work experience will broaden his range of communication. While this book deliberately includes only work suitable to the beginning stage of drawing the figure, it is hardly necessary to say that the student will want and need to go on to further and more intensive work. Advanced studies will include work that is more analytical—it is not the position of the authors that

the reasoning intelligence be excluded from figure drawing, but simply that factual study be offered as the need for it is realized, even sought, by the student. Thus the teacher suggests that the student become acquainted with books on the nature and behavior of materials, but after he has first explored them without preconceived ideas. Similarly a more thorough acquaintance with anatomy may be useful to the student after he has developed a strong conception of the figure as a totality.

These experiments show that the student achieves an objective grasp of the figure through subjective means rather than through an analytical and factual approach. In general they are able to produce a more precisely observed statement than students whose initial training has been "objective" and analytical. Whatever the individual abilities of the student, after this intensive experimentation of his first year, he shows an ability to see and express the figure as a structure in depth rather than as a thin facade, and he can deal with it as an embodiment of energy with shifting balances rather than a static thing. Although the student's attention has been directed only incidentally to anatomy, his drawings show an understanding of the presence of bones and muscles, of hard and soft flesh surfaces, and of the distribution of weight. The abbreviated case history of one student (p. 210) shows that an individual who is attracted to the fantastic can also produce carefully observed drawings of the model.

Outlook for growing

The student's continuing development in drawing should lead to a deepening of the subjective conception of the figure. His way of seeing, feeling reflect what he is. If little has been said of spiritual feeling, of transforming a representation of a man into thinking about Man, it is because of the danger of inviting clichés. The teacher who asks for a symbolic interpretation too often is rewarded with student drawings showing grief with bowed head, joy with uplifted hands—second-hand or fifth-hand ideas that have not been revitalized through the student's observation of forms in nature.

The teacher is always ready to recognize the emotional, dramatic element in a student's drawing, although he knows that he cannot indicate beforehand what that interpretation should be. He knows that any single pose of the model

may afford a wide range of meaning—what appears tranquil to one person will strike a tempestuous note in another. The same model in the same pose can appear demonic in one student's drawing, angelic in another's. This is as it should be. From the first experiment with "scribble" drawings we have seen that these psychological differences, like differences in handwriting, are not only accepted but accented in the various experiments.

If the teacher cannot indicate the direction in which the student will change and transpose what he perceives in the model, he can open up the avenues through which this transformation may take place. This is, in fact, not separate from technique but the reason for technique. The word "poetic," which recurs

in the introduction to certain experiments here is meant to suggest the "transformation" possible in drawing the model. It is not intended to mean associations with roses and moonlight. A tortured or grotesque quality in a figure can also be poetic.

In sleep all peoples are able to transform the stuff of everyday recollection into images of symbolic meaning—a natural activity of the nervous system not requiring any special talent or intelligence. This imagery, even when it can be recalled directly, is seldom immediately useful for esthetic expression. Yet in drawing, in the process of forming what we see, we are able to recover some of this magical ability to transform, on a level closer, perhaps, to daydream. The more sensitive our observation of reality in all its complexity and richness, the more meaningful are the associations we bring to this transformation, the more we can mint our dreams into the common coin of communication.

At a time when scientists like Robert Oppenheimer and Alfred North Whitehead have stressed the dangers of a world where the scientific—knowing—intelligence and the esthetic—feeling—intelligence remain estranged from each other, artists need no longer pretend that their realm is simply another kind of science. If it is partly their role to insist on the value of spontaneity and feeling, there is no area where it is more logical to reaffirm these values than in the interpretation of the human figure itself.

Dorothy Gees Seckler

Calvin Albert's
FIGURE DRAWING
COMES TO LIFE

Second Edition

1
Scribble the Figure

There are certain things that we can only do fast; certain kinds of lines that we can draw only at a stepped up pace; certain responses that occur only under pressure. The jazz musician responds instantaneously to the emotion of the moment and he improvises a series of notes, different each time he plays the piece, but something he could never accomplish in an atmosphere of isolation or by conscious design. In the same way, we can only scribble by an instantaneous reflex action. For reasons rooted in the nervous system, we cannot obtain this kind of rhythmic unity on the page, this particular intensity of line, except under pressure of speed.

The lines that are scribbled are different in degree of strength and verve from the lines we make any other way, yet they are strangely our own. In their consistent quality of smoothness, jerkiness, delicacy or boldness they correspond to the nervous reflexes of the particular individual as does his handwriting. For this reason, they are revealing for him to study afterwards.

A scribble (crayon on a pad large enough to accommodate large arm movements) tends to produce a total unit on the page. Automatically we compose this line in relation to the page so that the whole space is involved. This is an ability rarely developed in the fledgling artist. Ordinarily, whether in making an inventive design or a representative drawing, we do not see the forest for the trees: we are too much distracted by details to grasp the connections that make the unity of the whole impression.

Individuals react differently to the pressure of being made to produce drawings almost instantaneously, whether it is the initial furious succession of line scribbles or the subsequent scribbling of the figure. Nearly everyone feels insecure when asked to work at a pace where conscious control is impossible. Because so much of our sense of security in life comes from hewing to established habits, we resist abandoning them, even if they are only habits of drawing a line. But growth is constantly upsetting habit and we have to get used to a changing kind of equilibrium. We are actually more secure when we can be flexible— alive to the changing possibilities of the moment.

What can be set down on paper in a fifteen to twenty-second pose? Not contours and details, but the main masses and expressive action of the model. The drawings reproduced were all made in that time in consecutive poses. A

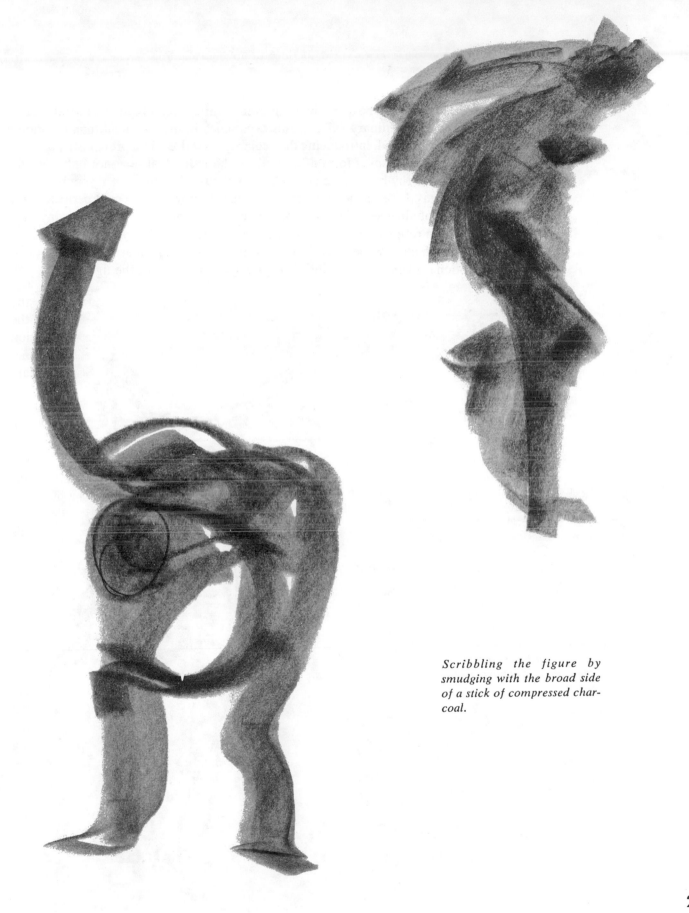

Scribbling the figure by smudging with the broad side of a stick of compressed charcoal.

27

day earlier the same individuals given fifteen seconds, would have produced a piecemeal thing, a head, perhaps, or even at thirty seconds, at most a half figure.

The extraordinary value of this experience is less technical than emotional and psychological, introducing the beginner, as it does, to a previously unknown capacity for grasping form as a totality. The individual now not only sees the figure in its rhythmic mass and action, but trusts his own felt response to it in these terms. Like the jazz musician, his purpose now is not a cold perfection but the kind of aliveness of impression that can only come when feeling is involved and when rational fears have been set aside. His new ability to see the "forest" instead of merely the "trees" is not a matter of remembering a rule, but an emotional identification with the expressive wholeness of the figure.

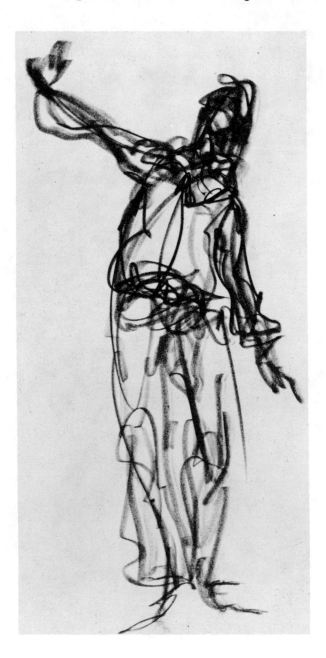

Linear scribbles made with the point of a conte crayon.

28

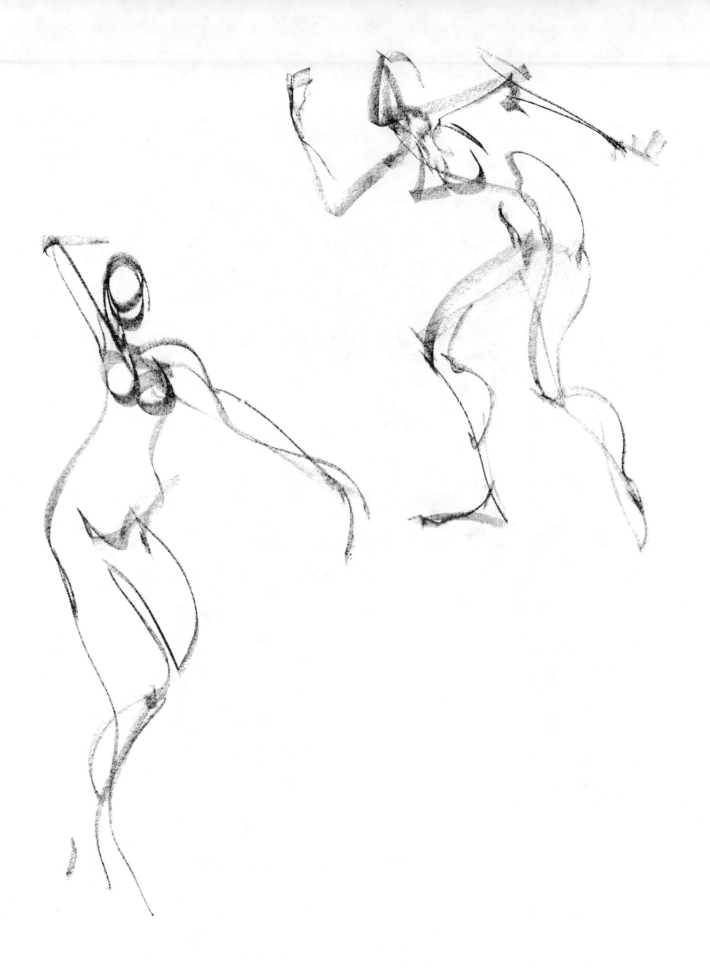

29

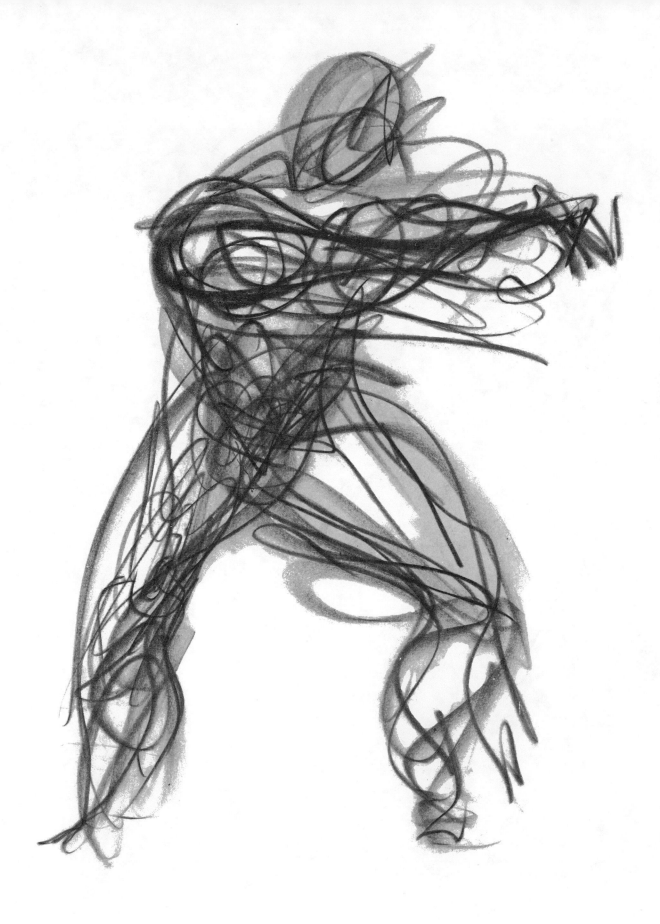

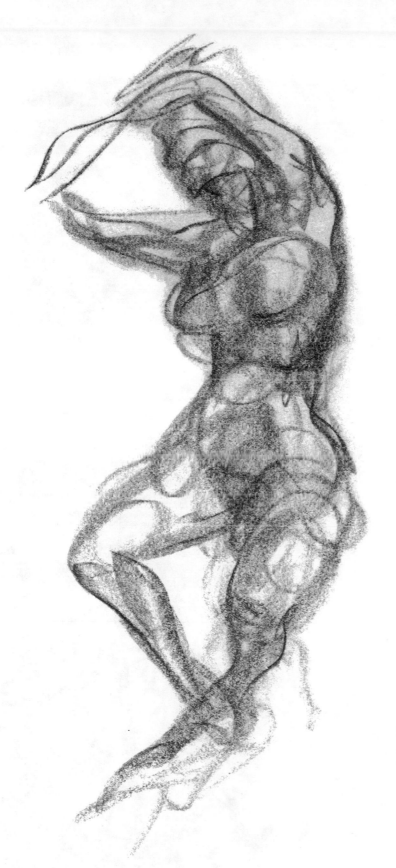

The mass of the figure emerges from a scribble of many criss-crossing lines.

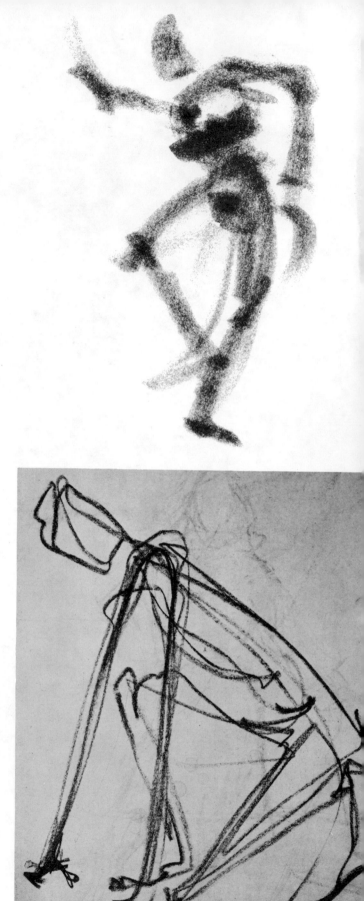

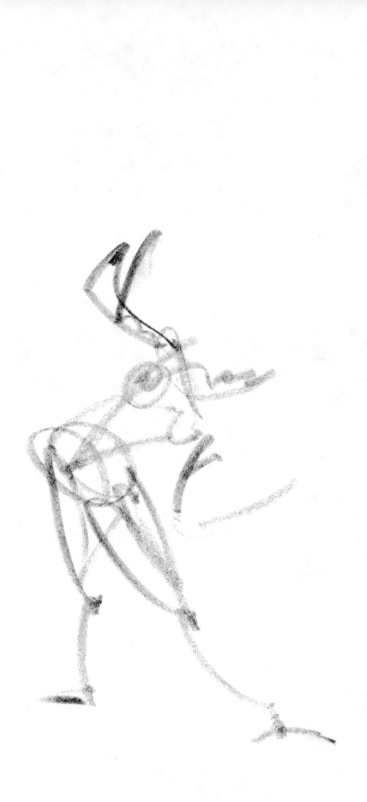

A more geometric scribble drawing.

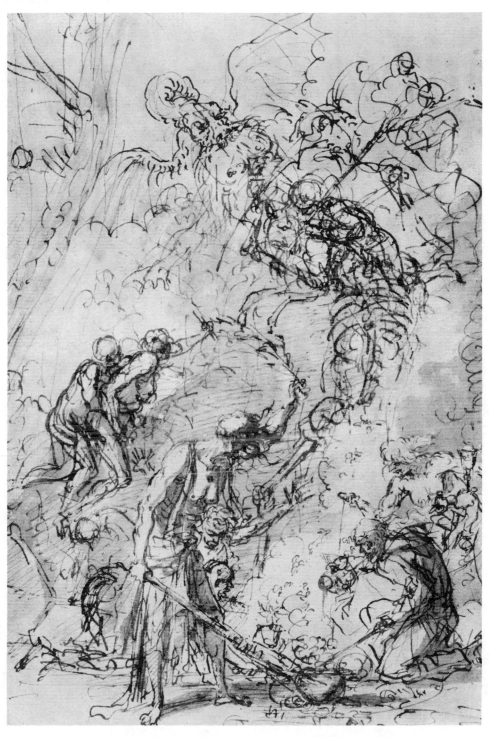

SALVATORE ROSA: *The Temptation of Saint Anthony,* pen and bistre with wash, 17th century. Courtesy of the Metropolitan Museum of Art.

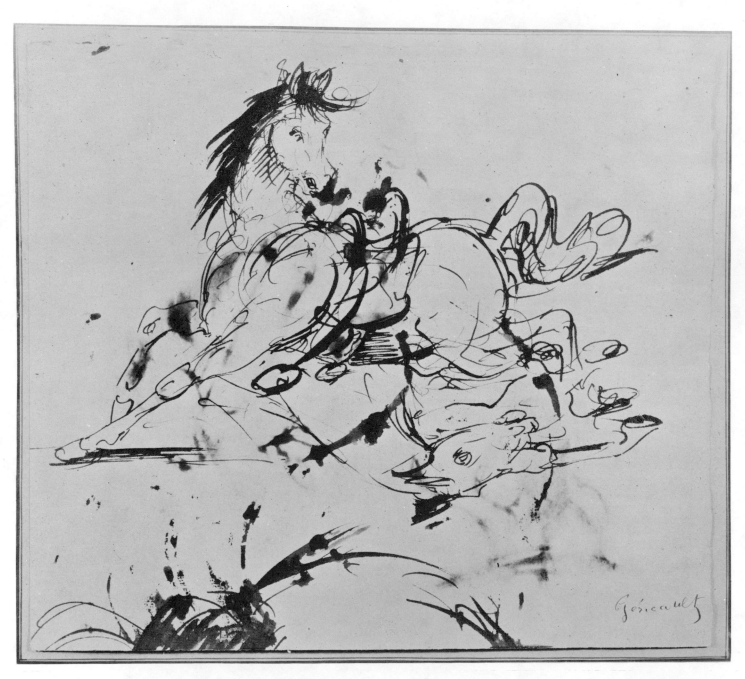

THEODORE GÉRICAULT: *A Frightened Horse.* Courtesy of the Detroit Institute of Arts.

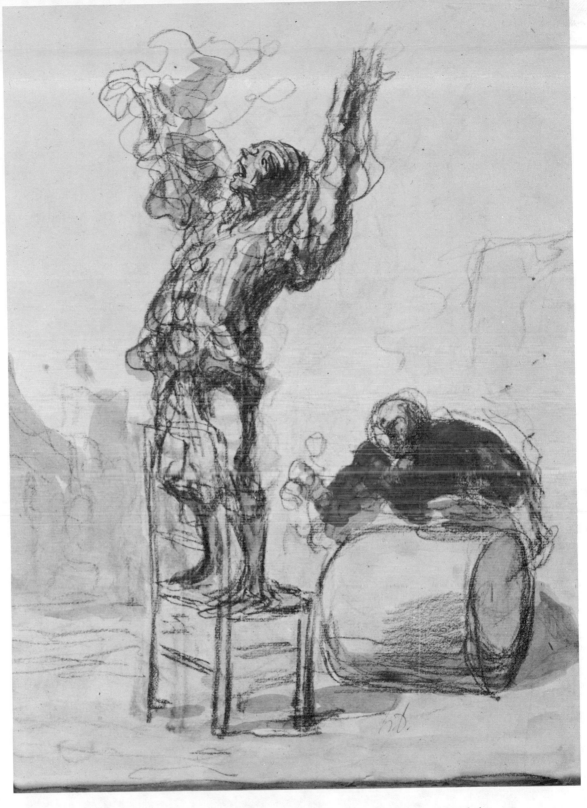

HONORÉ DAUMIER: *A Clown*, drawing with charcoal and water color. Courtesy of the
Metropolitan Museum of Art.

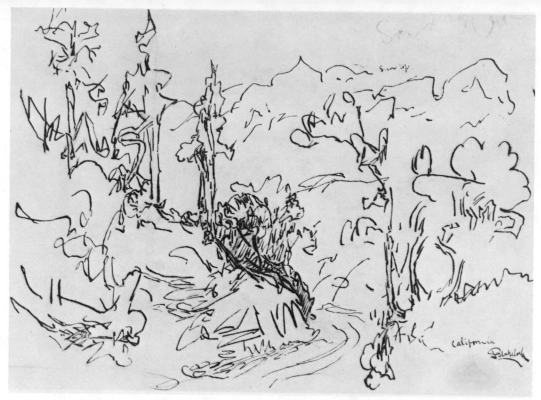

RALPH A. BLAKELOCK: *California*, 1869. Courtesy of the Addison Gallery of Art, Phillips Academy.

MARILYN CHURCH: *The Trial of Jack Abbott*, 1982. Courtesy of the artist.

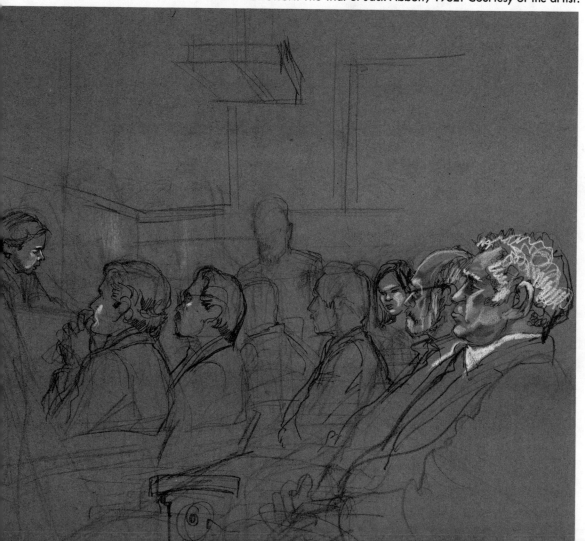

In sketching scenes for newspapers and television, the scribble method makes it possible to rough in an entire composition with some details of likeness and color, in no more than half an hour.

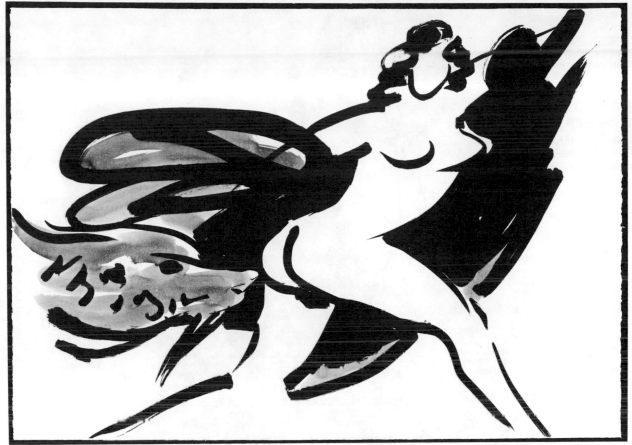

REUBEN NAKIAN: *Nymph and Goat*, 29³/₄ × 42 inches, 1982. Courtesy of the Marlborough Gallery, New York.

BETSY LEWIN: Illustration from *The Strange Thing That Happened to Oliver Wendell Iscovitch*, published by Dodd, Mead & Company.

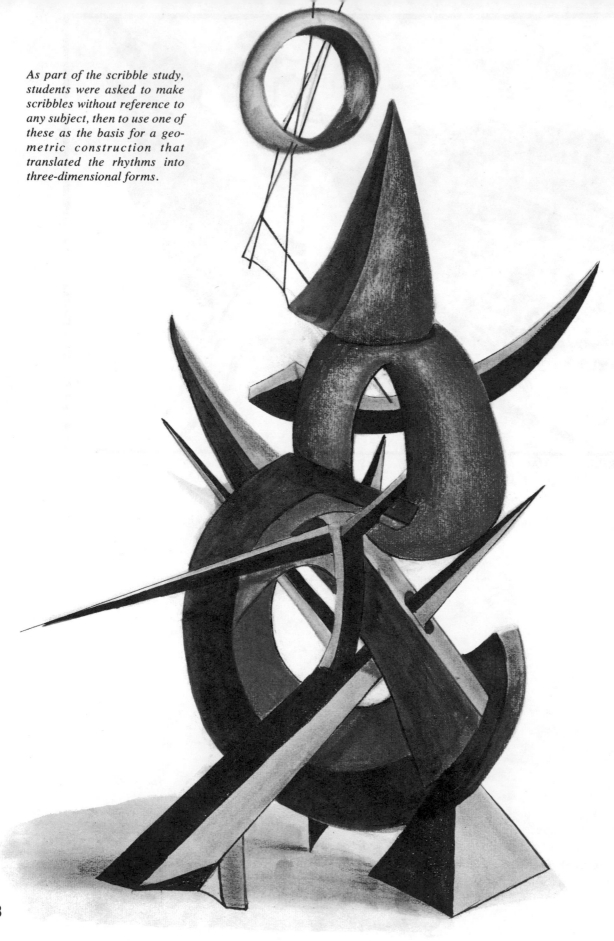

As part of the scribble study, students were asked to make scribbles without reference to any subject, then to use one of these as the basis for a geometric construction that translated the rhythms into three-dimensional forms.

38

2
Geometrical Interpretation

During the period when the painter is finding himself he develops through identifying with the work and outlook of admired artists, and this identification is often expressed through making (acknowledged) copies. Cézanne, Matisse and Van Gogh are among those who have left evidence of this impulse in the copies they made of work by distinguished predecessors. Writing of copying in a letter to his brother, Van Gogh said, " I started it by chance and I find that it teaches me things and above all it sometimes gives me consolation. And then my brush goes between my fingers as a bow would on the violin and absolutely for my pleasure . . . I can assure you that it interests me enormously to make copies . . . It is a kind of study that I need, for I want to learn." In another letter Van Gogh compared copying to the personal interpretation that a performer gives to musical composition.

For the beginner the emotional need for this kind of identification is evident in the long hours he gives to copying. This prodigious effort can be entirely wasted if he merely makes a mechanical transfer of lines, as a substitute for original expression. Undertaken as a study, however, it can provide a valuable experience.

The basic creativity of the act of drawing is in translating a subject that appears in three dimensions into lines and shapes on a two-dimensional surface. One who makes a copy, on the other hand, transfers only from two dimensions into two dimensions; the vital decisions as to the way depth should be transposed, have all been made by the original artist. The validity of the copy depends on the extent to which the copyist has understood and re-enacted those decisions —his ability to read into any line the full intention of the artist.

In the series of drawings illustrated, the first one, in each case, is a copy of a figure originally conceived by an admired artist. The second drawing in the pair shows a sequel in which the same subject was recreated entirely in geometric solids, an *interpretation* of its form.

In the process of translating the linear drawing into geometrical solids the

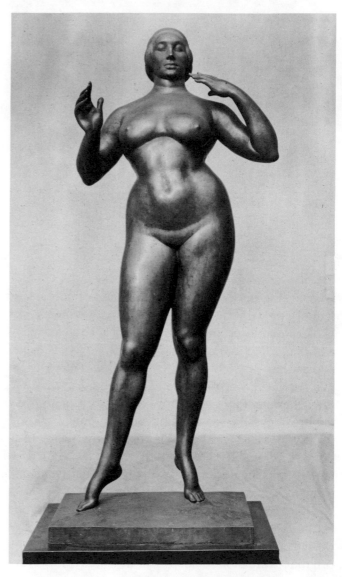

GASTON LACHAISE: *Standing Woman,* bronze. Collection Albright Art Gallery, Buffalo, New York.

copyist is forced to consider the figure as having a distinct front, sides, back and top and to decide where one begins and the other ends. He has to decide which solid—cube, triangle or sphere—is approximated by the forms of the drawing and articulate the joinings of each part. But if he is to fully interpret the figure copied he must go still further and find the larger, single units which will encompass a grouping of smaller forms. The decisions as to which forms are leading, pivotal ones and which are subordinate, always depend on the total action and feeling of the figure.

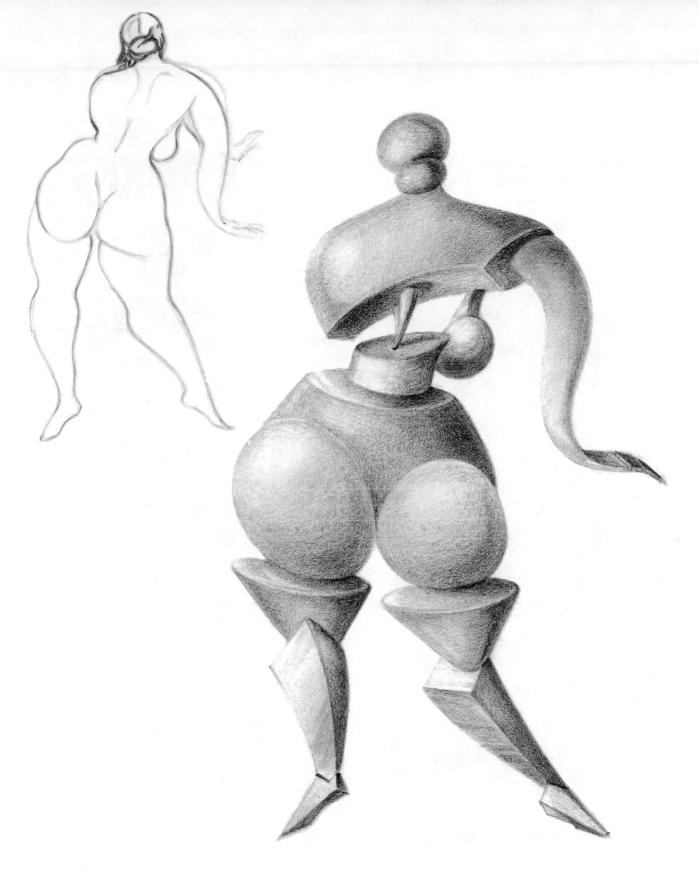

This copy of a Lachaise drawing owes its vitality to the student's grasp of the basic volumes enclosed by the lines, an understanding made explicit in the subsequent analysis into a logical structure of geometrical solids.

*A copy from Michelangelo
yielded first an analysis of
bone structure then a break-
down into a mechanism of
hollow volumes.*

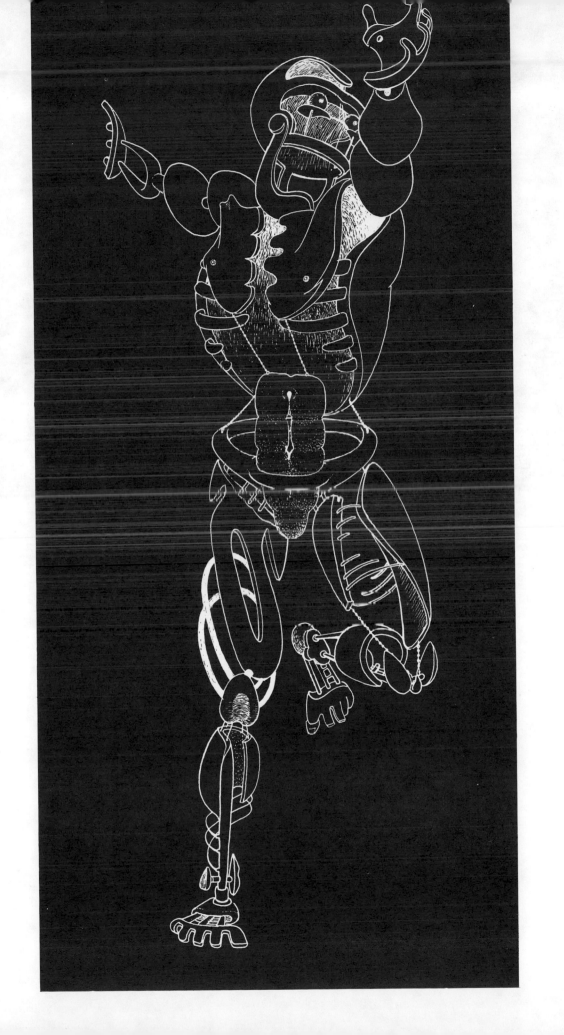

43

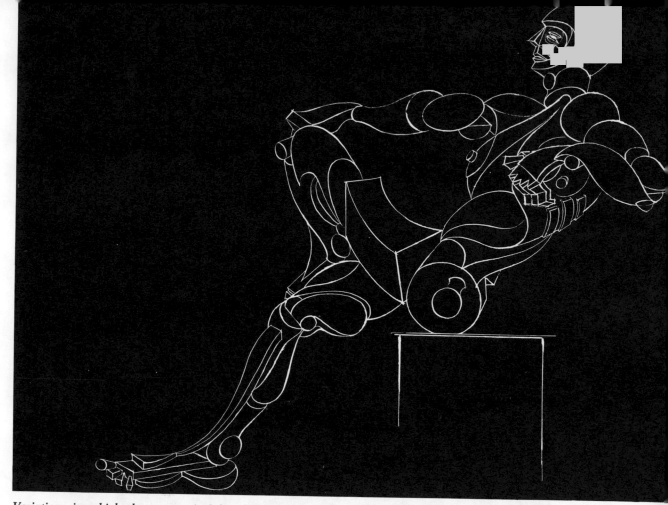

Variation in which the geometrical breakdown was made from the individual's own drawing from the model.

Taking the problem as an opportunity for a joke, this student transformed the classical nude he had copied into a gruesome but consistently characterized hag.

His ability to reconstruct the geometrical forms involved in a given pose was not impaired by the fact that this artist began with a pin-up type drawing from a magazine.

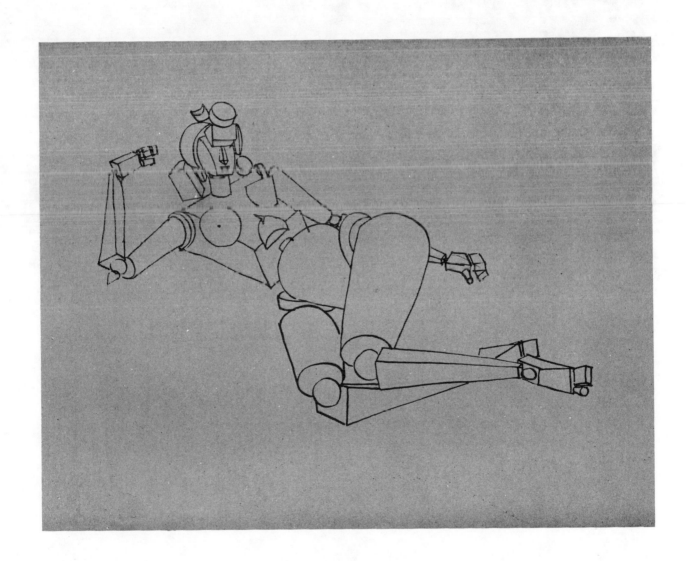

EUGENE DELACROIX: *Studies of Legs after Rubens' Coup de Lance,* reed pen, brown ink. The French master copied by Van Gogh, himself copied details from a work by his admired predecessor. Collection Mr. John Thacher.

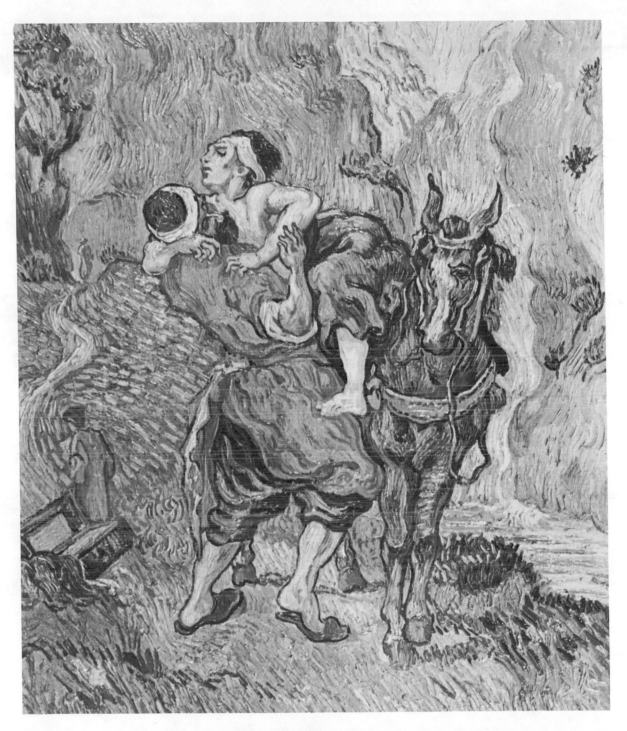

VINCENT VAN GOGH: *The Good Samaritan,* after the original by Eugene Delacroix. When Van Gogh copied this work by an admired predecessor he gave it a heightened tension both through distortions in the figure of the rider and through the convulsive swirl of his brush strokes, in a space that is flatter, a place less exotic than Delacroix's. Van Gogh compared copying in painting to the interpretation that a performer gives to a composer's work, a parallel supported by this and his other copies of master works. Courtesy Rijks Museum, Kröller-Müller, Otterlo, Belgium.

3
Mechanical Man

Popular science has introduced us to a world of fantastic figures whose fascination for us lies partly in gadgetry—the coming to life of the mechanical things which we handle from morning until night. Perhaps the reason that the problem of making a mechanized figure—finding equivalents in the operation of objects for the functioning of the body—often proves so stimulating, is that it gives free rein to the feelings in an area where we are visually at home. Dealing with both the similarities and differences between organic and mechanical things, the imagination is challenged to explore in many different directions. One person will invent a kind of clockworks figure in which every part corresponds to an actual function: the neck swivels; the hands are pincers; the joints, ballbearings. Others take off on a flight of pure fantasy, constructing figures that have grotesque logic of their own, as irrational and compelling as those of a nightmare. The potency and inventiveness of the drawings that follow suggest that, both as a visual and emotional experience, this vein is a rich one to explore.

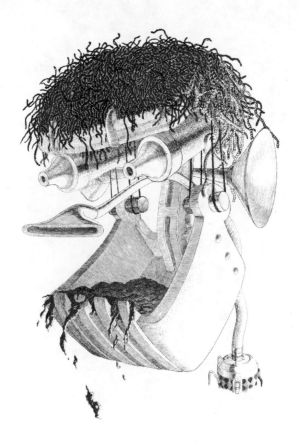

The objects that make up this grotesque head have a visual "punch" as well as justification of each part in function: the eyes, binoculars; the nose, a vacuum cleaner extension; the mouth, a steam shovel.

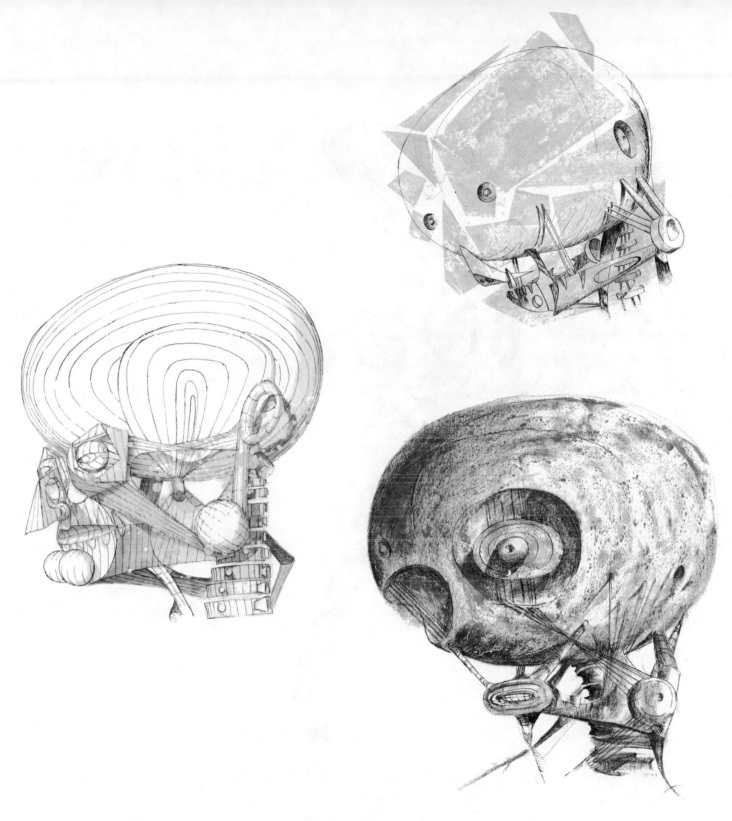

Fantastic interpretations of head structure in which the student has followed his feeling for inventive drawing rather than literal anatomy, concluding the series with a surrealist version which takes the skull into the realm of nightmares.

49

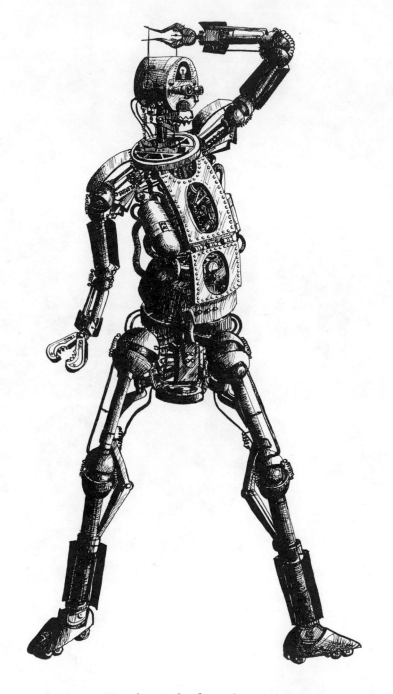

Electronic man: this complex image is not a robot, but a reconstruction of the workings of the human form in terms of electrical engineering.

Translating the figure into a system of workable mechanics forced this student to consider the functioning and interdependence of each part of the body.

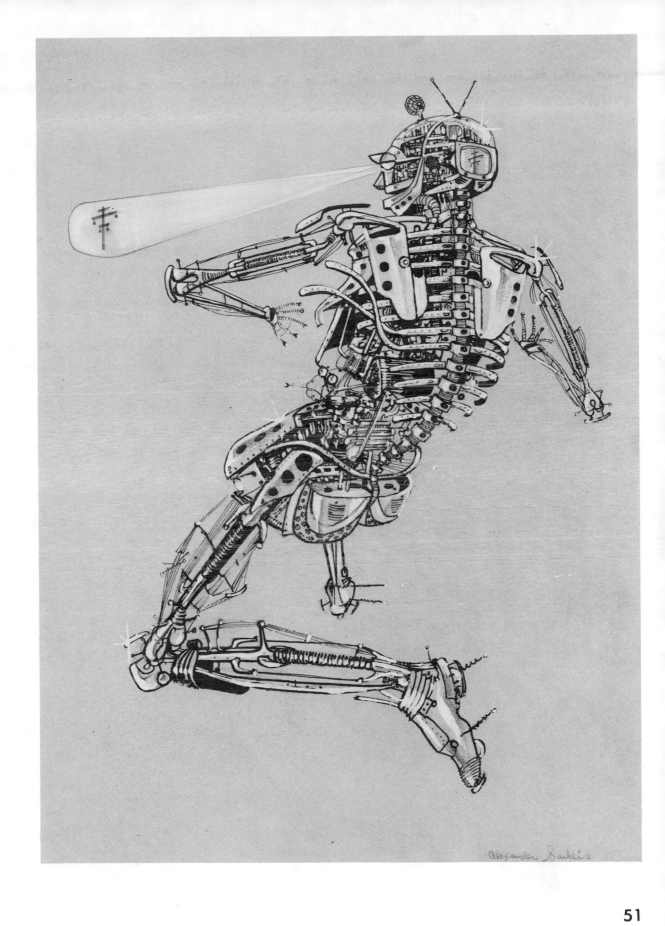

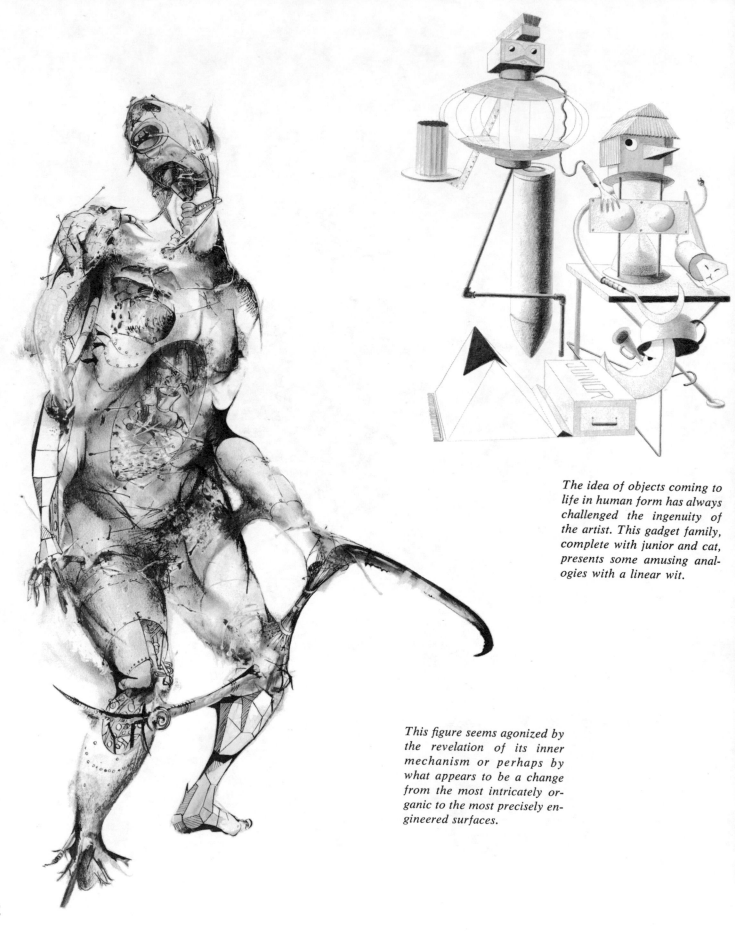

The idea of objects coming to life in human form has always challenged the ingenuity of the artist. This gadget family, complete with junior and cat, presents some amusing analogies with a linear wit.

This figure seems agonized by the revelation of its inner mechanism or perhaps by what appears to be a change from the most intricately organic to the most precisely engineered surfaces.

*Imaginary fabricated crea-
tures can evoke a variety of
responses. They can be war-
like and threatening, like ar-
mor, or mysterious like de
Chirico's painted assem-
blages. The Tin Woodman, al-
though made of cold metal, is
a warm and lovable charac-
ter, while Nancy Grossman's
creations suggest human be-
ings overlaid by protective
and aggressive artifacts.*

Illustration from *Dictionnaire du Mobilier Francais*, by Eugene Emmanuel Viollet-le-Duc.
Courtesy of The New York Public Library.

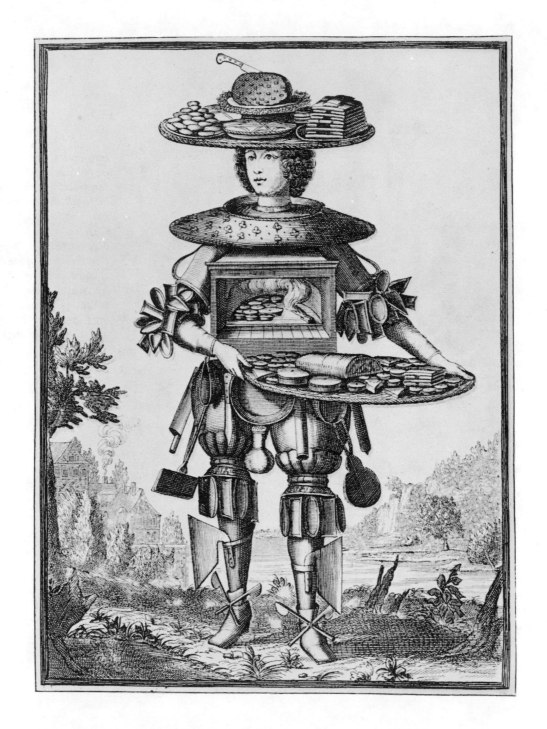

NICOLAS de L ARMESSIN: *Costume of the Baker*, 17th-century engraving. Courtesy of The New York Public Library, Prints Division.

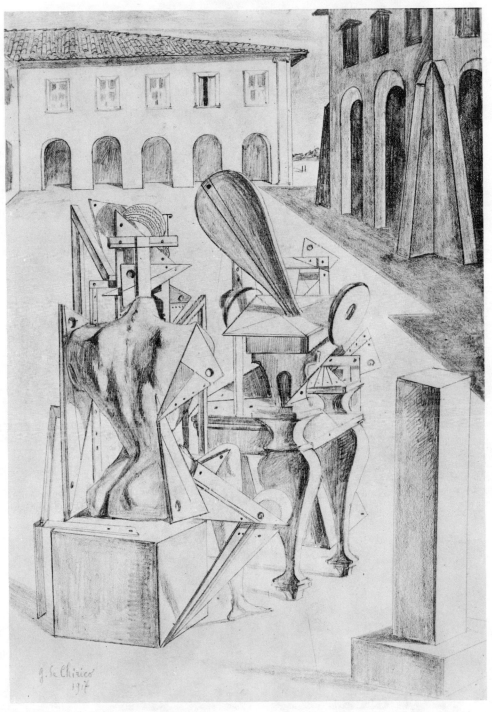

GIORGIO de CHIRICO: *The Mathematicians*, pencil, 1917. Collection Museum of Modern Art, gift of Mrs. Stanley Resor.

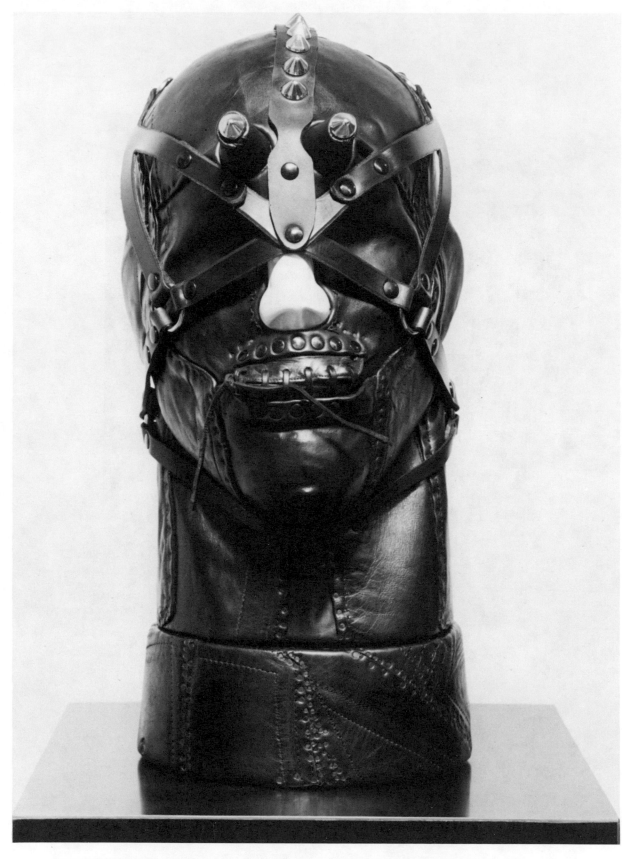

NANCY GROSSMAN: *Untitled Head Sculpture*, carved wood, leather, metal and lacquer, 1968. Courtesy of the artist.

NANCY GROSSMAN: *The Road to Life*, lithograph. 1976. Courtesy of the artist.

W. W. DENSLOW: *The Tin Woodman*. Illustration from *The Wonderful Wizard of Oz*, by L. Frank Baum. Reprinted by Dover Publications, Inc., 1960, New York.

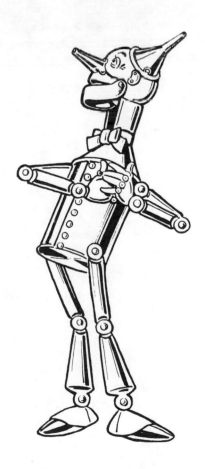

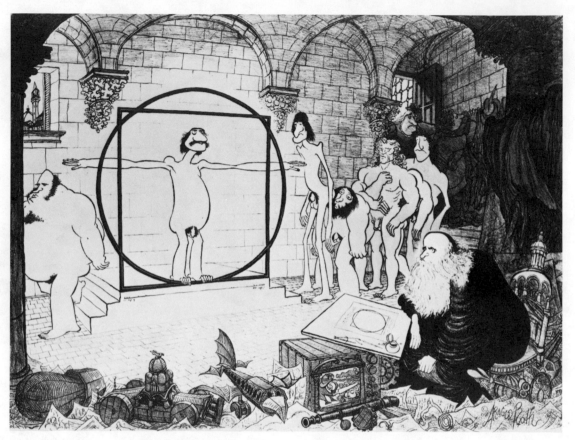

ARNOLD ROTH: *Leonardo at Work.* Courtesy of the artist.

4
Proportion

If the Negro sculpture is less than four heads high, this is not because the African carver overlooked the actual length of the legs but because he gave importance to aspects of the figure that had the most real or magical emotional impact for him—the head and face above all. He therefore gave most of his space as well as attention to those sensuous forms and reduced the legs down to a scale that, while departing from nature, is, on the whole, satisfactory for sculpture. Artists like El Greco, Botticelli and Lehmbruck, on the other hand, have made figures up to thirteen heads high, not because they liked long legs so much but because the vertical proportion is associated with elegance and spirituality.

It is obvious that the truth lies somewhere between these two extremes; but there are no rules that apply in all cases (classical proportion is helpful only to the artist who makes "a classical" figure). In order to develop a sense of proportion, taking measurements from the model is a procedure that has proved helpful. Having actually demonstrated to himself the considerable range of proportion—one model may be five heads high, others six or seven—the student becomes sensitive to these differences and he can either follow them literally or depart from them consciously if it helps the expressiveness of a particular drawing.

A drawing game popular with the Surrealist artists makes a dramatic introduction to the study of proportion. A paper is first folded into four equal parts. On this, artist number 1 draws a head and then folds it out of sight, leaving only two marks to guide the next participant. He then passes the folded paper to artist number 2, who draws the upper torso, folds his addition out of sight with the exception of the two guide marks, and passes the folded paper to artist number 3, who adds the section from waist to knees, folds, marks and sends it on to artist number 4 who supplies legs and feet. Each has drawn without seeing what had been done before. The incongruous results, like those reproduced, focus attention on the expressive possibilities of proportion.

Participating in this game, students enjoy a certain risque humor, but also come to recognize that in serious efforts it is important to pay attention to the size relationship of one part to another.

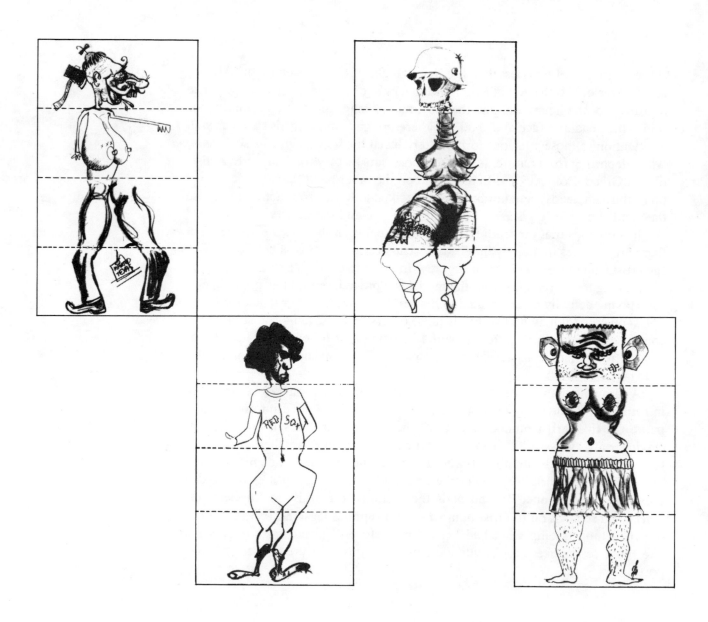

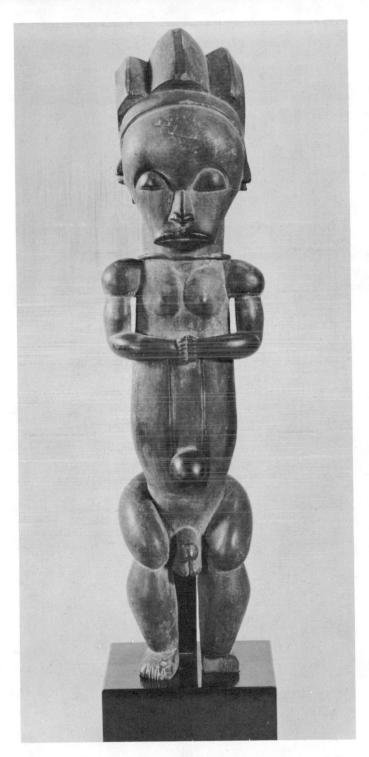

FANG TRIBE: *Male Figure.* In the Brooklyn Museum collection.

WILHELM LEHMBRUCK: *Standing Youth,* cast stone, 1913. Collection Museum of Modern Art, Mrs. John D. Rockefeller Purchase Fund.

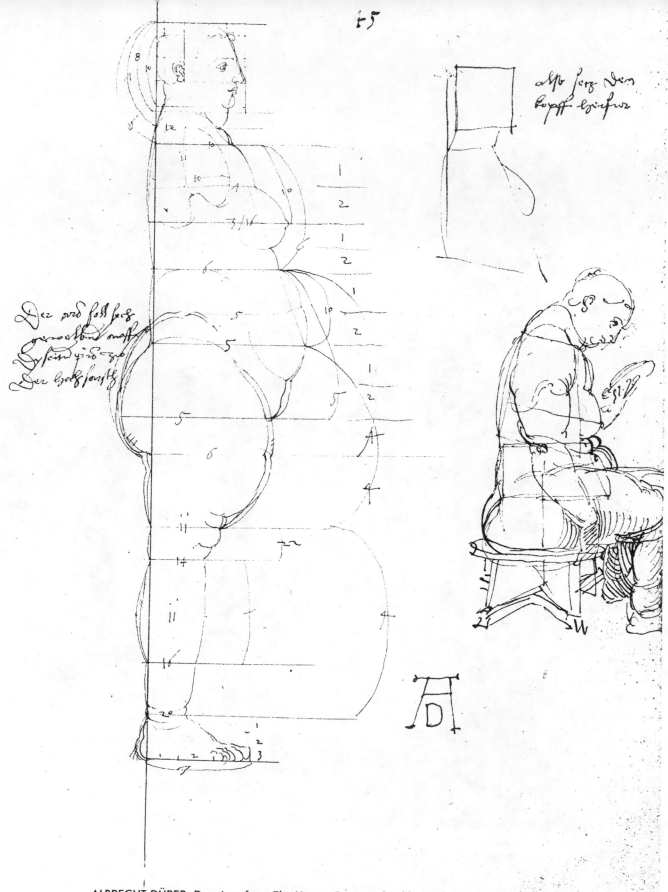

ALBRECHT DÜRER: Drawings from *The Human Figure*, edited by Walter L. Strauss. Reprinted by Dover Publications Inc., 1972, New York. Dürer made hundreds of studies of human proportions in order to devise a system for artists to use in constructing the figure. He described several methods in *Four Books on Human Proportion*, published after his death in 1528.

63

EL GRECO: *Laocoon,* c. 1610. National Gallery of Art, Washington. Samuel H. Kress Collection.

WILLIAM KING: *Air,* polychrome wood, 1980. Collection Mr. and Mrs. Herbert Landau. Courtesy Terry Dintenfass Gallery, New York. This sculptor makes many witty variations on the figure, most of them extremely tall and thin.

5
A Key to Characterization

Sketching the people that one encounters in his daily environment can provide a pleasant change of pace, supplementing the work from the model. The waitress at the lunch counter, the postman, one's best friend, the man next door— what do they look like? The attempt to capture the features, stance, gait and build of any individual, even from observation, is apt to be frustrated by the lack of a starting point, unless one adopts a definite point of view.

Exaggeration, the point of view of caricature, often offers a helpful approach. The moment one tries to envision all the various characteristics of his model in terms of one dominant quality, the various details begin to assume a pattern and consistency. The eye and hand of the artist are free to concentrate and select certain salient aspects that provide a key to the rest.

Some figures make one think of other things in nature—a rock, in the case of one whose stance is stalwart, a reedy quality for the wavering personality. A revealing resemblance to an animal or bird has provided the basis for caricatures since ancient times.

A waitress who, perhaps, consumed as much food as she served, provided a theme of rotundity in some of the caricatures here; in others, the wiriness of a model was the starting point.

A caricature of Calvin Albert by one of his students.

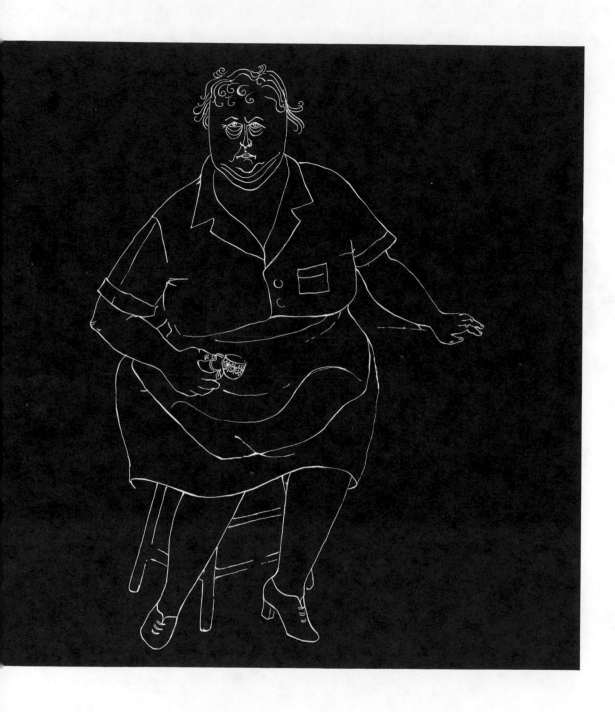

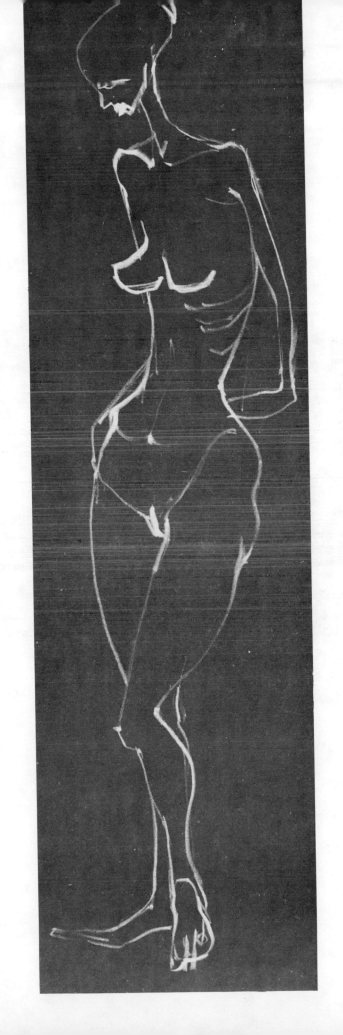

Characterization

*Examples
of similar techniques*

UNKNOWN ARTIST,
SCHOOL OF THE CARACCI:

Caricature of a Spanish Grandee. Courtesy
of the Metropolitan Museum of Art.

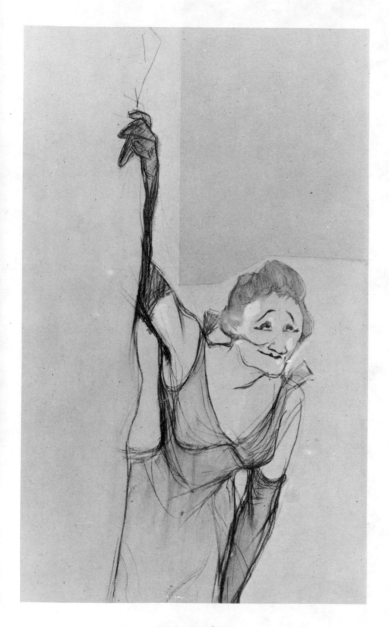

HENRI de TOULOUSE-LAUTREC:

Yvette Guilbert, chalk and watercolor on paper. Collection
Rhode Island School of Design, Providence, Rhode Island.

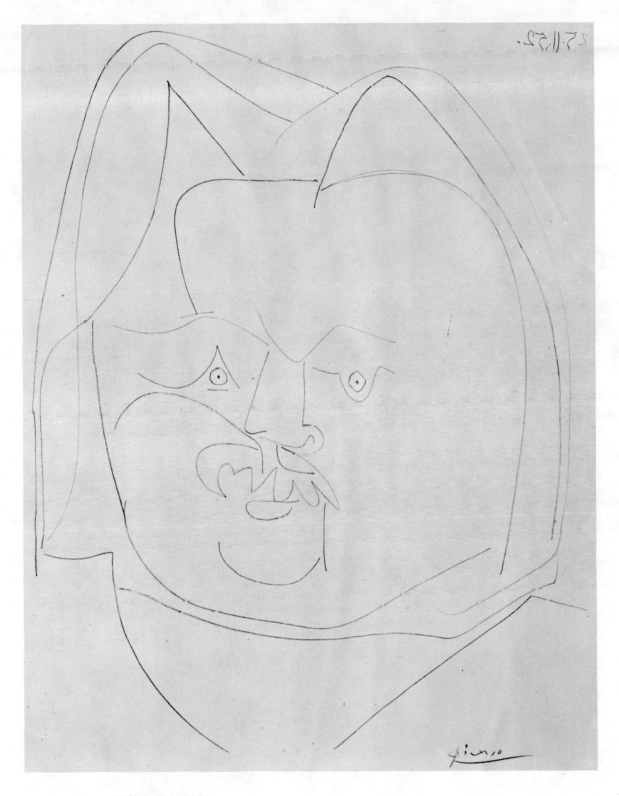

PABLO PICASSO:

Head of Balzac II, lithograph, 1952. Collection Museum of Modern Art, Purchase Fund.

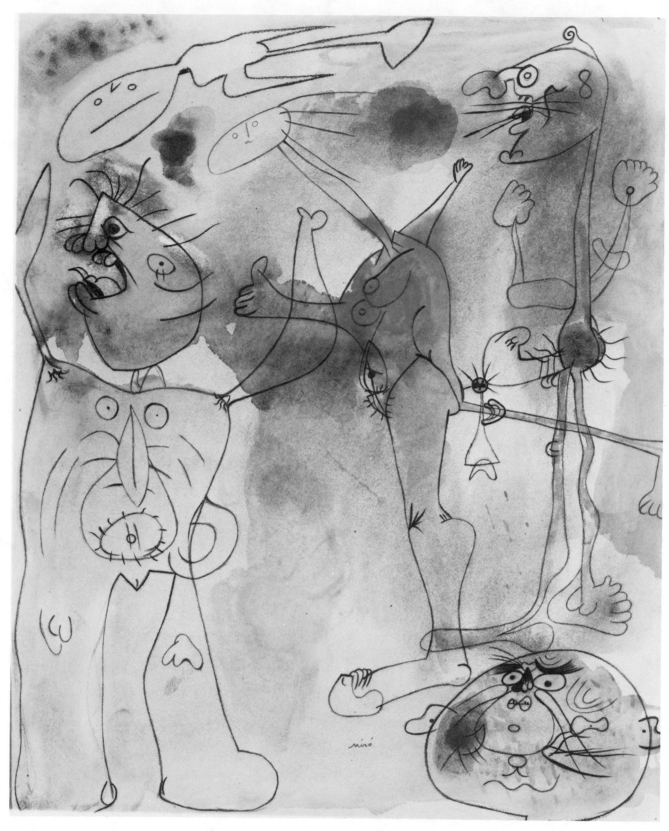

JOAN MIRO: *Persons Haunted by a Bird*. Collection of the Art Institute of Chicago. Miro gives
free rein to his playful imagination, making an assortment of distorted figures
and faces, fat and thin, square and round.

DAVID LEVINE: *The Offended.* Reprinted with permission from the *New York Review of Books.*
Copyright © 1964 Nyrev, Inc.

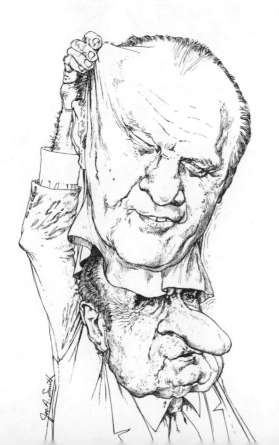

JOSEPH A. SMITH: *How Long Will Nixon Haunt the G.O.P.?*
Newsweek magazine, September 23, 1974.
Courtesy of the artist.

PABLO PICASSO:

Seated Nude, an etching with lines circling the form, made in 1931. Collection Museum of Modern Art, Purchase Fund.

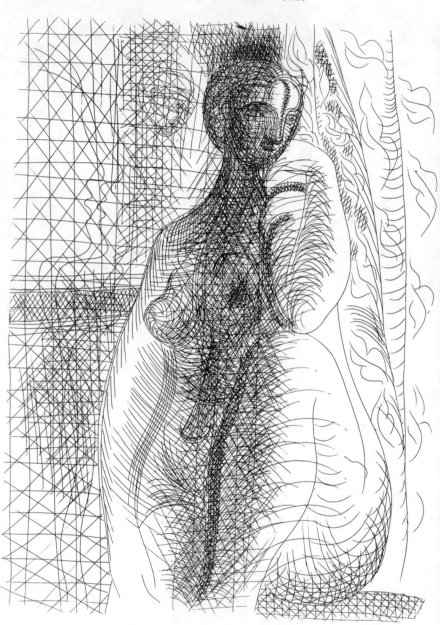

JOHN SEDDON: Decorative pen drawing from "The Pen-Man's Paradis," 1695. Courtesy of The New York Public Library.

6 Handwriting the Figure

Of all the ways of using pen and ink to interpret the figure, the method of "spinning" its volumes with a continuous line is surely the most accessible to the beginner. This approach brings to our aid the rhythmic movements which are also the ones most familiar to our hand—the spirals, figure-eights and zig-zags that are employed in our handwriting. It is just because these basic linear units correspond to the several most perfectly coordinated movements of arm, wrist and fingers that they constitute the elements of handwriting exercises like those of the Palmer method. But spirals and loop-the-loops are also familiar to us in a more pleasant connection—in the decorative angels, horsemen and American eagles created by folk artists with lines borrowed from the elaborate, flourishing signatures of earlier times.

In the drawings and prints of masters like Albrecht Dürer we find circling lines used very differently—not in the flat manner of the calligraphers, but defining the solid volumes of the figure. Here the lines are not carried completely around the figure but one mesh of curving lines is constantly intercepted by another series tilted at a different angle, to describe a change of surface. This method is used also by the sculptor, as we can see by studying his chisel marks on a stone carving of a figure.

The penmanship figures illustrated were produced by a method which combines elements taken from the calligraphers and the masters: the rhythm and hand-coordination of one, the volume-thinking of the other. As contrasted with the two-dimensional, "handwritten" motifs (like the bird illustrated) these figures are fully described in depth. Through a constant shifting of the angle of each linear unit and also by means of overlapping one unit over another, the artist conveys the action and many-sidedness of the model. The transparency of this technique enables him to show the tilt of one part of the body against another. Changes in the spacing of lines suggest foreshortening.

The handwriting units are used as directed by feeling, not by any system. Spirals, figure-eights and zigzags are combined differently for each pose and in the interpretation of each individual. Eventually they tend to disappear. What remains is a spontaneous flow of lines expressing the volumes of the figure.

Practise with penmanship figures (about 1½ inches high) brings into play several basic arm, wrist and finger movements.

To avoid spilling, blotting and jabbing:

1. *Use fine round-nib lettering pen instead of steel point*
2. *Have ink bottle no more than half-inch full*
3. *Use smooth-surface bond paper*

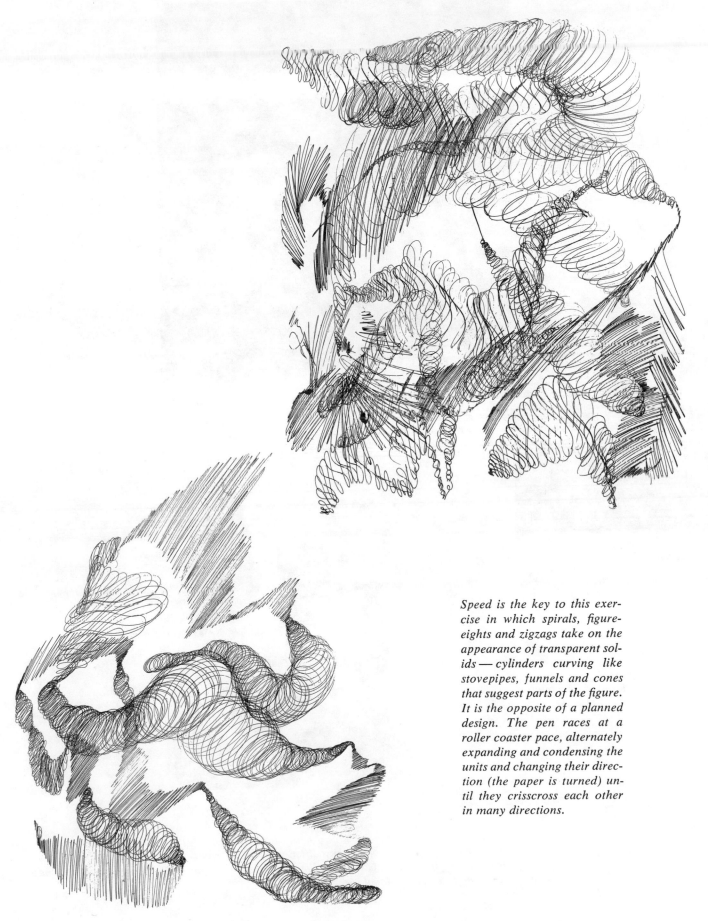

Speed is the key to this exercise in which spirals, figure-eights and zigzags take on the appearance of transparent solids — cylinders curving like stovepipes, funnels and cones that suggest parts of the figure. It is the opposite of a planned design. The pen races at a roller coaster pace, alternately expanding and condensing the units and changing their direction (the paper is turned) until they crisscross each other in many directions.

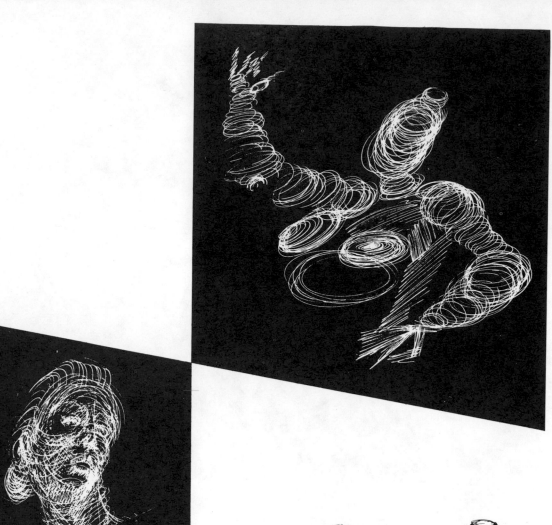

A spiritual mood is emphasized by a play of oval rhythms.

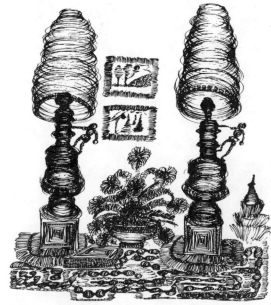

Penmanship exercises suggest many different kinds of subject matter that lends itself to this linear treatment. In this still life, the basic linear units are used both decoratively and to indicate three-dimensional space.

78

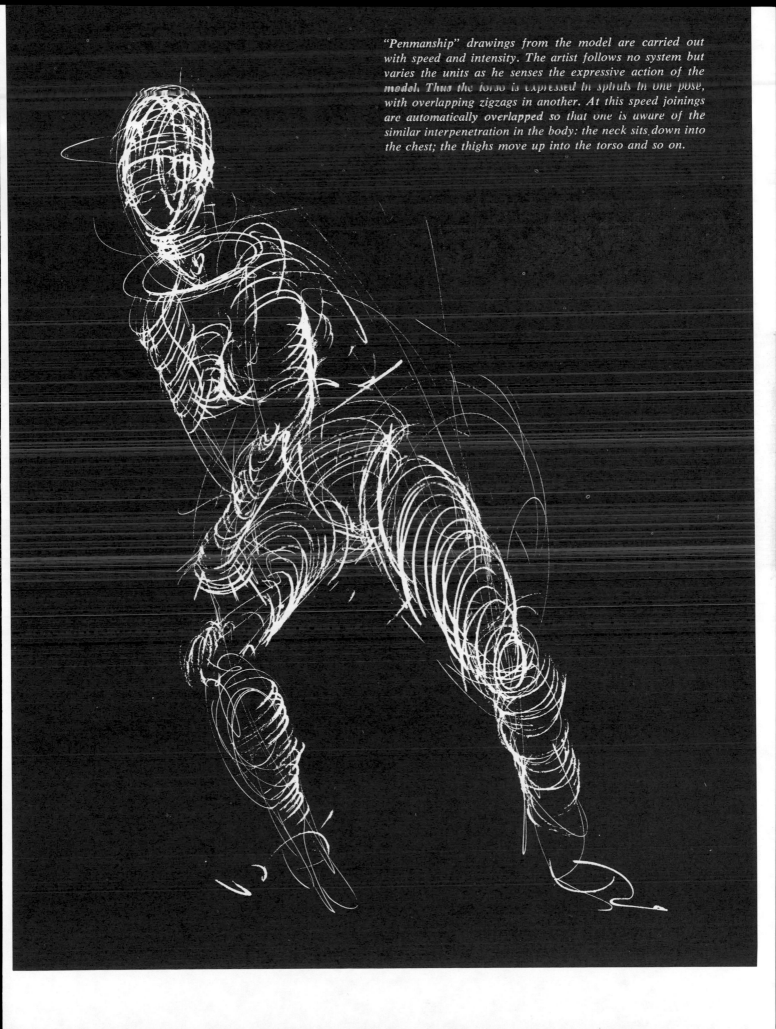

"Penmanship" drawings from the model are carried out with speed and intensity. The artist follows no system but varies the units as he senses the expressive action of the model. Thus the torso is expressed in spirals in one pose, with overlapping zigzags in another. At this speed joinings are automatically overlapped so that one is aware of the similar interpenetration in the body: the neck sits down into the chest; the thighs move up into the torso and so on.

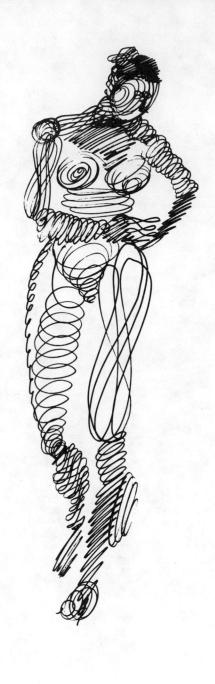
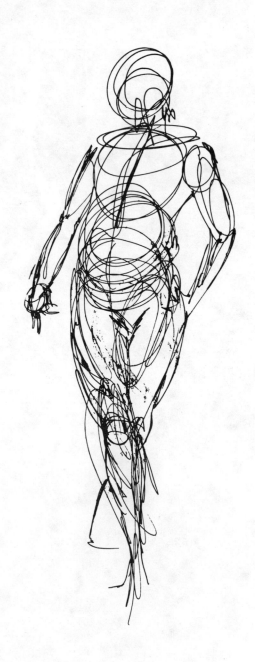

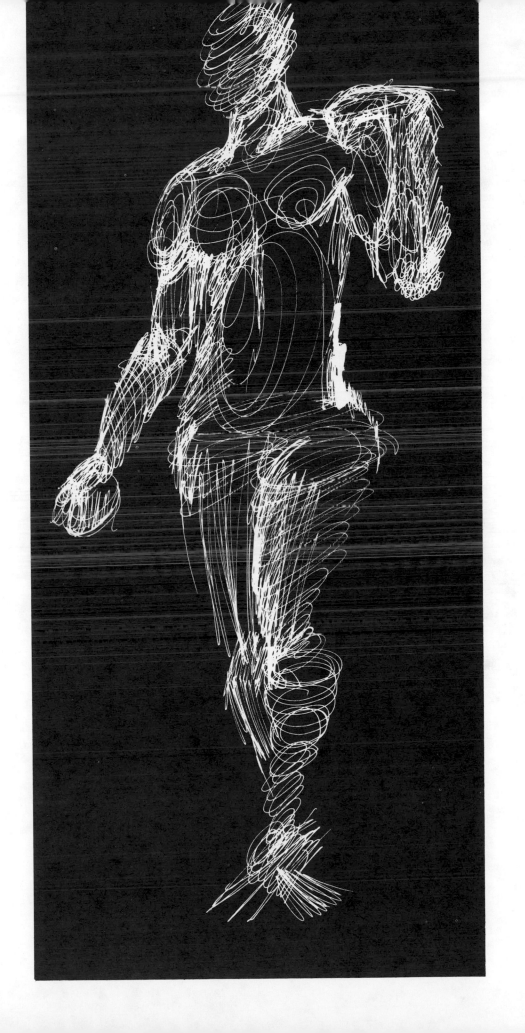

81

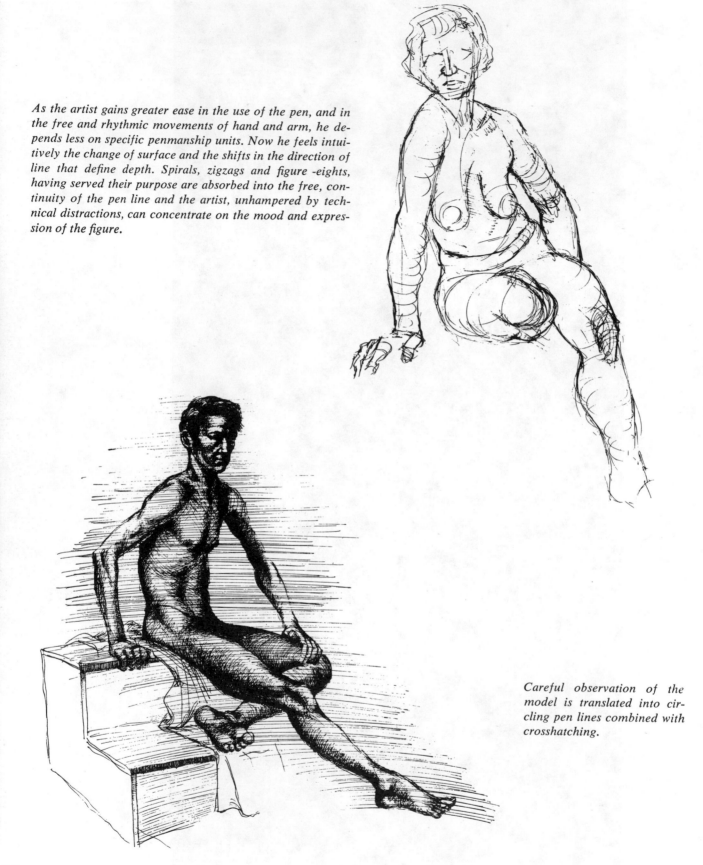

As the artist gains greater ease in the use of the pen, and in the free and rhythmic movements of hand and arm, he depends less on specific penmanship units. Now he feels intuitively the change of surface and the shifts in the direction of line that define depth. Spirals, zigzags and figure -eights, having served their purpose are absorbed into the free, continuity of the pen line and the artist, unhampered by technical distractions, can concentrate on the mood and expression of the figure.

Careful observation of the model is translated into circling pen lines combined with crosshatching.

82

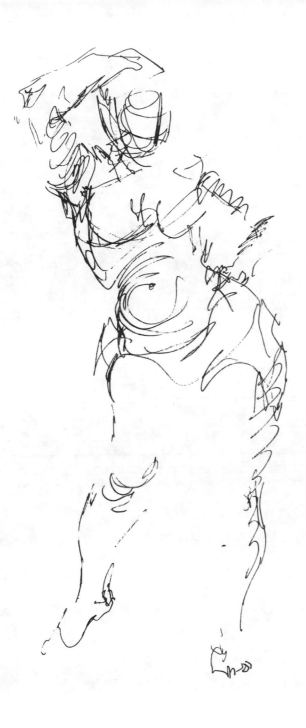

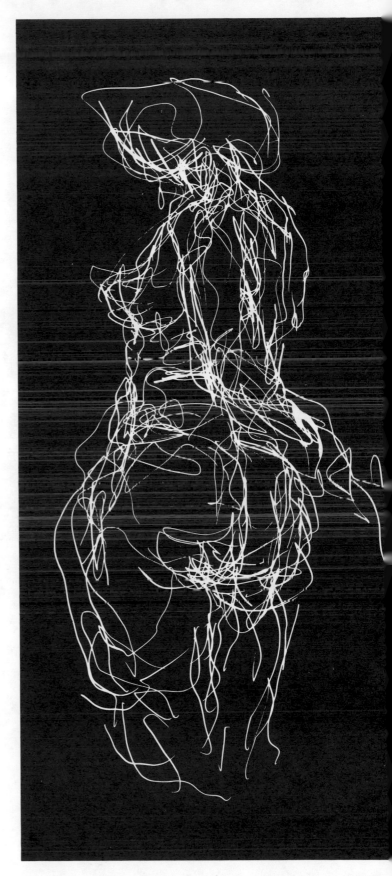

VINCENT VAN GOGH: *Street in Saintes-Maries,* 1888, drawing with ink and reed pen. Collection Museum of Modern Art, bequest of Mrs. John D. Rockefeller, Jr.

ALBRECHT DÜRER:

Two prints showing the use of a pen line technique similar to that of his drawings. Whether he was dealing with a landscape theme like this detail from his copper engraving, *Saint Eustace,* about 1501, or a figure like his *Saint Sebastian,* he built his forms with lines circling around their thickness rather than simply along edges. Compare his tree trunk with penmanship forms. Courtesy of The New York Public Library, Prints Division.

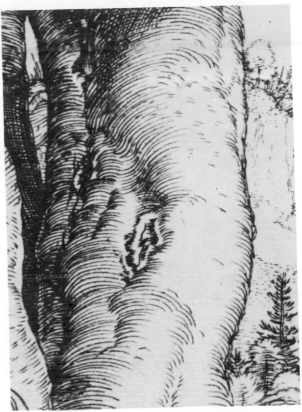

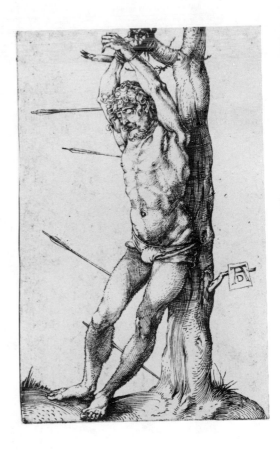

7
The Contour Multiplies

One contour

For a full range of experience in drawing the figure one needs not only to study its general qualities—mass, structure and rhythm—but also to concentrate at times on the contours, the rich variations within each edge, that accentuate the particular expressive character of a specific model.

An initial recording of the outside contour of the model (the small drawing) following its every deviation as if the eye were magnetized to the edge, reveals both the visual interest and the relative flatness of this pure outline drawing. There is little in this outside edge to indicate the real depth of the figure. Everything seems to be on one plane, although the knee in front could be nearly a yard away from the elbow at the back.

The addition, in the second figure, of contour lines moving in from the outer edge immediately amplifies the reality of the figure. The overlapping edges at such breaks as the shoulder, buttocks, legs and especially in the hand —it defines the turning of the hip it rests upon—describe the weight and pull of the surface. They also clarify the back and forth extremes of the position.

Many contours

If a model is posed by a sunny window that is equipped with Venetian blinds, the pattern of horizontal shadows breaking across the figure clearly reveals a series of graduated contours as precise and descriptive as those of a contour map. The promontories and indentations disclosed in this way emphasize the tactile qualities of the figure, qualities familiar to us through the sense of touch. A drawing in which the pen or crayon follows these "interior contours" (interior used here to denote a position seen as inside the outlines of the figure) emphasizes the particular character of the body surfaces—their passing from firm to soft, their folding and dragging.

"Interior contours" vary with every pose, as one can see whenever a shadow is cast across the body surface. This kind of shadow-contour can be produced by holding a long dowel stick between the light source and the model. Held upright, its shadow will define the vertical contour in a wavy line; held slanting, a diagonal contour, and so on. But this device should not be used mechanically. For the artist the important thing is to grasp which kind of "interior contour" or combination of contours will best interpret the expressive action of the figure. The individual who becomes fully aware of the "multiplied contours" of the body will take into account their presence and expressiveness in any kind of drawing and he may also find that this kind of forming through contour lines has in itself an esthetic appeal, as the reproduced head by Henry Moore suggests.

Visualization: *"Imagine that the model is a plaster cast. We take a saw and make several vertical cuts, not just anywhere but precisely through the area that is most varied, visually interesting and revealing of the character of the figure. Next we saw horizontally, then diagonally through the cast, always placing the cut where the section will tell the most about the form. The plaster model is now lying in dozens of pieces on the floor. We re-assemble and glue together the pieces until the plaster figure is entirely complete as in the beginning, except that there are cracks wherever a cut was made. Make a drawing of the model, representing, by a line, each of these cracks across the surface."*

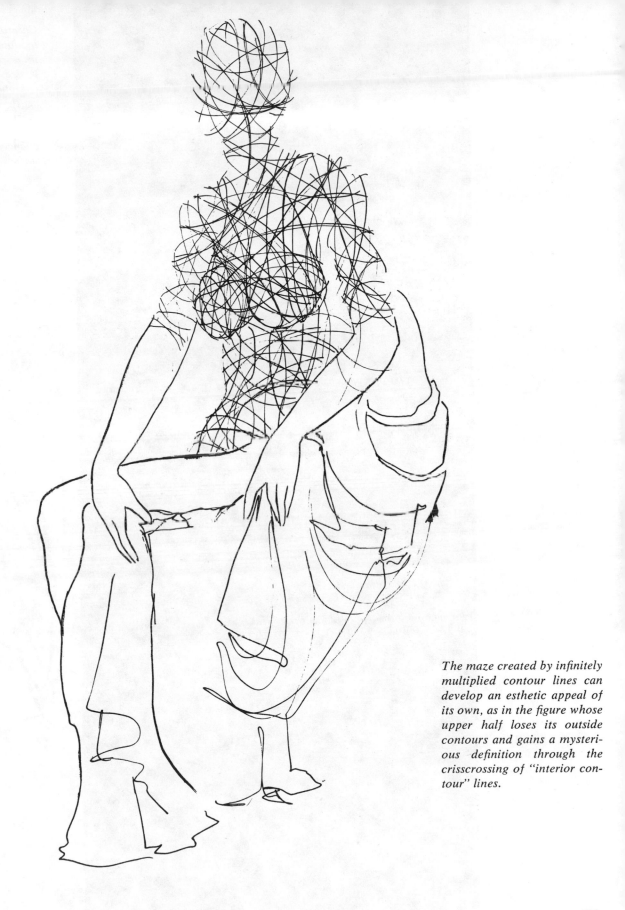

The maze created by infinitely multiplied contour lines can develop an esthetic appeal of its own, as in the figure whose upper half loses its outside contours and gains a mysterious definition through the crisscrossing of "interior contour" lines.

89

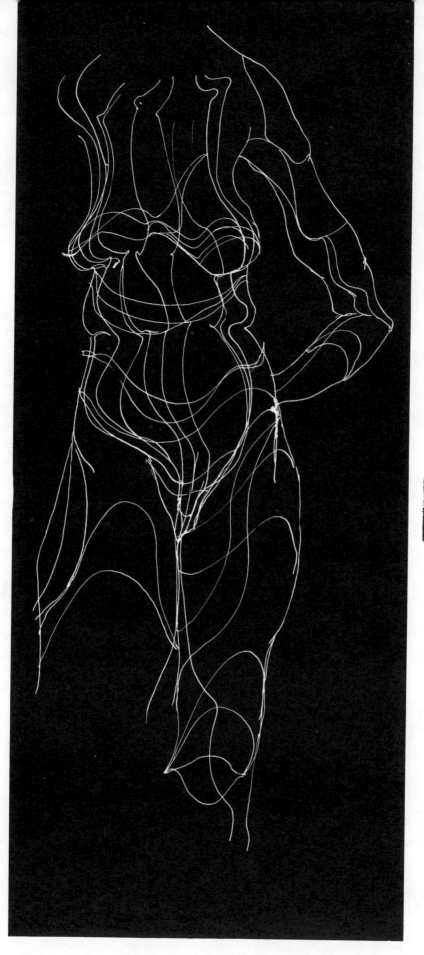

Careful observation of the modulations of body surface in a particular figure is revealed in these "multiplied" contours. They cross the figure at those points where they most effectively register the twist of the torso and the changes from firm to relaxed surfaces.

The expressiveness of this drawing derives from the artist's use of those contour lines which best reveal the characteristics of the torso in this reclining position: the weight of the body, the pull of flesh across the bony structure and its flattening as it meets the supporting surface.

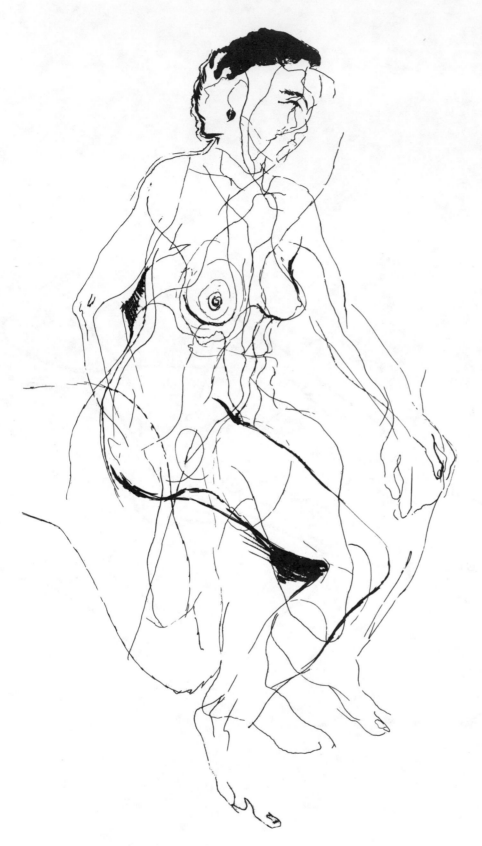

The impression of movement (similar to that exploited by the Futurists) results from superimposing slightly different views of the same pose, since we see simultaneously, edges which were actually visible in a succession of positions.

(Right.) A self-portrait homework assignment. The large size, 44 × 36 inches, allows an extremely detailed exploration of form.

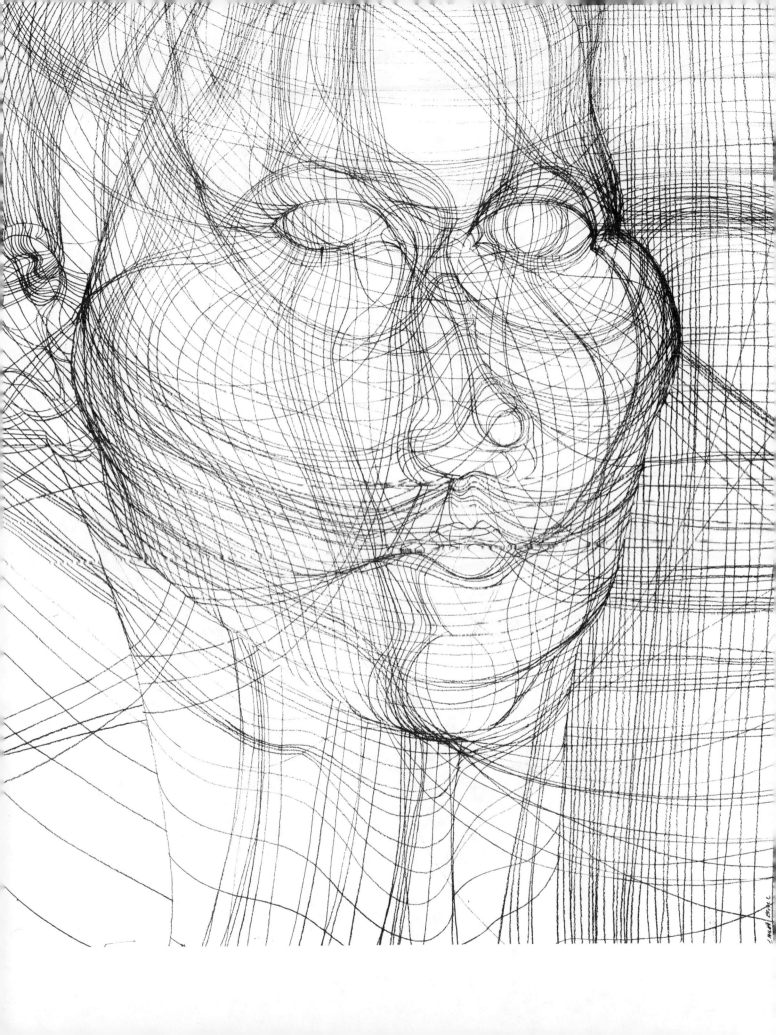

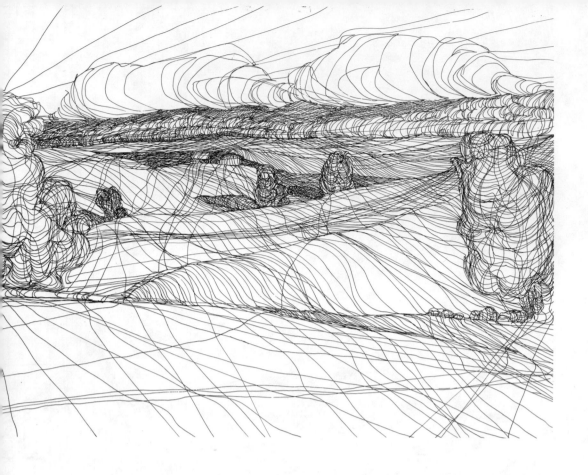

This student used multiple contour lines to indicate complex forms and spaces in a landscape and an interior.

94

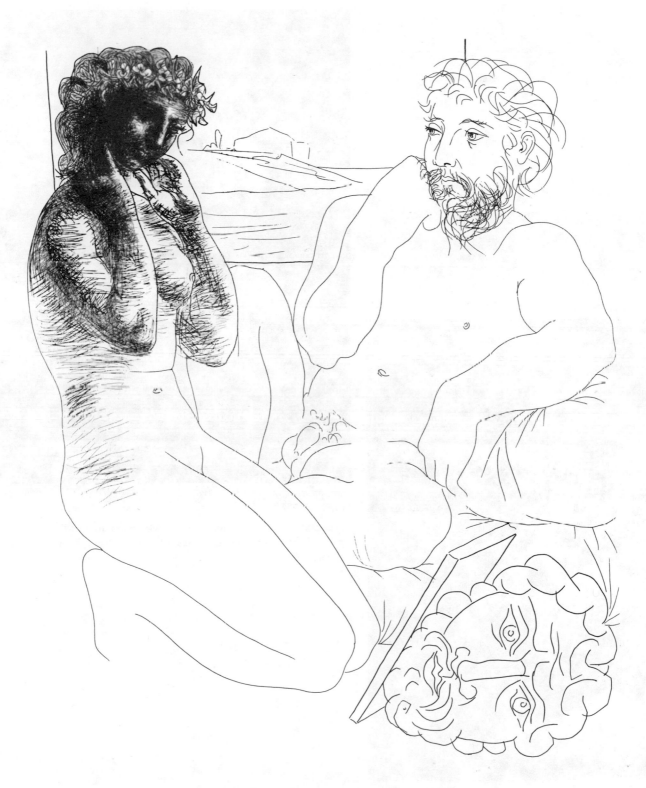

PABLO PICASSO: *Sculptor and Model,* etching, 1933. Collection Museum of Modern Art.

95

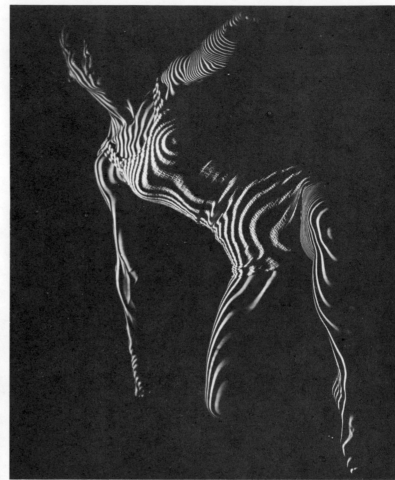

M. M. KERPER:
A special scientific lighting device was used to obtain this image of a figure defined entirely by lines of light. Photograph courtesy M. M. Kerper.

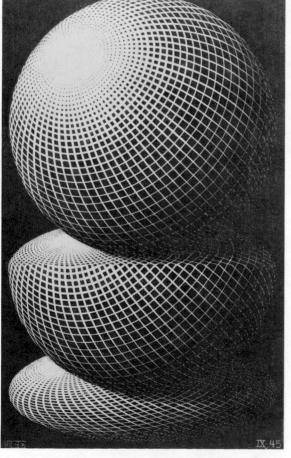

M. C. ESCHER: *Three Spheres,* wood engraving, 1945. Collection Museum of Modern Art.

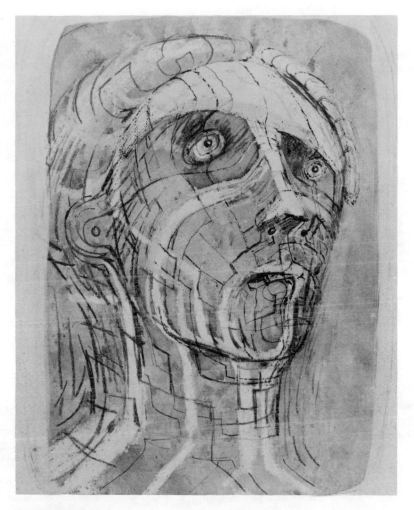

HENRY MOORE:

Head of Prometheus, pencil, chalk and watercolor, 1951. The black and white contour lines used by the British sculptor in this drawing, emphasize the same strong sense of solid volumes that distinguishes his work in wood and stone. Collection of Mrs. Irina Moore; photograph courtesy of Henry Moore.

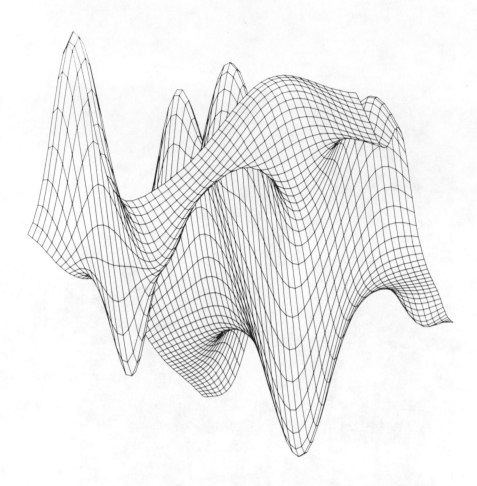

MELVIN L. PRUEITT: Computer Generated Drawing from *Computer Graphics*, published by Dover Publications, Inc., 1975, New York. The visual representation of a set of numbers that defines the positions of points in space, connected by lines; a compelling image of contours of an abstract landscape. Many artists are turning to computers to create images that can be made with no other tool.

J. SEELEY: *#156 From The Stripe Portfolio.* In a photograph without any halftones, sharp black and white stripes define the surfaces of legs, hands and drapery in great detail.

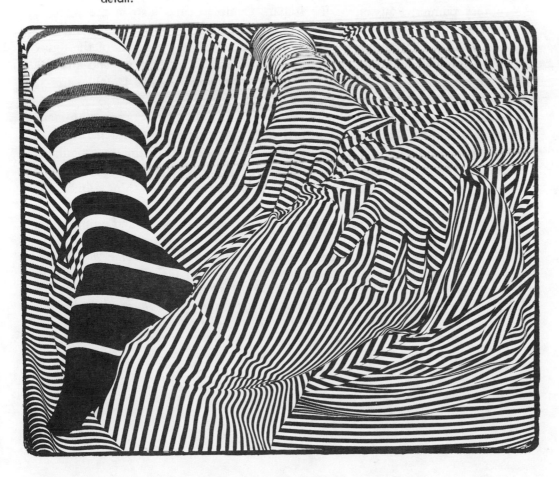

8
Building with Straight Lines

Most of us appreciate the beauty of straight edges and strongly defined masses in architecture, which satisfies our emotional need for a sense of order in the environment. Although it is more difficult for us to grasp this same structural quality underlying the more amorphous surfaces of the figure, we recognize its presence in compositions of old masters like the French 17th-century painter, Poussin, or the Italian, Cambiaso and also in the work of the Cubists. Once we are able to grasp, as they did, the straight lines and rectilinear shapes in the figure, we are enabled to relate the forms of the figure to the architectonic aspects of our environment. A new clarity and strength is added to our drawings when we penetrate beyond surface irregularities to the simple, structural forms underneath.

In exploring a straight-line esthetic, we close the gap between man-made things and man. The Cubists helped us to appreciate this parallel. Through their eyes we came to see the figure as a structure of distinctly articulated sides, or planes, and finally, to see these planes extended into the space around the figure, so that figure and environment became one thing. Once the "building principles" of nature are revealed to the artist, he is challenged to rebuild and recreate, asserting his dream of a world of order and equilibrium.

> "The beginner's complaint that he 'cannot draw a straight line' has become a joke. Since teaching this procedure is one of the simplest tasks of the teacher, one can promise the student 'his money's worth' in this respect, very easily: Place a square conté crayon on one of its sharp edges. Holding it so that this angular edge (entire length) rests on the paper, draw the crayon across the page with a large movement of the whole arm, just as you would push or pull a very small toy train."

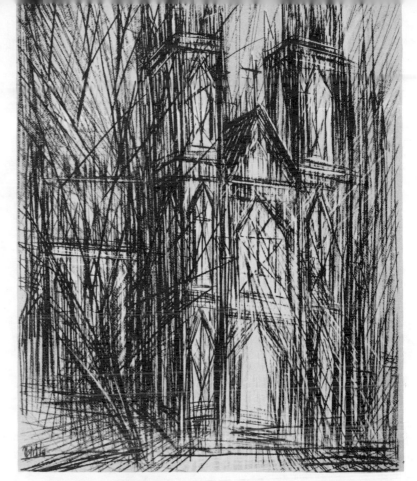

The artist becomes sensitive to the strength and esthetic appeal of straight lines, by using them exclusively in drawings of bridges, ships and buildings, subjects where he sees the structural element most readily. In the cathedral drawings illustrated, walls and towers were not outlined with straight lines, but their forms were created from clusters of diagonals, horizontals, and especially the verticals, which accent the aspiring quality of the subject.

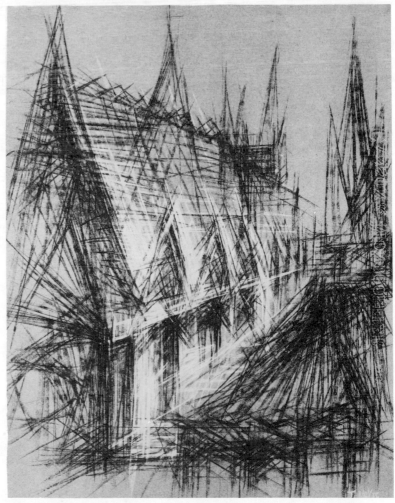

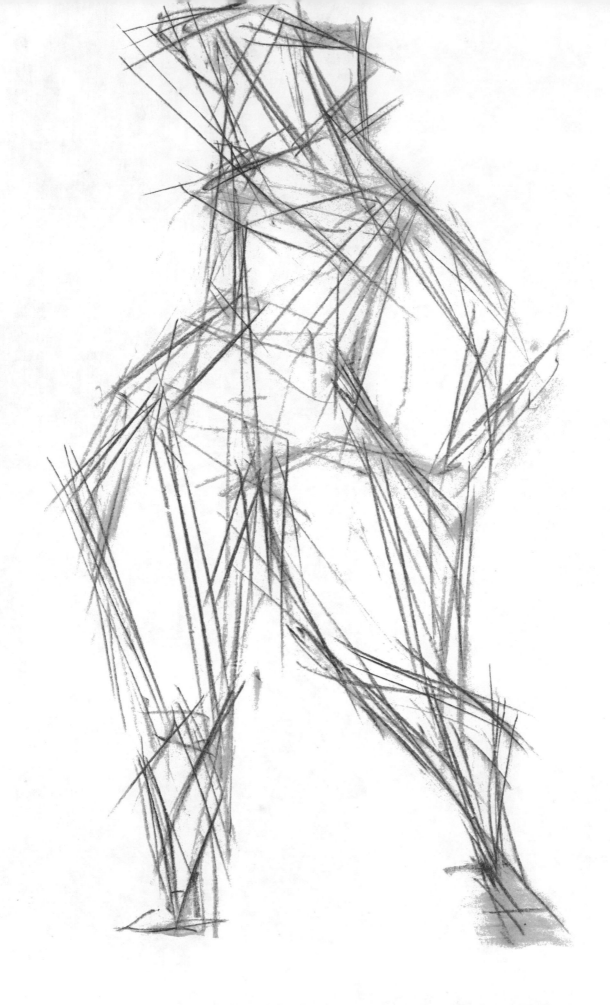

102

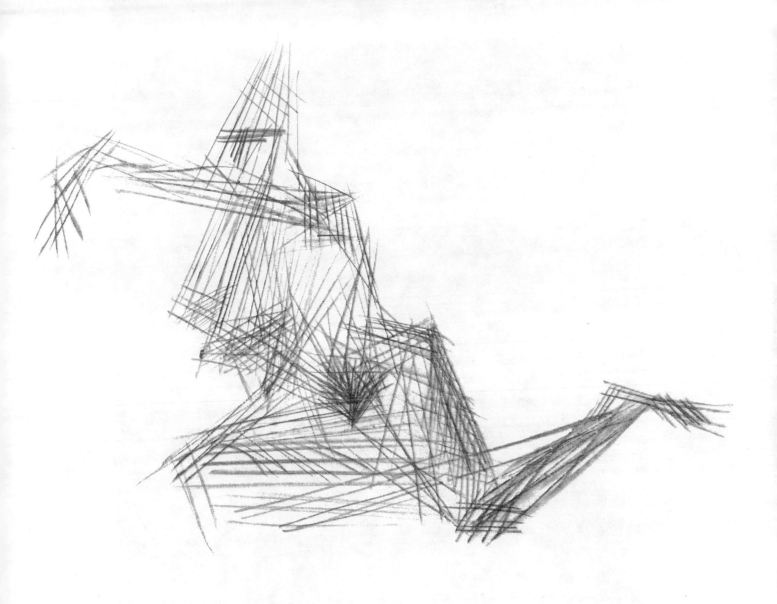

In the first straight-line draw-
ings from the model the figure
is made of different directions
of straight lines extending
through and slightly beyond
the form.

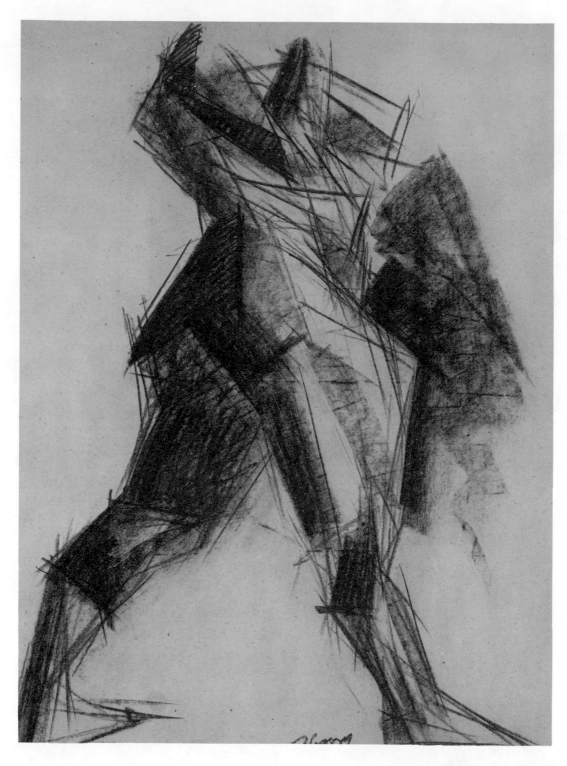

Broad strokes, made with the flat side of the crayon, block out the figure in simple, angular forms.

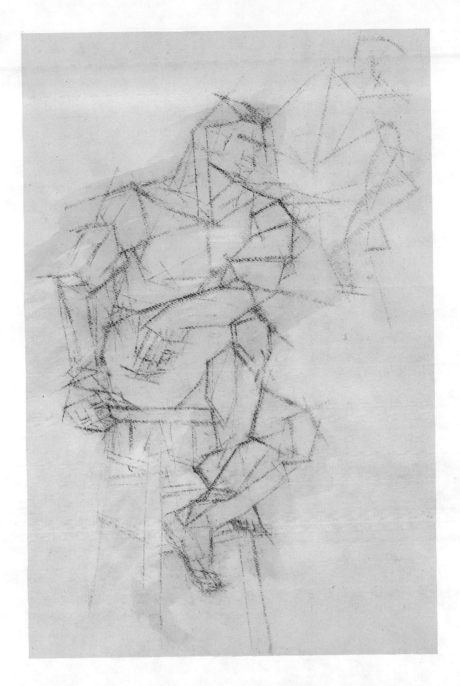

After intensive work with straight-line drawings, the artist can translate his new aware-
ness of constructive aspects of the figure in drawings more closely related to the model.
The plane structure, emphasized by the darks (figure at left) can now be clarified by an
analysis of the model which takes into account each change of surface. Observation of
the model shows that the straight-line interpretation was not arbitrary as it had appeared:
areas of the body where the bone structure is close to the skin do show taut, "straight-
line" surfaces. The decision as to how many planes are required to express the turning
from one side of a form to another, is a matter of feeling rather than of system. The
twisted shape of the upper arm (our right) is here translated into four planes — it could
be expressed in two planes or six planes according to the feeling of other individuals.

The experience of manipulating the advancing and receding planes of the figure, prepares the artist to do the same thing with the space around the figure. Planes of light or dark are extended into the surrounding area according to their effect on the figure, of seeming to pull certain parts forward or push other parts back. It is no longer possible to distinguish a specific background: the light-edged plane of the arm appears to advance but so does the light (diamond-shaped) plane at the extreme left of the space. Each comes forward because of its relation to an adjoining plane. Certain planes are in back in relation to one neighbor, in front in relation to another. The result is a decentralized composition in which no part is self-contained; every part is dependent on every other for its meaning.

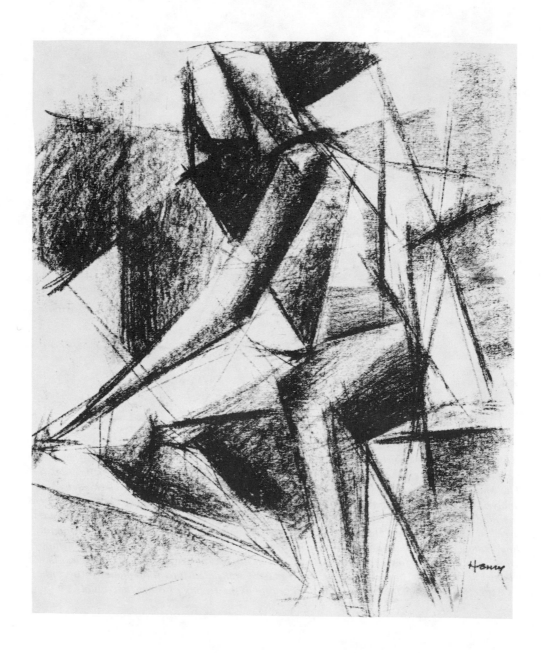

An example of figure and surrounding space interpreted in a structure of advancing and receding planes that move through both figure and the area around it.

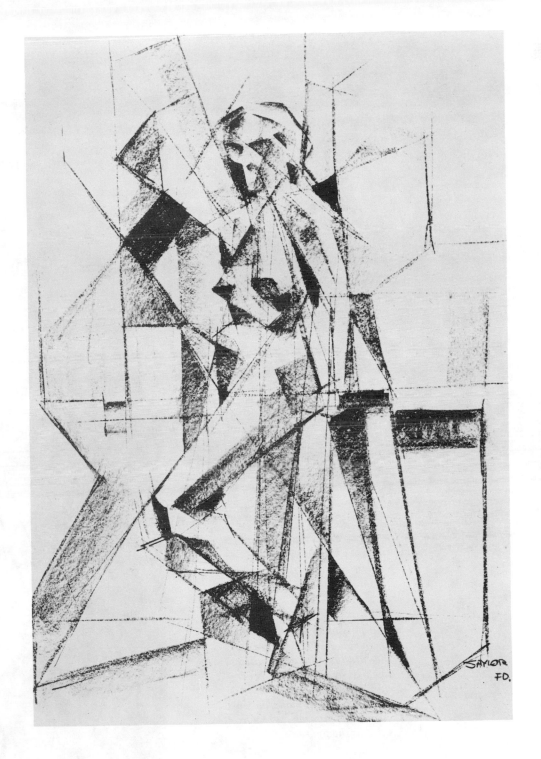

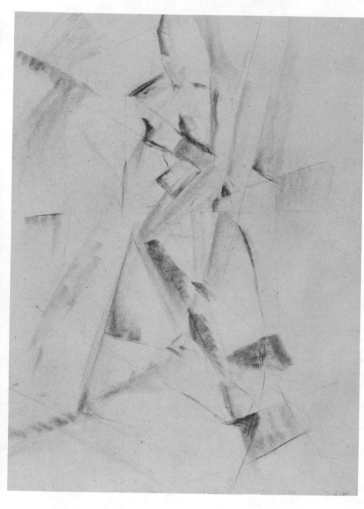

The possibility of manipulating the planes of the figure and the planes of surrounding space as one continuity is carried to an extreme in two drawings, which make the environment appear as many-sided as the figure.

JACQUES LIPCHITZ: *Man with a Guitar,* stone, 1915.
Collection Museum of Modern Art,
Mrs. Simon Guggenheim Fund.

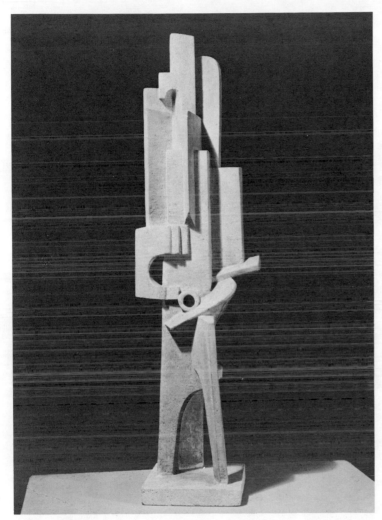

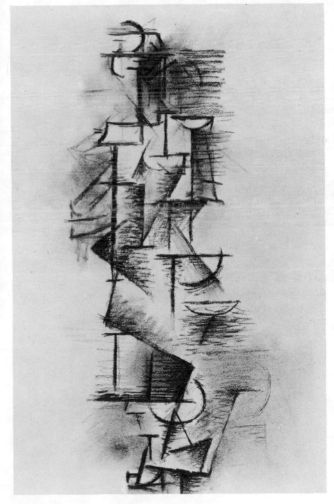

PABLO PICASSO: *Nude,* charcoal, 1910.
Courtesy of the Metropolitan Museum of Art,
Alfred Stieglitz Collection.

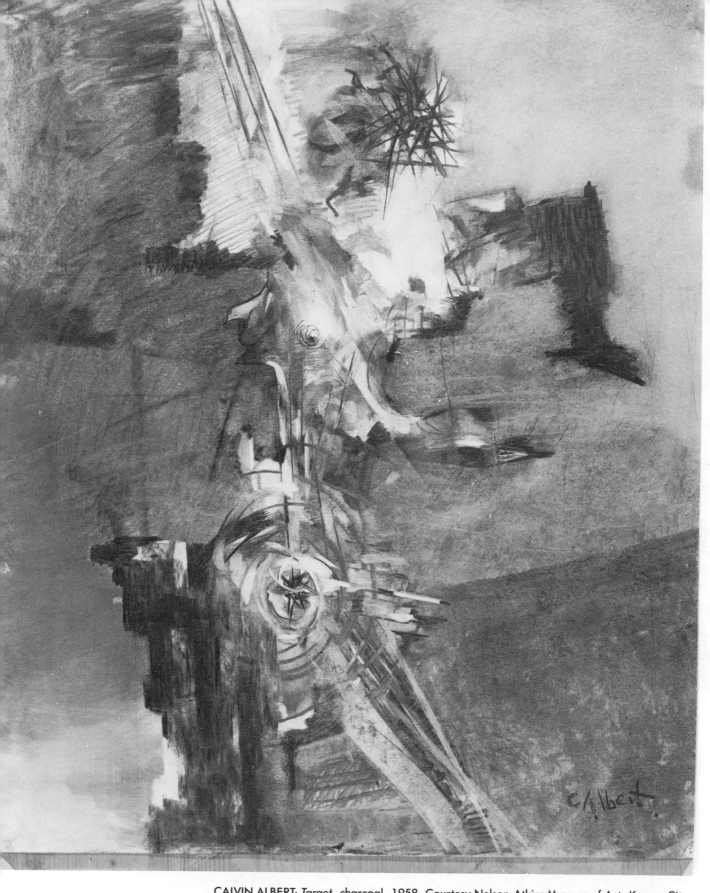

CALVIN ALBERT: *Target*, charcoal, 1958. Courtesy Nelson-Atkins Museum of Art, Kansas City, Missouri (gift of Mrs. Jane Wade Rosenberg in memory of Curt Valentin).

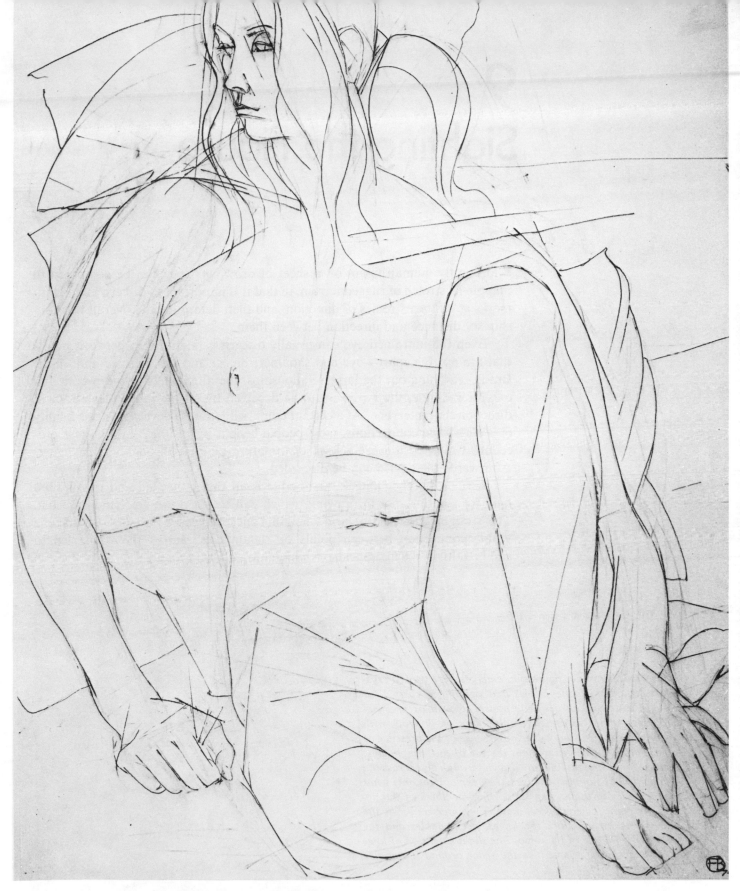

FRITZ BULTMAN: *Debora—Seated,* pencil on paper, 1974. Courtesy Ciba-Geigy Corp.

9
Sighting the Figure

Plotting the human figure on a sheet of drawing paper can be compared to mapping a stretch of rugged terrain, in that it is important to discern main landmarks at all the extremes of direction, and then determine the overall relationships of distance and direction between them.

Even the untrained eye can usually discern a relationship between points that are not far apart—eye and shoulder, breast and hip or knee and ankle. But in searching out the large relationships, the alignments between chin and toe, for example, the eye is apt to be deceived by all the minor deviations of direction that intervene. At a certain point, while one is developing this faculty of seeing large connections, most people benefit by a simple mechanical procedure which establishes a kind of armature of lines throughout the figure. Afterwards the device can be discarded.

A ruler or other long, straight edge is all that is needed and this is used only for sighting, not in drawing, which can be set down freehand as usual. The straightedge, held at arm's length (one eye closed) is used to make a visible connection between points or "landmarks" across the whole length and breadth of the figure and extending into the background.

The seated, bent over figure that emerges here from a crystalline structure of lines shows that sighting, if carried far enough, can have an aesthetic appeal as well as practical usefulness. After an intensive discipline of drawing with sighting lines, one usually develops a sense of the presence of such relationships, even without the use of the straightedge. Because these straight lines are drawn through and across the figure, without stopping at edges, they explain not only what we see, but also the unseen supporting members of the figure. The points where a great many lines intersect locate the main shifts in direction: the knees, neck, ankles and the bend in the middle of the torso. The slight extension of lines beyond the figure relates it to the space around it and also to the page.

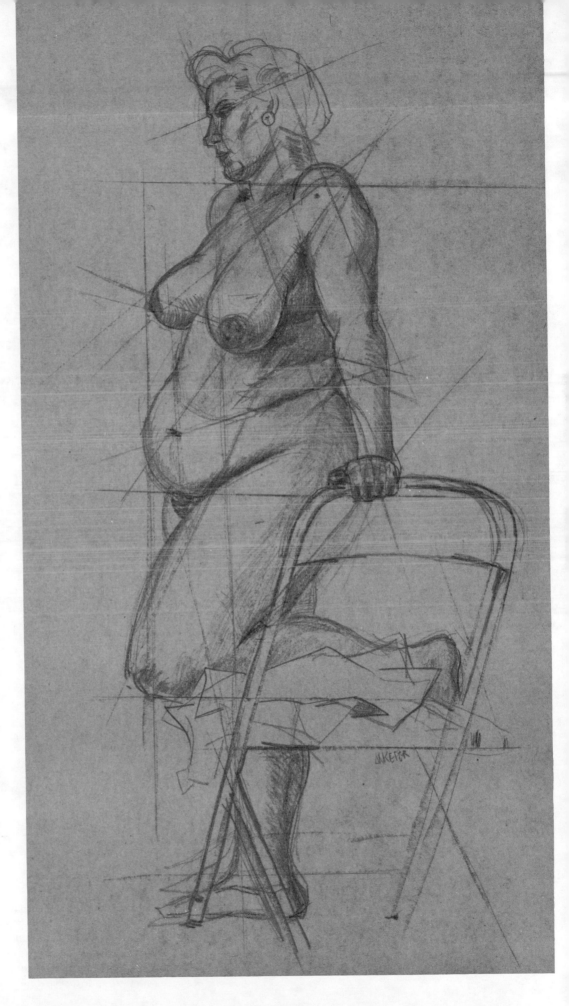

In the figure at right, the straightedge revealed a vertical alignment between forehead and the arch of the foot, a slanting alignment between ear, hand and chair and crossing these, connections between shoulder and breastbone, armpit and navel and, horizontally, knuckles and stomach. Other alignments could be gauged in reference to these pivotal relationships. The more sights taken, the more easily mistakes can be corrected. The addition of vertical lines at the extreme sides of the figure and horizontals at top and bottom points, affords a basis for judging the slant of sight lines. The horizontals of the chair (and in other drawings windows or tables in the background) furnish additional aids to the eye.

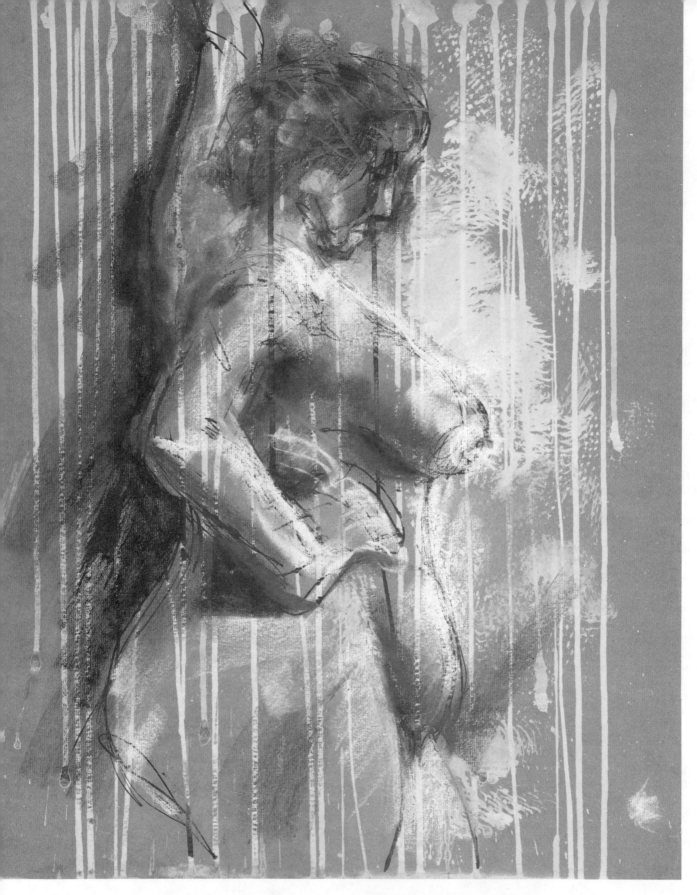

To establish a grid against which the figure can be sighted, a series of cords is sometimes hung vertically against the wall behind the model. In this case the student made the grid part of the drawing by dripping a series of paint lines down the paper, but did not make the adjustment to the grid, drawing the upper torso too far forward.

*Examples
of similar techniques*

In this drawing the grid clarifies the degree of departure of body outlines from the vertical and horizontal. This is another way to study the shift and balance of body forms, starting with the spinal curve in relation to the grid.

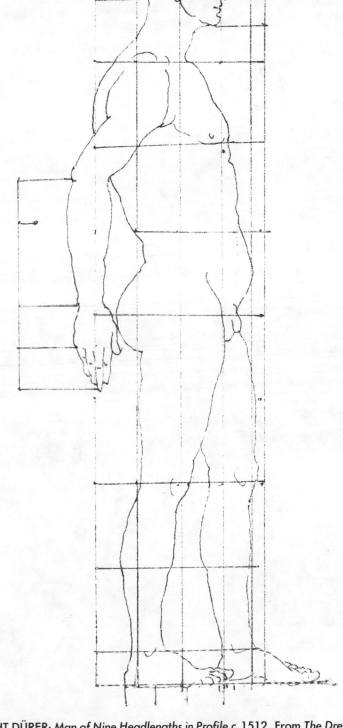

ALBRECHT DÜRER: *Man of Nine Headlengths in Profile* c.1512. From *The Dresden Scetchbook,* reprinted by Dover Publications Inc., New York.

JOHN LITTLE: *Male Nude*, charcoal on paper, 1938. Courtesy of the artist. This drawing was made in class at the Hans Hofmann School in New York, by an artist who later became a leading abstract-expressionist painter. Hofmann's teaching had a great influence on many of the important American artists.

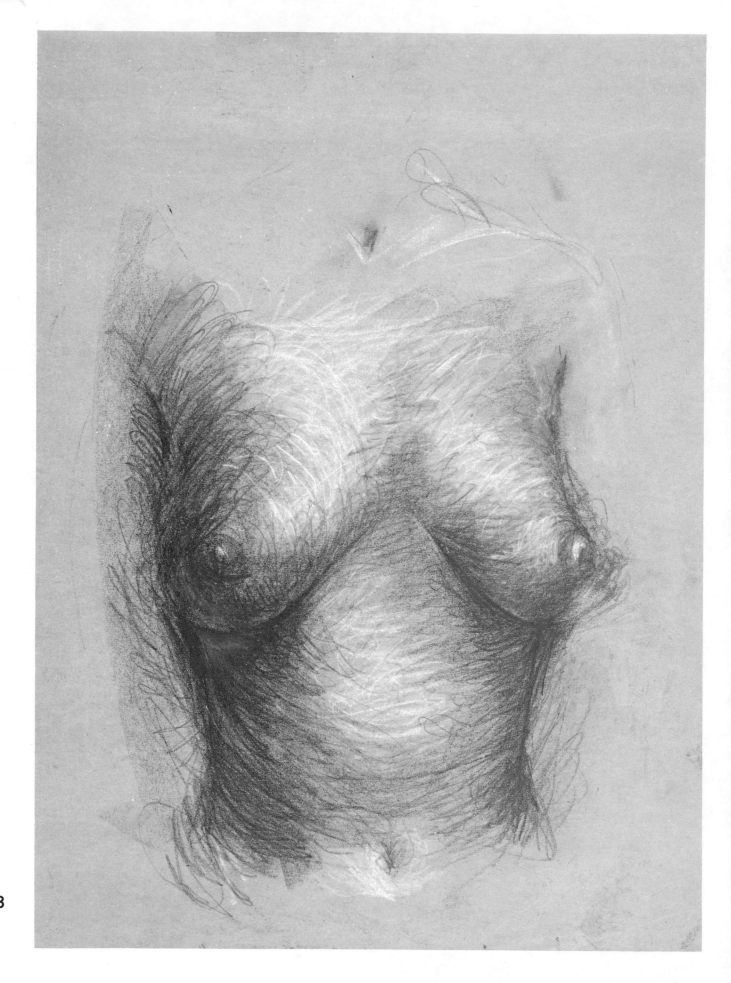

10
From a Ball of Yarn

The technique of drawing with white and black lines on a middle-toned background, projects a thread-like flow of light and shadow.

The advantage of thinking, initially, of this flow of light as yarn, is that it makes it possible to deal with the criss-crossing black and white lines around a shape and on a scale that can be comfortably encompassed by the imagination. The yarn is mentally visualized (never physically observed) as it is drawn first as a dishevelled ball and then, in subsequent exercises, as unravelled and wound around various kinds of shapes in changing positions, until a whole yarn world is generated. Like a bird growing first from an egg, then as a ball of fluff, through an extended maturation, into a complex and fully articulated form, with many varied textures and surfaces—so grows the ball of yarn.

There is a gradual transition from thinking about yarn to thinking about light and shadow as the work shifts from exercises to the drawing of the model. But not all at once. In the first drawing from the model, the pose is used simply as a point of departure for a fanciful yarn-doll construction whose exaggerations could evoke fantastic or dramatic associations.

The imagination, prepared by the exercises to deal with the flow of lines back and forth in space, now readily grasps the possibility of extending the mesh of lines completely around the subject, so that the figure appears enfolded in a fluid atmosphere. This treatment introduces an element of impressionism. Edges now dissolve under a battery of lines, leaving a hazy but evocative suggestion of the figure.

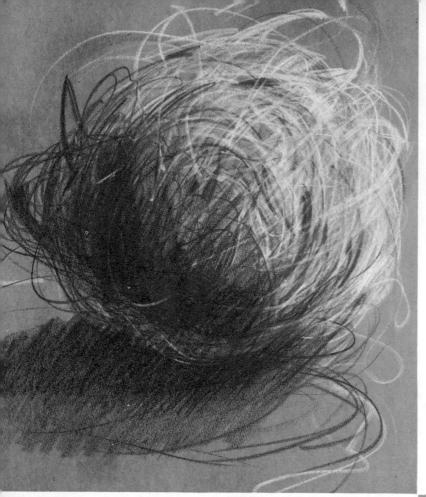

The visualization of a ball of yarn is the starting point for a series of exercises in which the concrete yarn, temporarily substituted for the flow of light, gives a tangible reality to the forms drawn with white and black lines on a grey background.

Opened up in imagination, the yarn exhibits contrasts of straight and curving, taut and relaxed surfaces as it is mentally draped over two rigid supports.

Visualizing a further three-dimensional construction of uprights and slanting supports requires the artist to extend black and white lines back and forth and in different directions.

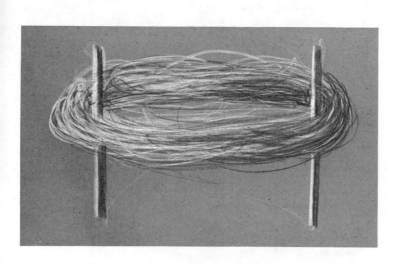

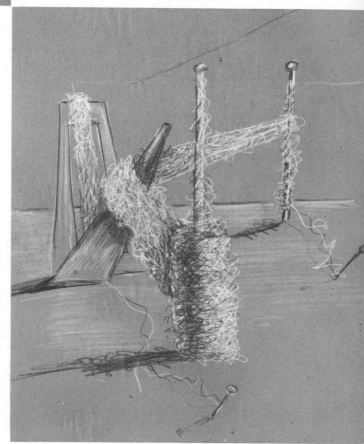

120

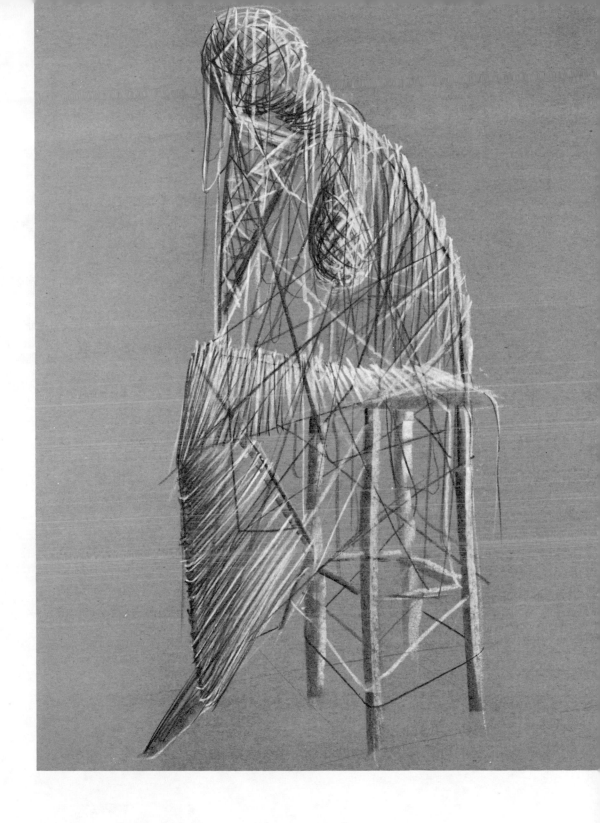

An imaginatively constructed yarn doll, based on the action of the model, projects a fantastic mood quality. It also presents new complexities of three-dimensional building and more precise distinctions between rigid supporting structure and soft surfaces. (See additional examples on page 122.)

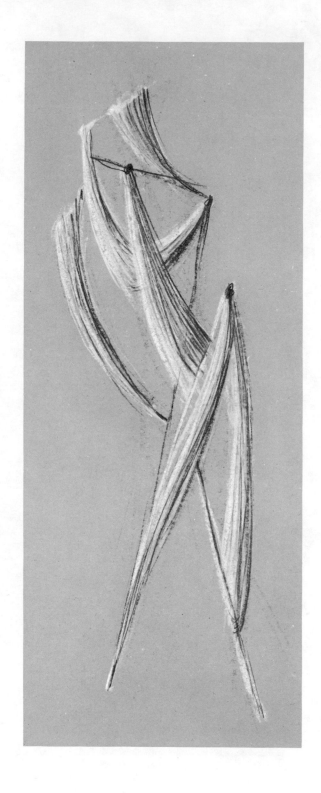

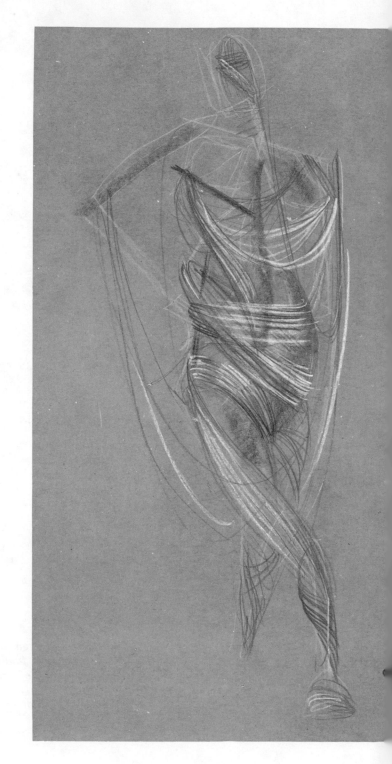

122

Drawing with a white crayon on a grey-toned paper reverses our usual way of thinking of line as dark, paper as light. Since the paper now represents the unlighted parts of the picture the crayon seems to act as a wandering beam of light that weaves around surfaces, gradually materializing them from shadow. The light beam does not distinguish sharply between the luminosity of the form and the luminosity of the air around it, except by making a denser mesh of threading lines where the surface is most fully exposed to light.

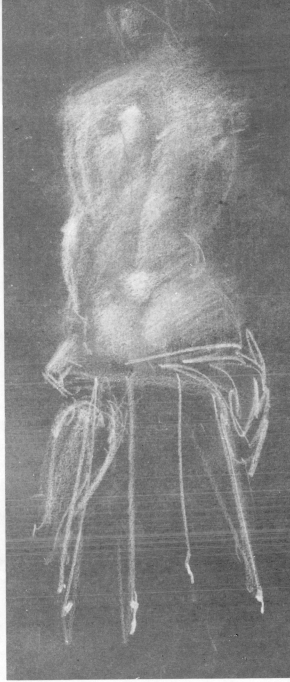

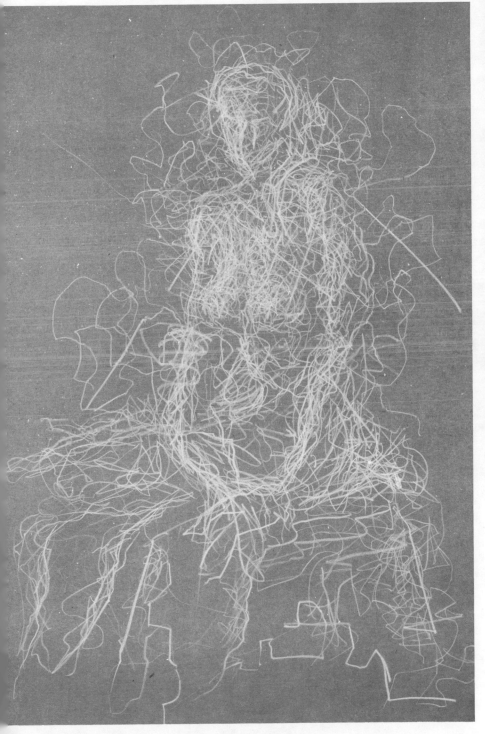

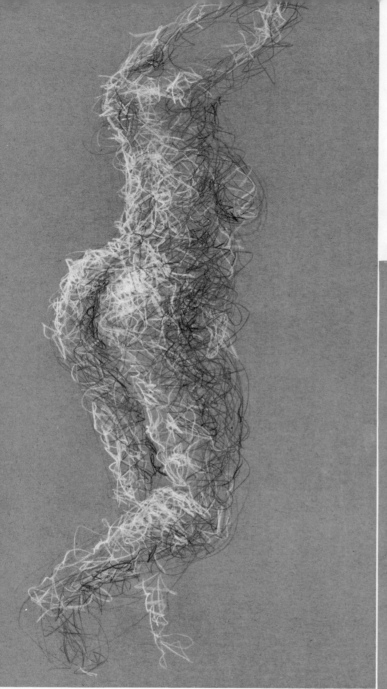

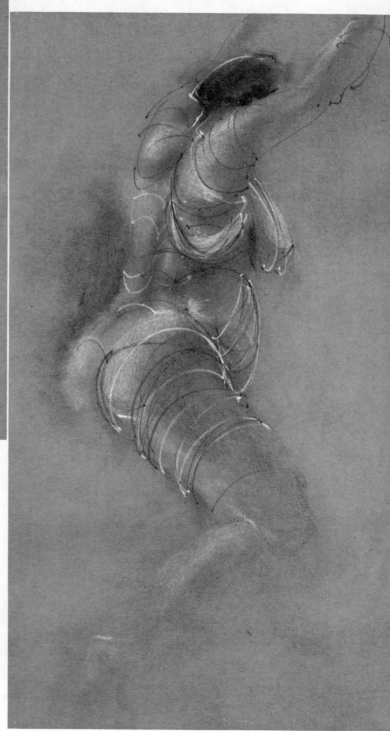

The addition of black lines accentuates the flow of shadow around the unlighted side. It also contributes a new richness and depth of surface texture in areas where the black lines mingle with white.

Although white and black lines are used here as an element of stylization, their flow around the form and the delicacy of feeling obtained by whites over crayon tones, relates this variation to the idea of the problem.

124

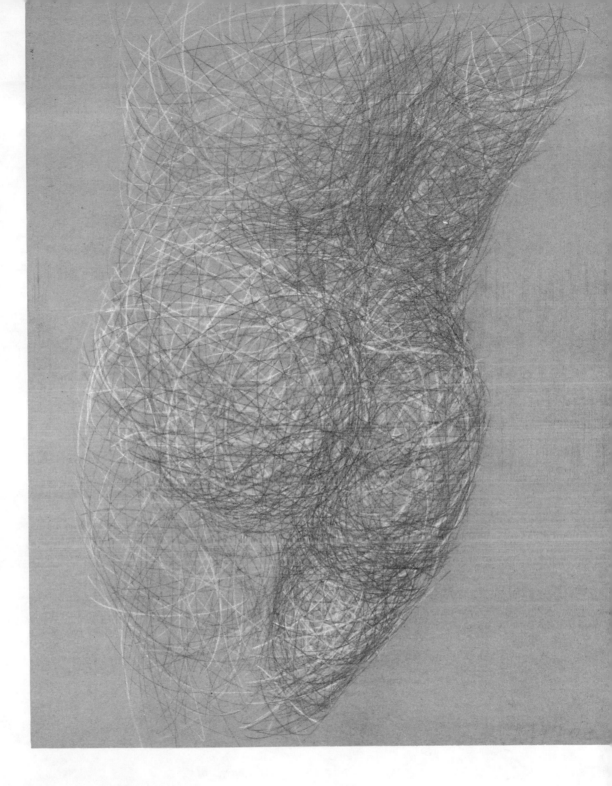

The concept of threading lines replaces that of the coarser yarn. Black and white conté pencils are used instead of crayons to create this more sensitive mesh circling a series of rounded forms.

The idea of expressing the at-
mosphere around forms as
well as the forms themselves,
familiar since Impressionism,
is a logical one to explore
with threading lights and
darks. In this drawing — a
first attempt to apply this con-
cept to a subject — objects in
a corner of a room, including
a television set on a table,
emerge from a tangle of lines.

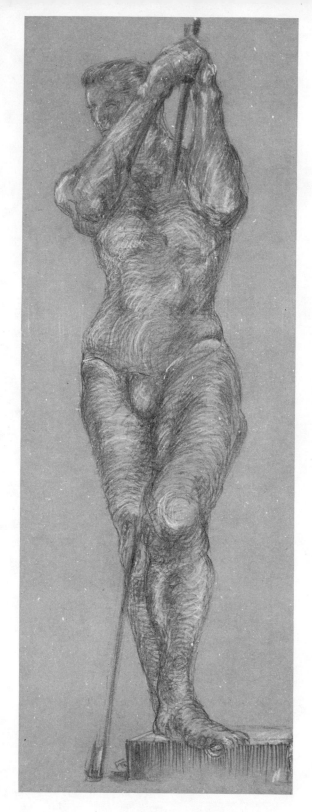

The mingling of black and
white lines accentuates the
sensuous modeling of body
surfaces in this figure, and at
the same time preserves a tex-
ture so lively that we scarcely
notice the missing length of
staff.

A hazy atmosphere, shadowy in some drawings, more luminous in others, dissolves the edges of the figure, leaving only a vague but poetic suggestion of her presence.

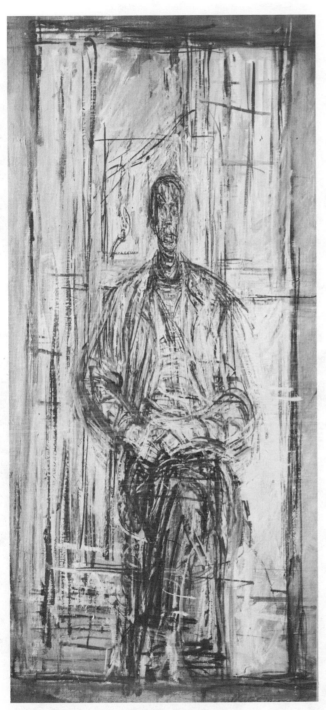

GIACOMETTI: *Man Seated*, oil. Collection of
Morton G. Neumann, Chicago.

VITTORIO CARPACCIO:

Two figures in *Triumph of Saint George*, 16th-century.
Collection of the Art Museum, Princeton University.

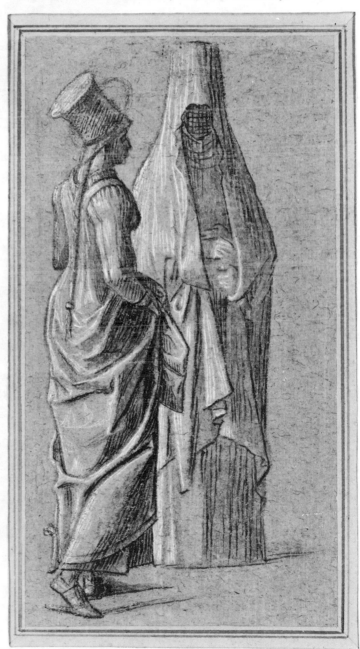

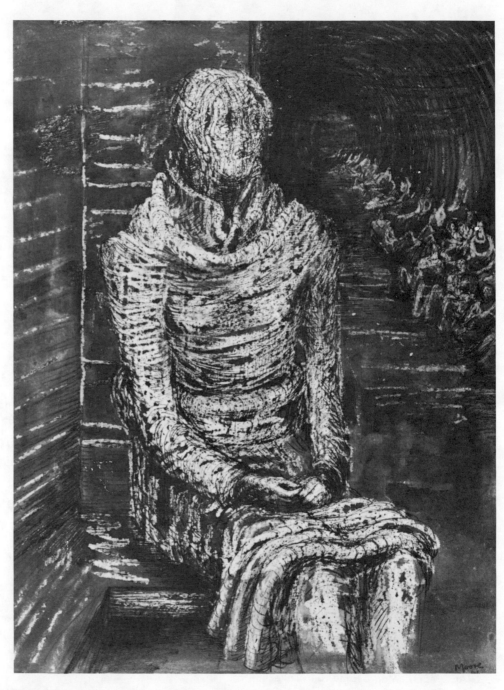

HENRY MOORE: *Woman Seated in the Underground*, 1941. Courtesy of the Trustees, Tate Gallery, London.

MARK TOBEY: *Broadway*, gouache, 1936. Collection Metropolitan Museum of Art. Photograph courtesy Willard Gallery.

11
Material and Method

The resistance of materials—the fact that they refuse to deliver up, neatly packaged, the preconceived ideas of the artist, actually provokes and crystallizes his emotional response. In any really creative art form, the passage from idea and feeling to the final object created, is through a series of changes in which the materials and tools give an entirely new and unexpected character to the subject.

Moderns like Paul Klee, Georges Rouault and Henry Moore have shown what special power is available to the artist who "lets the material speak." In their work the particular character of the material, the flow of paint, the furrows of the knife, the chemical reactions of resistant mediums—is very apparent and plays a leading role in the expression. Yet we applaud their unconventional use of materials not because it is daring, but because, through being audacious, they have more fully realized themselves. The strange fact is that through a loose, as opposed to a precise, control of material, these artists are able to remain perfectly in command of the over-all mood of the picture.

Thus in Georges Rouault's "Clown," the roughness of oil paint scrubbed over paper eloquently expresses the tragic quality of the old performer's face. Similarly, the blistered appearance of certain drawings by Henry Moore, made by the imperfect blending of materials he deliberately combined, is exactly appropriate to the eroded character of the subject.

Freedom and purposefulness both play a part in the handling of materials. For the beginner purpose often grows out of an initial playfulness. He realizes what he wants to say when he discovers in the material a way of saying it. The work illustrated in this section suggests that the conception of the model was changed and accentuated by the behavior of paint, and the tools with which it was applied. An individual working with a sponge discovers the way contours of the figure can appear diffused in light; another, experimenting with wet washes over charcoal, pursues the dramatic quality revealed by streaking and blurring. The experience makes each aware of the range of possibilities in that direction. The rewards in realization of mood, for this audacity, encourage him to break away from conventions and find something of his own. As his own direction is realized, he can then turn to books for the information he needs, without risking the inhibitions of rules and formulas.

A medium is a substance to glue pigment to a surface; tools are an extension of fingers. It is easier to demonstrate to oneself these basic qualities in dealing with unconventional, rather than traditional materials. Homemade and improvised mediums and tools, usually inexpensive and lacking entirely the preciousness associated with manufactured products, invite the explorer to prove to himself what is possible and what is not. Their very deficiencies emphasize the qualities of spreading and adhering essential to an art medium.

The way an artist handles materials and tools—whether slashing with the palette knife or caressing the surface with the softest of brushes, whether strokes are abrupt or delicate, whether paint goes on in broad strokes or precise touches—is an expression of the kind of person the artist is. A Van Gogh makes a violent attack on his materials, a Paul Klee handles them with attentive interest, alert to what they will reveal. With each man, his approach is less a matter of consciously choosing tools or a method that will produce certain effects, than it is a matter of following the impulses of the nervous system and the path urged by emotional inclination. The attack on materials, indeed, is symbolic of the life pattern.

A fledgling artist needs the opportunity to find out which way is his own. In the course of handling a great many materials he discovers not only what range of expression is possible for each kind of tool and material, but he finds out also which way of working corresponds to his emotional bent.

Cardboard strips and combs, sponges and knives were among the unconventional means used to interpret the model in this problem. (In one part of the work they were used to apply pigment which was mixed with all sorts of improvised binders, including even toothpaste, furniture polish, etc.) One kind of material requires a pounding rhythm as the tool is pressed first into ink, then onto the paper; another medium produces a flow, so that the tool barely touches the paper. Each invokes a different mood and is suitable for a particular kind of person.

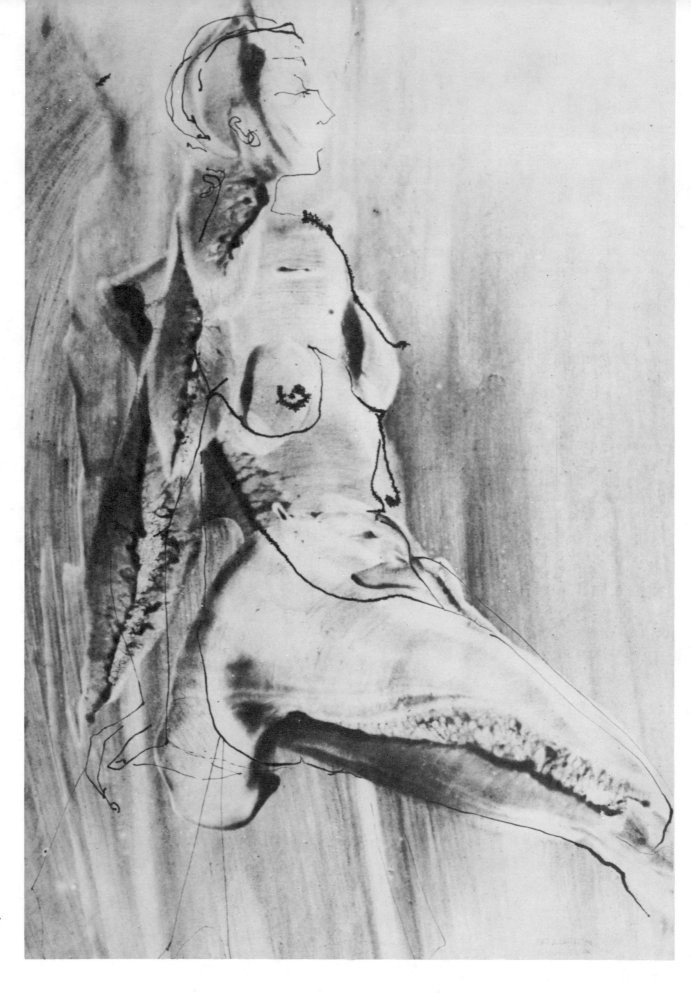

134

Immersion in materials: a scene suggesting a storm at sea was carried out in finger paint by the use of the whole forearm as well as the hand. The freedom gained in this spontaneous manual exploration of the material is preserved in "finger-painted" interpretations of the seated figures.

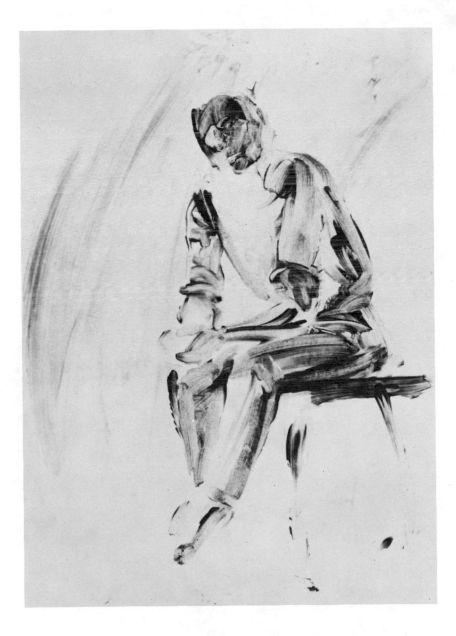

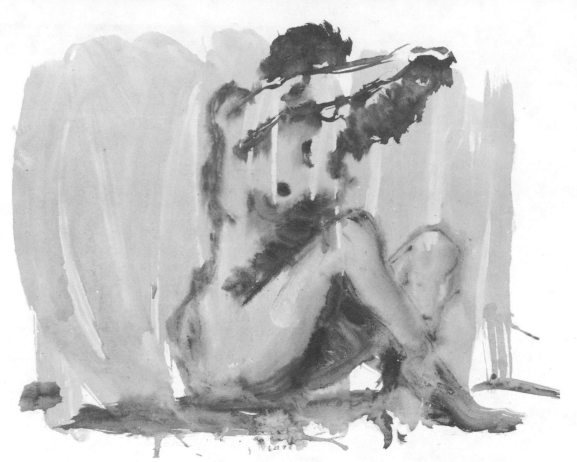

The quality of wetness: water-color introduced on an already moist surface cannot be precisely controlled but this direction of flow can be utilized by the artist to emphasize the overall character and "gesture" of the model.

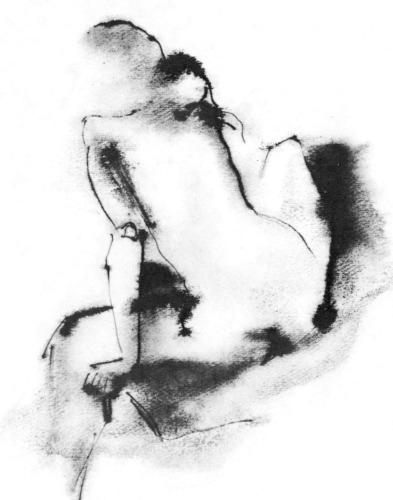

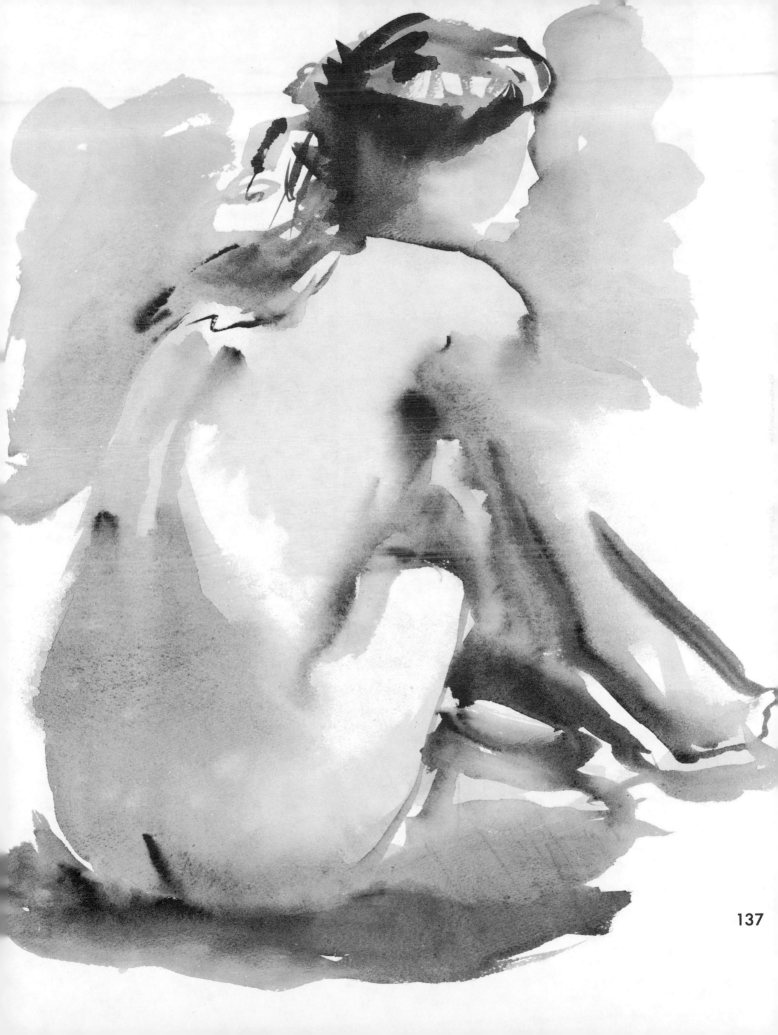

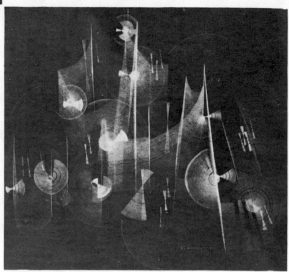

A design of arcs and wedges, made by turning the flat side of a crayon around a center with varied pressures, produces an abstraction in a limited depth or suggests a stylized figure.

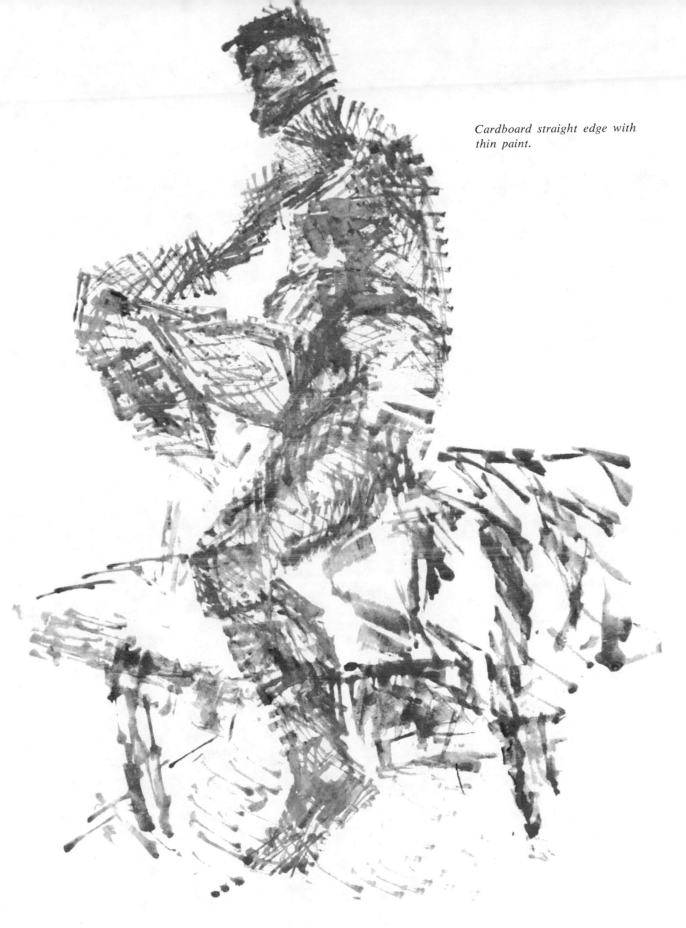

Cardboard straight edge with thin paint.

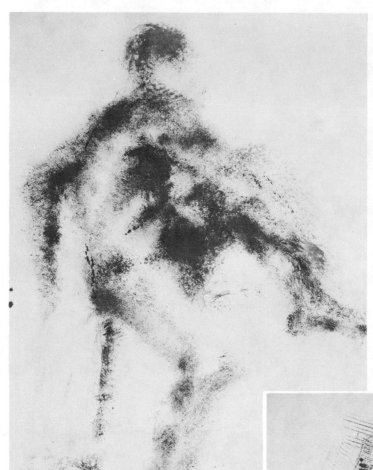

Sponge with gouache.

Charcoal and ink with house painter's wood-graining comb.

140

Pen and ink with paint.

*Wide blade of putty knife
with oil paint.*

Comb with oil paint.

142

With a fine pen, the student used cross-hatched lines massed or scattered to indicate changes of tone.

143

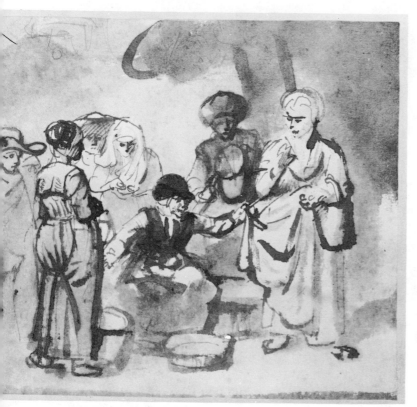

NICHOLAS MAES:

The Scolding Fishwife, wash drawing. Collection Metropolitan Museum of Art.

GEORGES ROUAULT:

Clown, oil on paper, 1907-08. The Dumbarton Oaks Research Library and Collection, Harvard University (Robert Woods Bliss Collection).

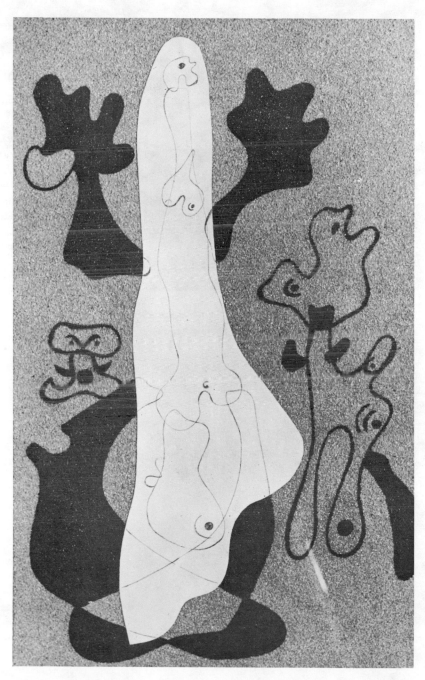

JOAN MIRO: *Collage*, paper pasted on sandpaper painting, 1931. Collection of Dr. Charles Rosen, East Orange, New Jersey.

HANS HOFMANN: *Reclining Nude*, matchstick and ink, 1950. Courtesy Addison Gallery of American Art, Phillips Academy, Andover, Massachusetts.

CHUCK CLOSE: *Phil/Fingerprint II*, stamp-pad ink and pencil on paper, 29¾ × 22¼ inches, 1978. Collection of the Whitney Museum of American Art, New York. Purchased with funds from Peggy and Richard Danziger, (Acq # 78.55). A surprisingly realistic portrait is made with fingerprints on a grid of pencil lines.

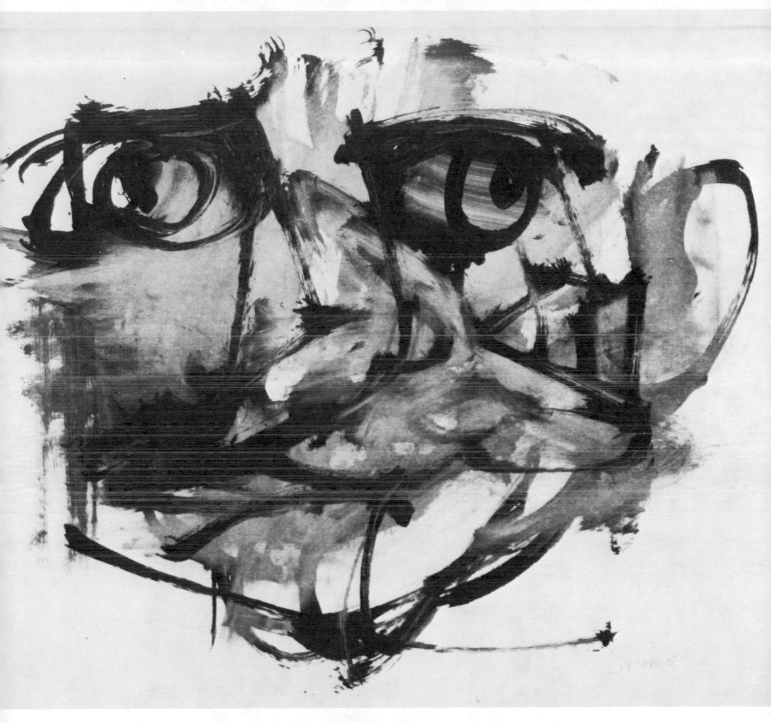

NICOLAS CARONE: *Head,* oil on gesso-coated Bristol board. Courtesy of the artist. A powerful drawing whose emotional impact is due to the close-up view of the face, the divergent focus of the eyes and the rapid application of the paint which is clear in every brush-stroke.

CALVIN ALBERT: *The Ritual,* charcoal, 1954. Collection of the Art Institute of Chicago.

. . . a work where there has been a conscious exploration of the textural potentialities of charcoal as a medium. Calvin Albert's "Ritual" is at first glance deceptive, for the direct quality of the surface textures suggests less calculation than is revealed by closer examination. With careful study of the detail of the drawing, one can discern a full and conscious exploitation of the potentialities of charcoal. Various roughnesses of grainy surface, smooth gradations, sharp lines, blurred tones, and clean erasures create a visual texture-banquet of pleasing variety. The full drawing reveals the thoughtful distribution of these elements throughout the composition.

—Daniel M. Mendelowitz
DRAWING
Holt, Rinehart and Winston, Inc.

148

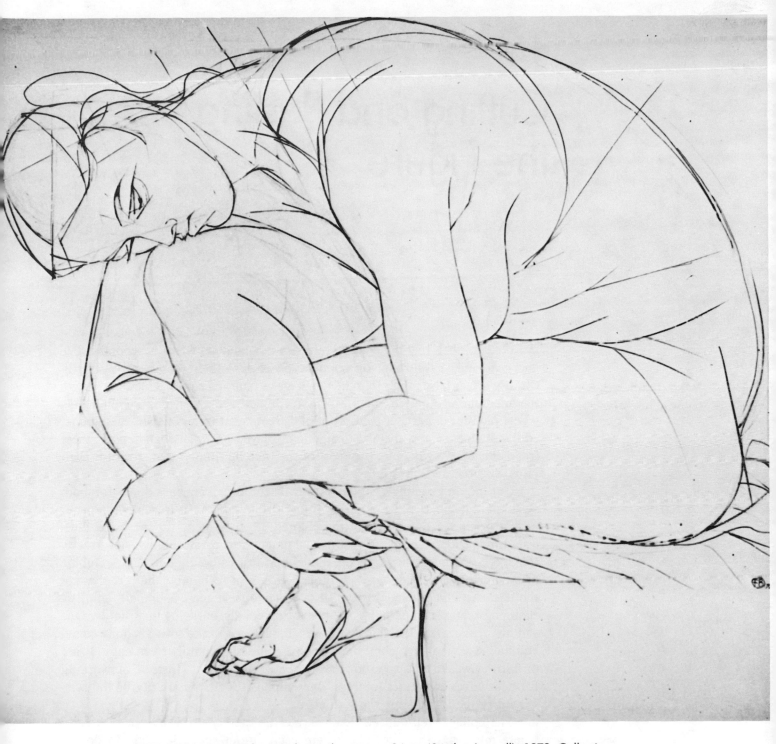

FRITZ BULTMAN: *Laurel—Spiral,* pencil on paper, 34 × 40 inches (overall), 1973. Collection
of the Whitney Museum of American Art, New York. Anonymous gift, (Acq #
74.93).

12
Cutting and Pasting the Figure

Just as the poets feel the need to refresh the language, when it becomes stale and academic, by introducing popular speech into their verses, so twentieth-century artists have revitalized the language of painting by introducing, through the medium of "pasted pictures," a fresh vernacular element. Composing whole pictures or parts of pictures of old street-car transfers, labels, newspaper and wallpaper scraps, the artist sometimes played on the associations of these fragments of everyday life, but most of the time he simply used them for their visual surprise and surface texture.

Cutting and pasting a figure (from the model) can be a tonic for both spirit and imagination. Materials are provided by any well-stocked wastepaper basket or they can come from the colored advertisements in the large illustrated magazines. The point of this technique is to create boldly, not exactly transpose, the main shapes of the model and just as boldly cut, tear, combine and contrast the "snippings." Although this is a technique that emphasizes the flat, two-dimensional surface, it is possible to suggest a limited depth by changing textures, superimposing pieces, especially darks against lights. One can also exaggerate the shapes of cut silhouettes to take into account actual volume. A vivid image comes not from planning but simply from capitalizing on all the wealth of suggestion in chance combinations. Instead of working for neat edges and exact joinings, one emphasizes the angularity of the scissor cut or the jaggedness of a torn edge.

The collages reproduced demonstrate the quality of visual wit in a form where much has been left out, where each cutout shape is made to do the work of several in reality, and where accidents of modulated surfaces have been utilized provocatively. The possibility of seeing many of these forms in two ways, simultaneously, gives a special tension and aliveness to the image.

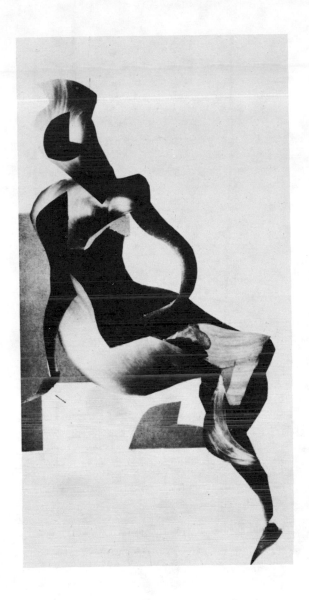

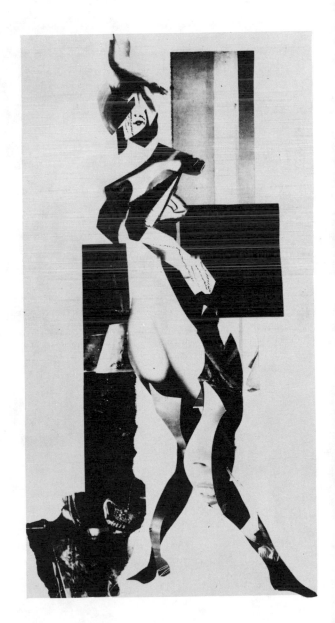

A newspaper advertisement featuring wavy hair may have contributed the flowing texture that surprisingly models this witty cutout.

The modeled surfaced of a bit snipped from an advertisement provided this figure with an illusionistic passage in an otherwise amusingly stylized page composition.

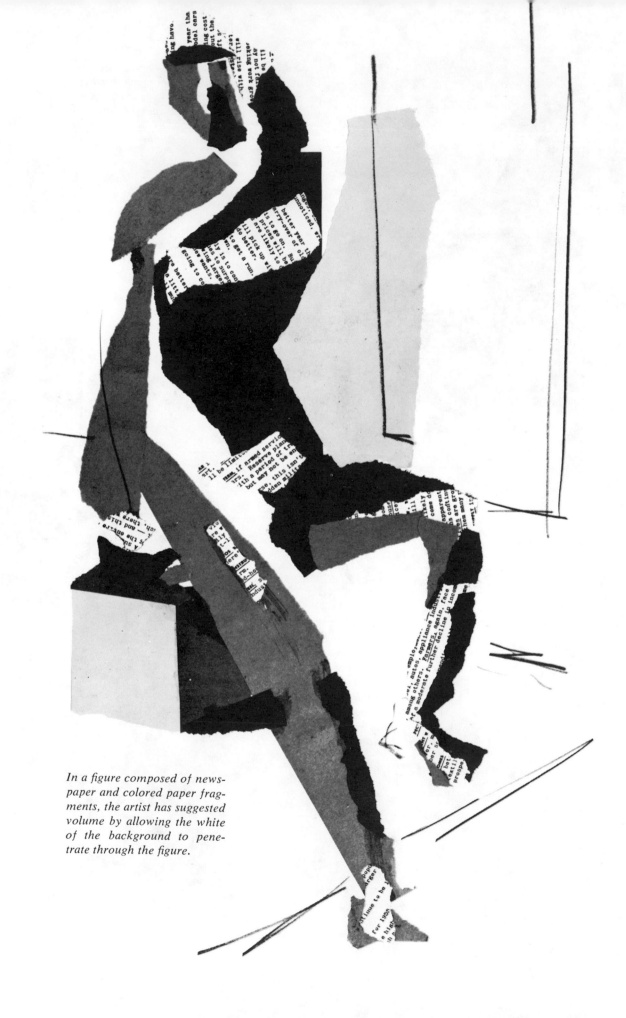

In a figure composed of newspaper and colored paper fragments, the artist has suggested volume by allowing the white of the background to penetrate through the figure.

Each element in this collage fights for our attention simultaneously in two different ways: the machinery as itself and as a background texture; the newspaper headline doubling for a hip; the black-stockinged leg which can also be seen as the side of a ship.

Newspaper, dotted swiss fabric and colored paper plus shorthand touches of drawing, make a figure and a suggestion of a room.

JUAN GRIS: *Still Life*, 1914. For this collage, Gris pasted strips of wallpaper and simulated wood grain, part of the front page of a newspaper and leaf from a book, juxtaposing these "real" objects with drawn fragments of these same things. A. E. Gallatin Collection, Philadelphia Museum of Art.

HENRI MATISSE: *Icare*, 1947. In his dazzling (originally) cutout series—*Jazz*, from which this stencil plate was made, Matisse showed with what imagination the scissors can be used to shape the figure, compensating by the distortion of the silhouette for the lack of interior details. Plate 8 of the *Jazz* series published by Teriade for Editions Verve, Paris; stencil (pochoir) plates in the collection of the Museum of Modern Art; gift of the artist.

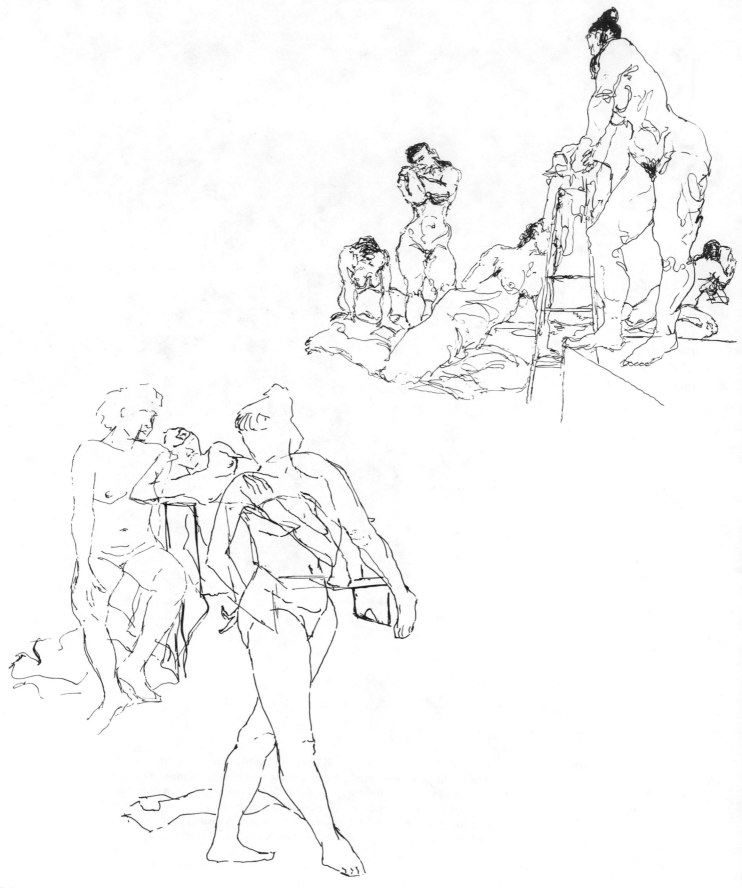

13
Composing the Page

Composing groups of figures on a page, an important discipline, need not require the services of a number of models. The compositions illustrated were made by combining on a single page, drawings made in a series of poses. In some the figures were drawn in perspective and in sizes diminishing in relation to distance from the spectator; in others drawings were superimposed and transparencies were utilized to tie together the different elements.

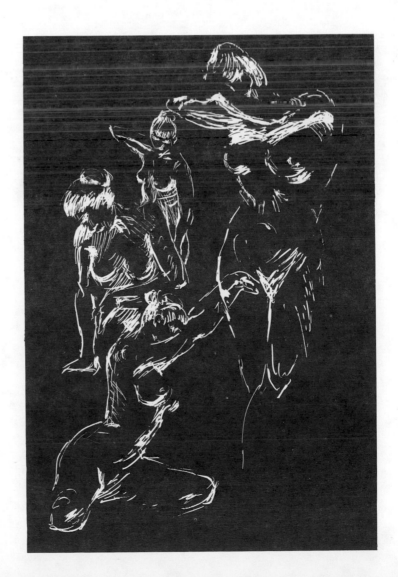

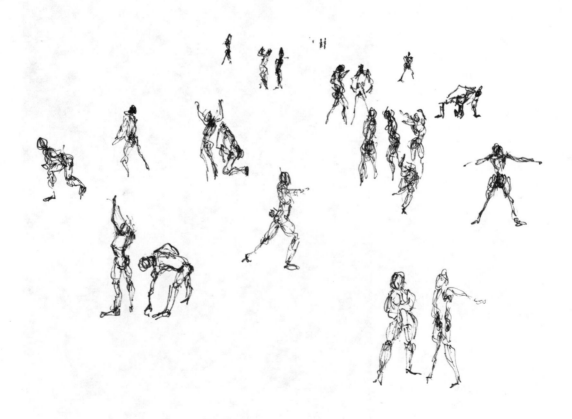

STOW AND BLEEK: Facsimile from "Rock Paintings in South Africa."

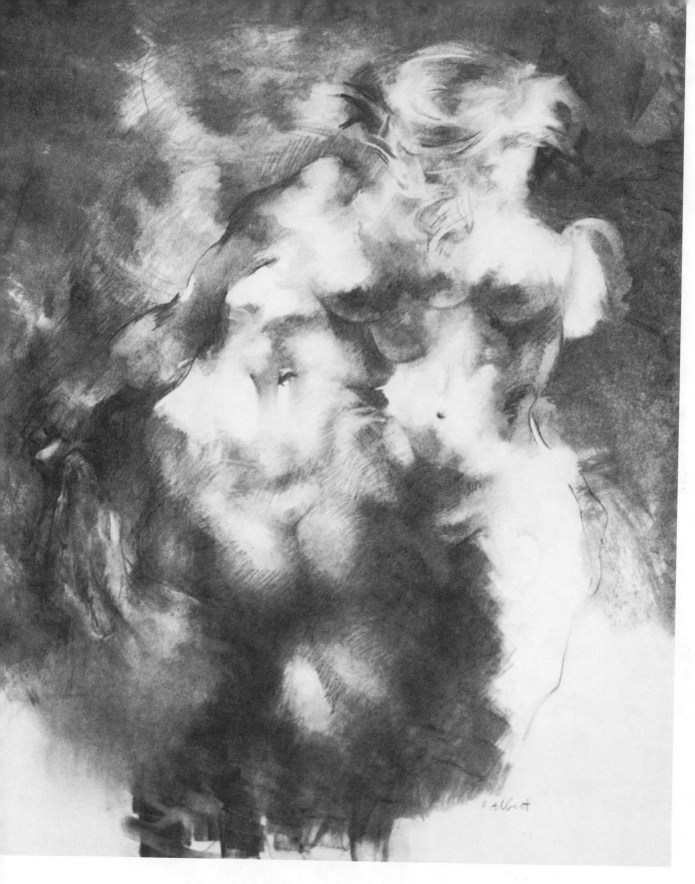

CALVIN ALBERT: *Woman*, charcoal. Courtesy of the Ingber Gallery, New York. The figure is drawn from imagined multiple points of view, with a degree of realism that almost convinces the viewer that such combinations can and do exist.

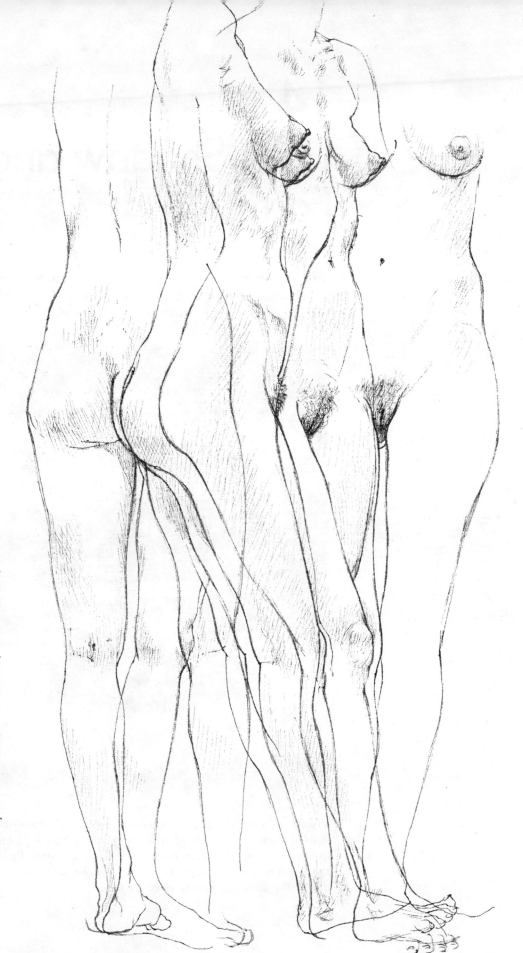

Often, talented students enter art school with an already formed style that has won them so much praise that they are afraid to experiment with new ideas. The talented student who has an open mind and tries many things, can enjoy discoveries and make great progress. Joseph A. Smith entered Pratt Institute with a well developed talent and was interested in experimentation; four of his first-year drawings are included in this book. He is now a versatile and successful painter, illustrator and teacher; some of his mature drawings have been added to the second edition.

161

JOSEPH A. SMITH: *Standing Figure 1969*. Courtesy of the artist. While the model held a long pose, the artist moved around her, drawing the pose from four points of view.

14
Light, Shadow and Form

We see objects because light shines on them, causing gradations of tone which indicate forms and their position in space. Homework assignments were used to explore this through imaginative exercises.

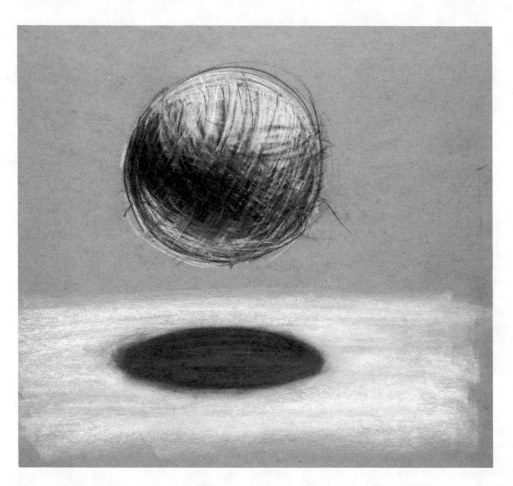

Visualization: *"Imagine a sphere suspended above a flat surface and lighted from directly above. The top of the sphere is light, it gets darker as the surface recedes from the source of light, some light is reflected into the shadowed area from the floor, and the cast shadow shows how far above the floor the sphere is suspended."*

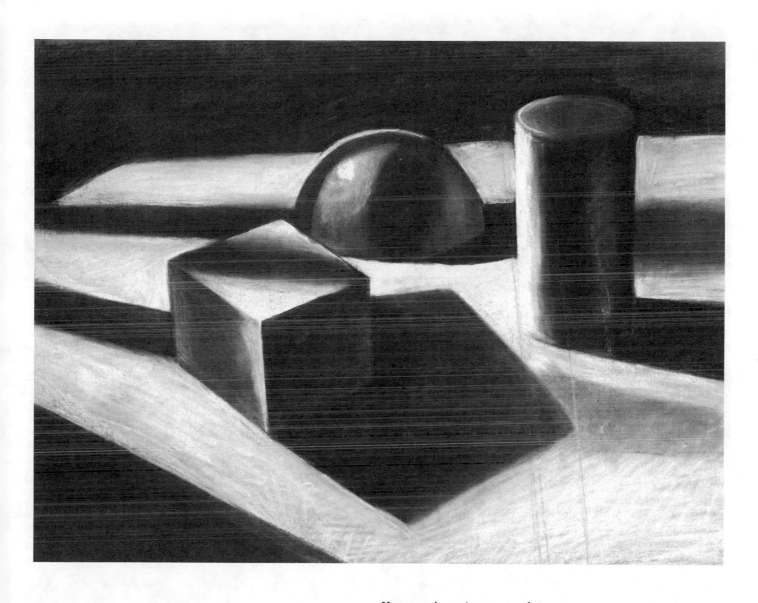

Homework assignment: the student draws an actual or imagined arrangement of geometrical objects side-lit from a clearly understood spot. In this drawing two unseen bars interrupt the light, casting additional shadows on the arrangement.

163

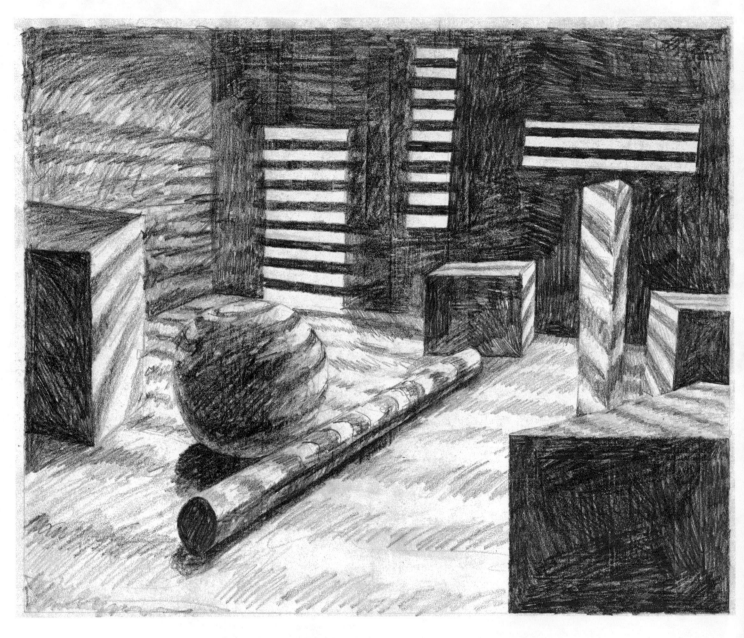

This student has visualized an elaborate combination of objects whose forms are defined by light shining through variously shaped barred apertures.

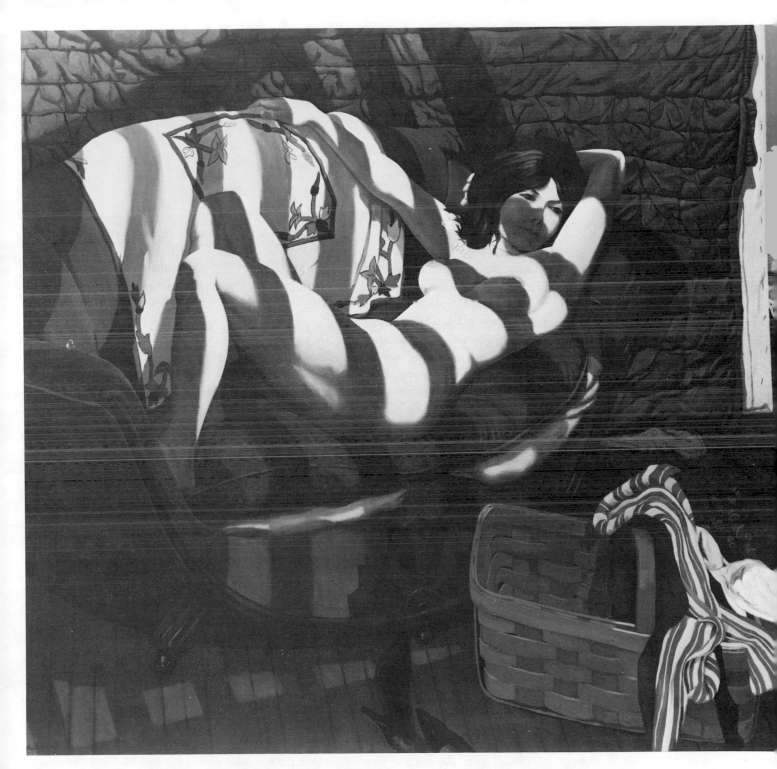

JACK BEAL: *Striped Nude*, oil on canvas, 66 × 72 inches, 1965. Courtesy Allan Frumkin
Gallery, New York. Light from above is interrupted by bars, causing the pattern
of light and shadow to define the forms of the figure and surroundings in an
unexpected manner.

15
The Drama of Light and Shadow

Charcoal is a kind of dust. Like finger paint it can be manipulated freely across the page by the fingers and it can be lifted off with a flick of a cloth. Any dust resists being confined within edges. But the subtle play of rich and vibrant tones, when it is spread out across the paper surface, makes it an ideal medium with which to explore every quality of shadow—not only its flow around forms but also its diverse ways of breaking across forms. In the compositions of Rembrandt and Goya we respond to the drama of a subject enveloped in a shadowy atmosphere. Through it the light seems to play its own capricious game, highlighting a face here, a shoulder there. Actually it is the artist's game—his way of focussing on the elements that heighten mood.

In the charcoal drawings illustrated, the tones establish the mood of the picture. They do not stay in the background but strike boldly across the figure, pushing certain parts back into shadow and allowing light, by contrast, to pull other parts forward.

The freedom evident in these drawings was made possible by an interesting switch in procedure: tones first; figure afterward. The figure in each case was superimposed on previously set down areas of tone. This procedure was deliberately arbitrary—the pose of the model kept very simple; the areas of tone, on the other hand, varied as richly and irregularly as possible (including sections of white paper).

As the drawing is superimposed on the background it is broken up by the various patches of tone, alternating with whites, that it happens to cross over. Shadowed parts of the model coincide with some darker and lighter tonal areas but they also encounter whites in other parts of the background. In reverse, lighted parts of the figure are seen against middle tones and darks but also against whites. Stimulated to reconcile, imaginatively, the disparate elements of figure and background, the artist takes into account all the possibilities that could create such a breaking of tone. He does not ignore a logical light source but he allows for things intervening between the light and the model and also for the loss of certain details that could be out of focus (the attention does not focus equally on all parts of a scene). He strengthens and

defines key areas in the figure—those that explain its action and basic feeling. But he does not want to "find" all the edges that were "lost" where lights meet lights or darks meet darks. He deliberately allows some parts to be diffused or to actually merge with the background.

Open parts of the composition, where lights or darks sweep across the figure into the background without defining edges between them, reinforce a pictorial unity. They invite the onlooker to participate imaginatively by projecting his own associations into the areas left vague and mysterious.

Visualization: *"According to one prevalent conception of realism, a person realistically rendered looks immobilized, as if injected with a paralyzing fluid. His clothes have been sprayed with a hardening substance and the air has been drained out of the room, leaving a vacuum . . . As a contrast to that, think of your actual sensations in some typical episode—a party, for example: someone laughs, flicks the ashes off a cigarette. One person leans forward into a patch of light; another settles into shadow, his face lit once in a while as he draws on a cigarette. A car goes by, throwing light patterns on the ceiling. You glance out of the window for a moment, then your eyes return to the person next to you. How can we find an equivalent, in tones, for such a constant flicker and movement?"*

Odilon Redon: *"I discovered charcoal crayon, that powder which is volatile, impalpable and fugitive . . . This ordinary medium which, by itself, has no beauty, aided my research into the chiaroscuro of the invisible."* Quoted from article by William S. Lieberman in *"Redon—Drawings and Lithographs,"* publication of the Museum of Modern Art.

A fantastic head was suggested by the accidental figurations in a first exploration of charcoal. The suggestibility of the field of tones, previously set down, is like that of old, discolored walls or the shifting patterns of clouds in which we visualize animals, monsters and grotesque faces.

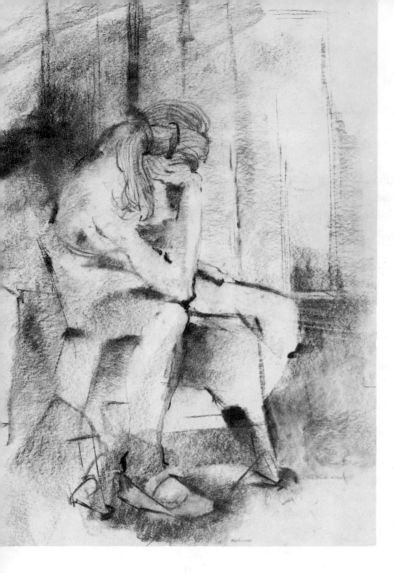

Charcoal tones, unifying fig-
ure and background, create
an illusion of a place where
various objects and structures
intervene between the light
and the subject.

A more fully articulated head shows the control of the medium at a more advanced stage and demonstrates the vigor and unity gained by retaining some of the original tones against which the drawing was superimposed.

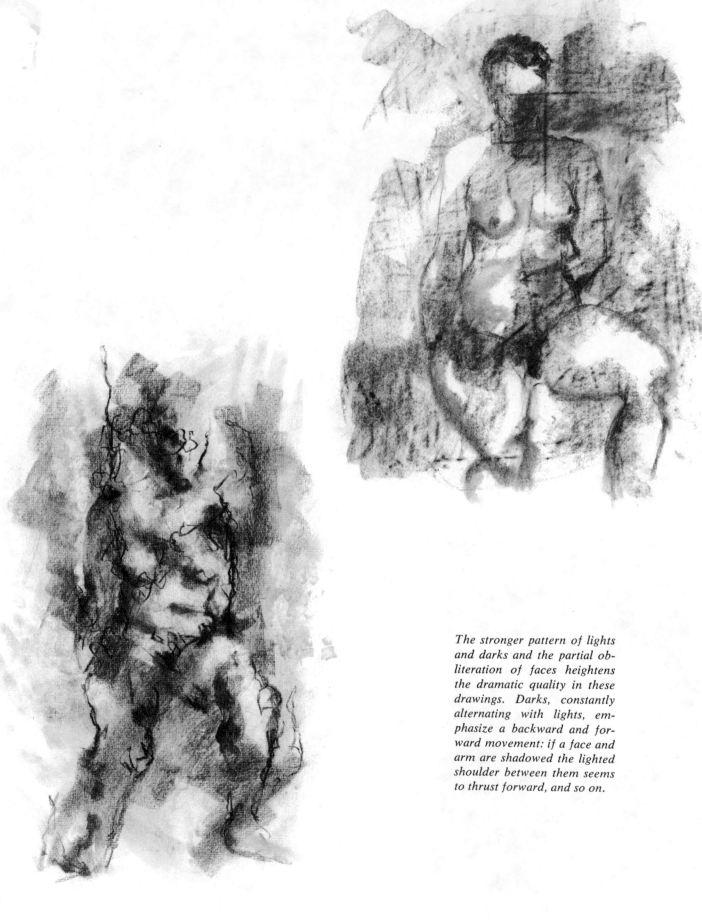

The stronger pattern of lights and darks and the partial obliteration of faces heightens the dramatic quality in these drawings. Darks, constantly alternating with lights, emphasize a backward and forward movement: if a face and arm are shadowed the lighted shoulder between them seems to thrust forward, and so on.

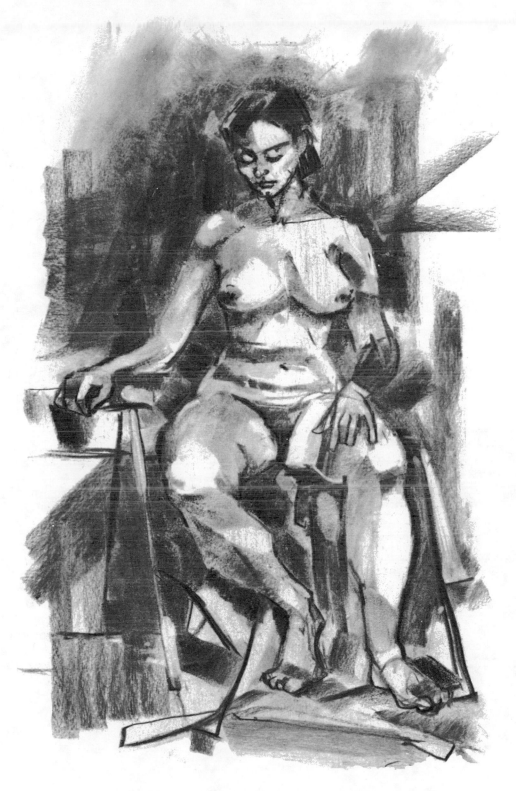

*Even in a seated figure staccato patterns of darks accentuate
a nervous, active quality.*

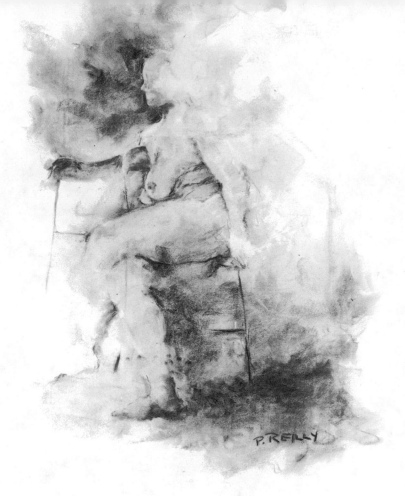

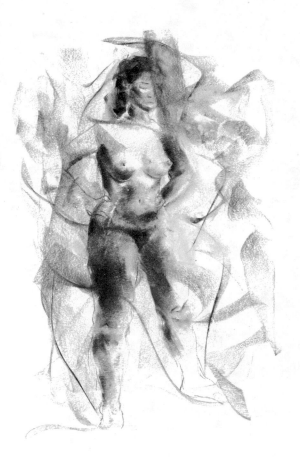

Here certain edges were left undefined by the coincidence of lighted parts of the figure with white areas of the paper and also of shadowed parts meeting darker charcoal tones. These forms, deliberately left open, are well understood since other controlling parts of the figure are clearly defined. The partial dissolving of edges enhances an agreeable mystery in the subject and invites the onlooker to fill in imaginatively the forms and places suggested.

172

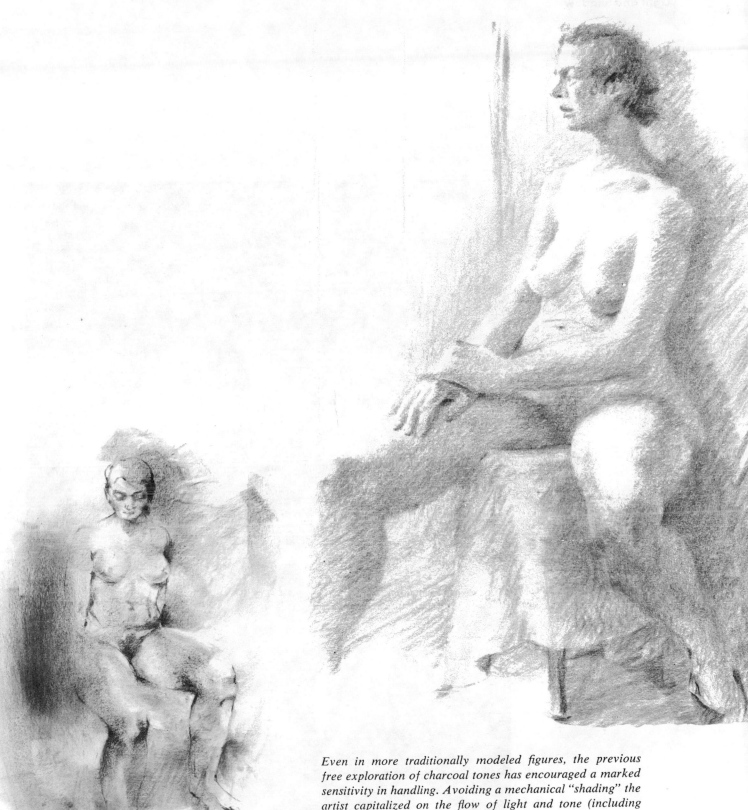

Even in more traditionally modeled figures, the previous free exploration of charcoal tones has encouraged a marked sensitivity in handling. Avoiding a mechanical "shading" the artist capitalized on the flow of light and tone (including open edges) from figure to background and makes use of a patterning and massing of tones within which subtle fluctuations define changes in structure and surface.

173

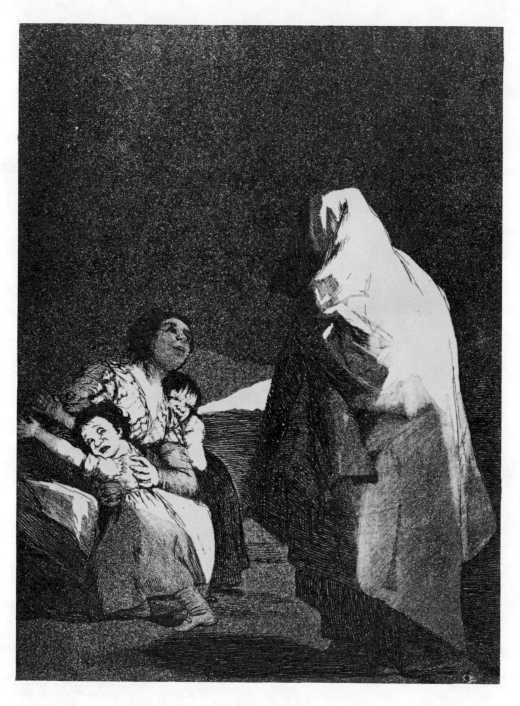

GOYA: *Que Viene el Coco (from The Caprichos).* Courtesy of The New York Public Library, Prints Division.

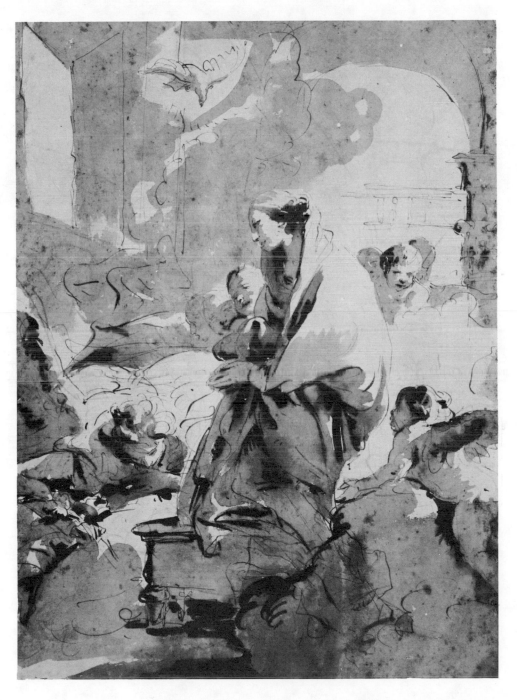

TIEPOLO: *Annunciation*. Courtesy of the Cooper Union Museum.

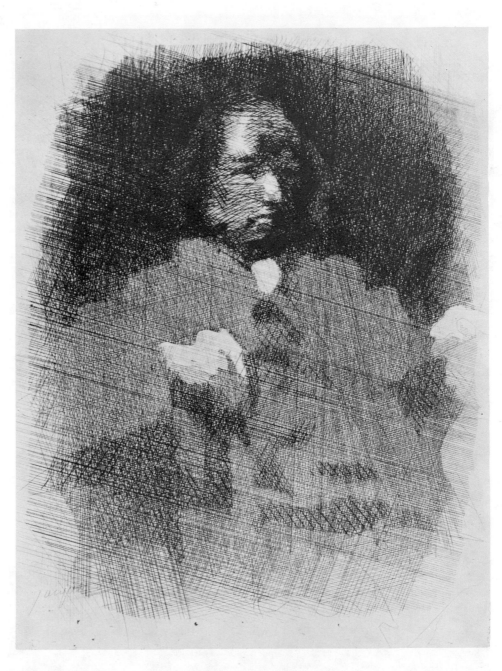

JACQUES VILLON: *J. P. Debray (Le Savant)* etching and engraving, 1933. Collection
Museum of Modern Art.

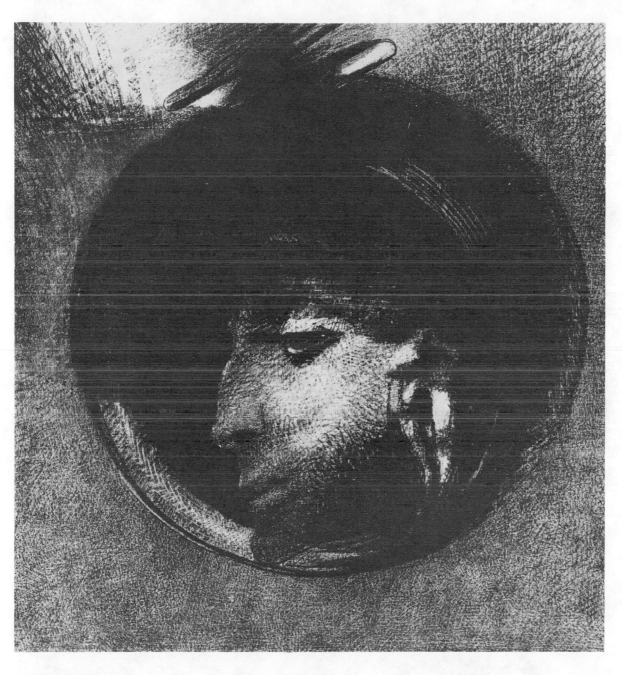

ODILON REDON: *The Cell of Hearing*, lithograph. Collection Museum of Modern Art.

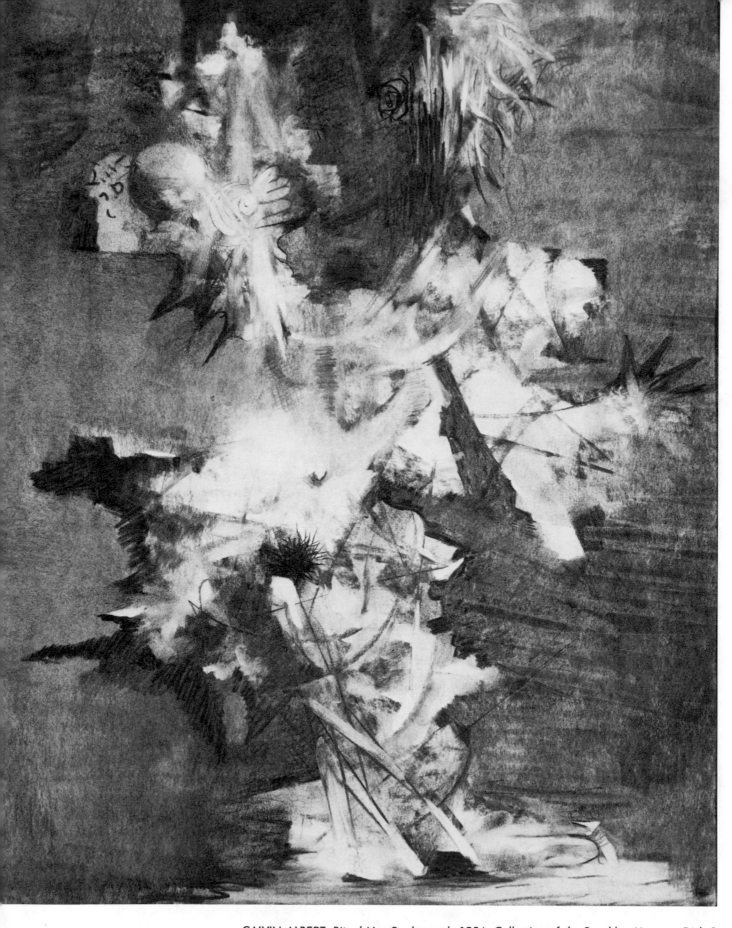

CALVIN ALBERT: *Ritual No. 2,* charcoal, 1954. Collection of the Brooklyn Museum, Dick S. Ramsay Fund.

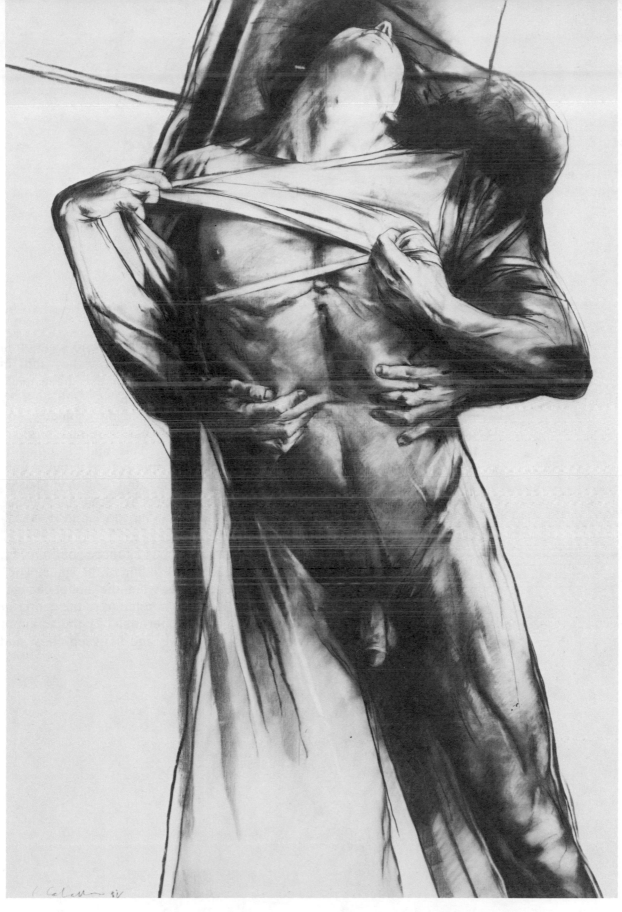

LUIS CABALLERO: *Untitled,* charcoal and conte crayon on paper, 72 × 57 inches. Courtesy of Sindin Galleries, New York. The unusually large size of Caballero's drawings increases their dramatic impact.

16
Building with Blocks

To understand the figure in terms of volume, articulation and location in space, it is necessary to divide it into blocks to see how they shift in relation to each other and to the artist's eye. Many artists have made drawings showing their interest in this approach. In the 16th century Albrecht Dürer made many figure studies emphasizing geometry and perspective, and Luca Cambiaso made elaborate compositions in which the figures were broken into geometric forms. This understanding is fundamental to the artist's needs, and should come before detailed anatomical study of bones and muscles. In the 20th century George Bridgman, who taught thousands of students at the Art Students' League in New York, published several books in which he illustrated his own way of seeing and drawing the human figure.

Bridgman visualized the head, chest and pelvis as three solid blocks, each unchanging in itself, strung on the flexible column of the spine. They turn, twist, bend and tilt in relation to each other when the model changes position, but the total figure is always balanced in relation to the center of gravity. The movement of the three blocks is determined by the action of the spine in the space between head and chest, and between chest and pelvis.

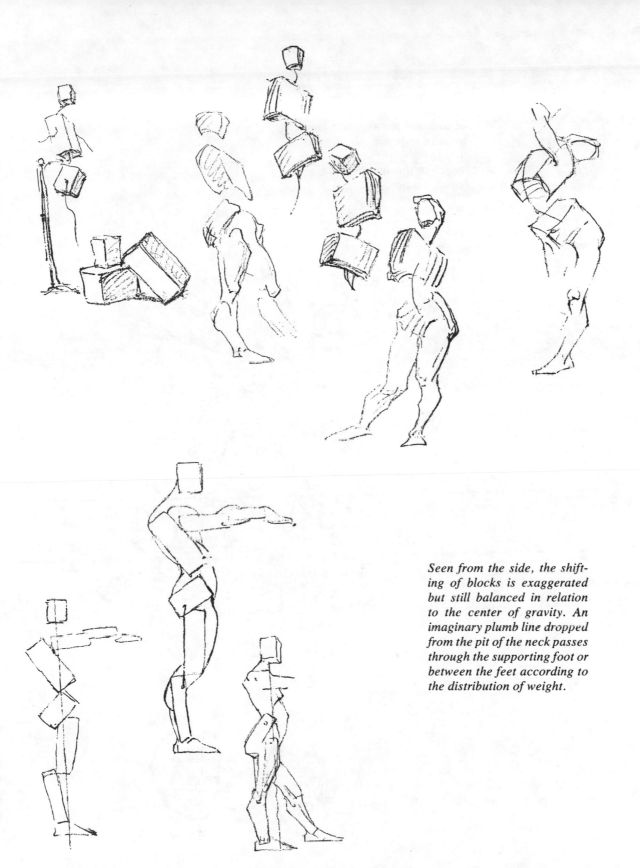

Seen from the side, the shifting of blocks is exaggerated but still balanced in relation to the center of gravity. An imaginary plumb line dropped from the pit of the neck passes through the supporting foot or between the feet according to the distribution of weight.

GEORGE B. BRIDGMAN: Illustrations. (See also the illustrations on the following page.) Reprinted by permission of Sterling Publishing Co., Inc., Two Park Avenue, New York, NY 10016. From *Bridgman's Complete Guide to Drawing from Life,* by George B. Bridgman, published by Sterling Publishing Co., Inc., © 1952.

181

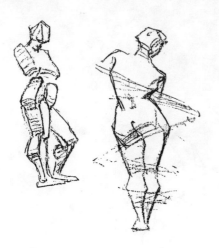

When the weight is on one leg, the hip on that side is raised and the shoulder lowered in response. On the opposite side, the lowered hip requires the leg to bend in compensation.

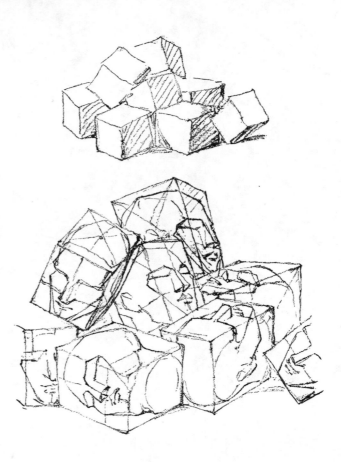

Drawing the head as a cube makes it possible to place it in position and perspective before modifying it to show details of the forms.

182

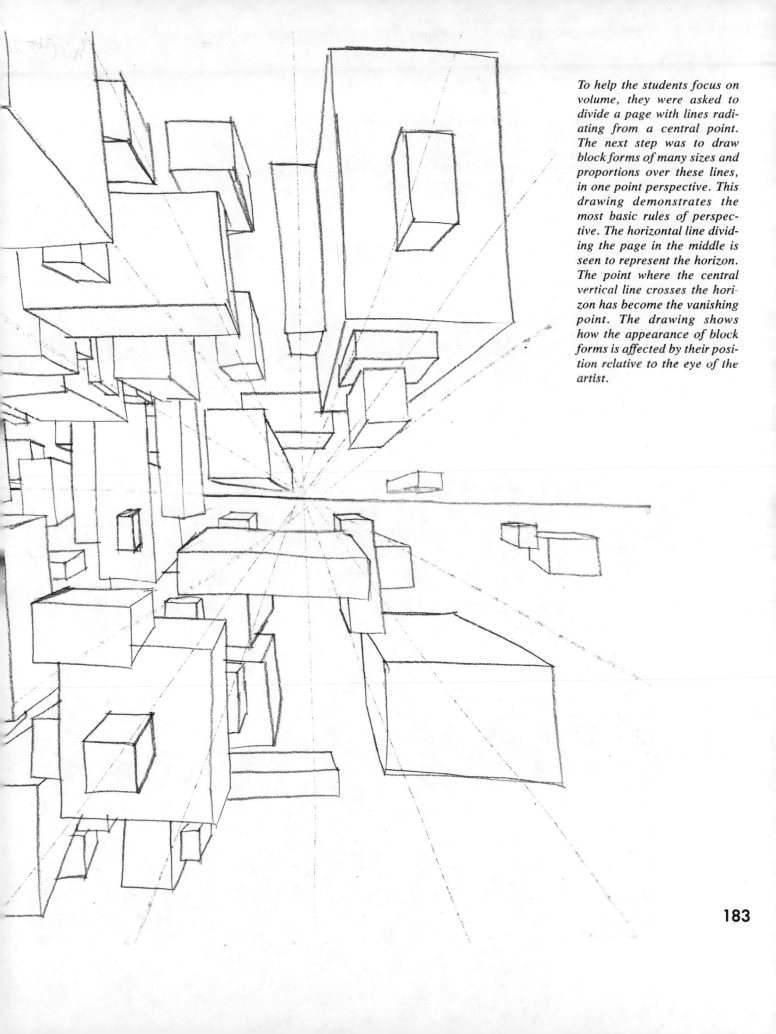

To help the students focus on volume, they were asked to divide a page with lines radiating from a central point. The next step was to draw block forms of many sizes and proportions over these lines, in one point perspective. This drawing demonstrates the most basic rules of perspective. The horizontal line dividing the page in the middle is seen to represent the horizon. The point where the central vertical line crosses the horizon has become the vanishing point. The drawing shows how the appearance of block forms is affected by their position relative to the eye of the artist.

183

The volumes of the figure are also subject to the laws of perspective. A figure broken down into blocks, with the vanishing point at about the center of the pelvis, demonstrates the same principles as the previous drawing. Only one plane of the pelvis is seen, but all other forms show one side and top or bottom planes according to their position in relation to the viewer's eye.

Three different poses show the blocks shifting in space, using a horizon and various vanishing points. The figures are smaller as they get closer to the horizon.

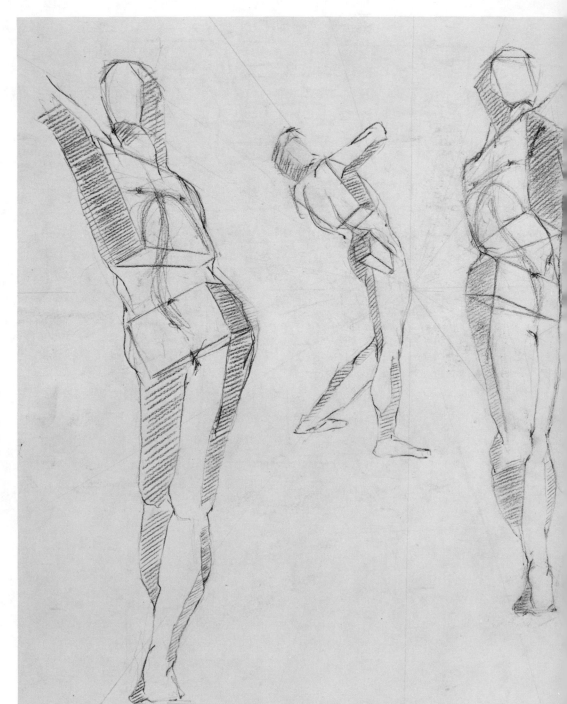

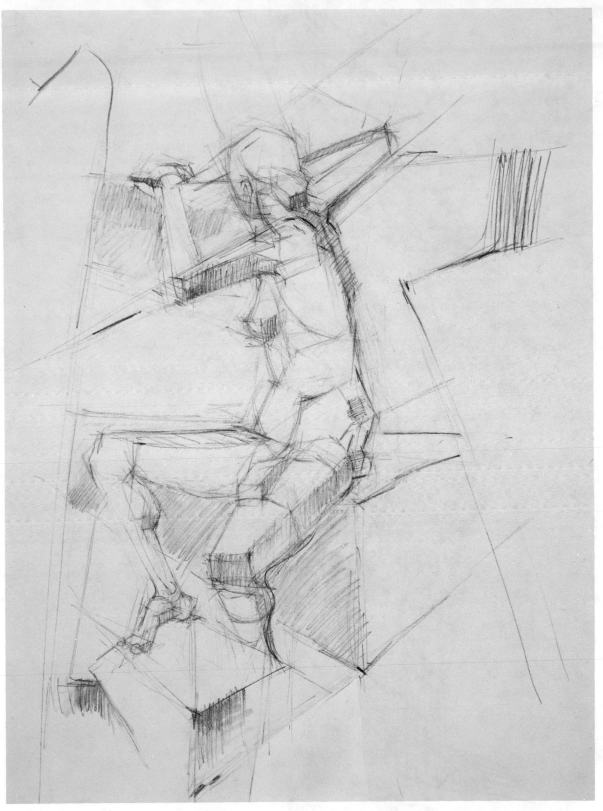

A more complex breakdown of planes in perspective, including some elements of furniture and surroundings. The entire surface and space of the composition is articulated, as in a cubist drawing.

185

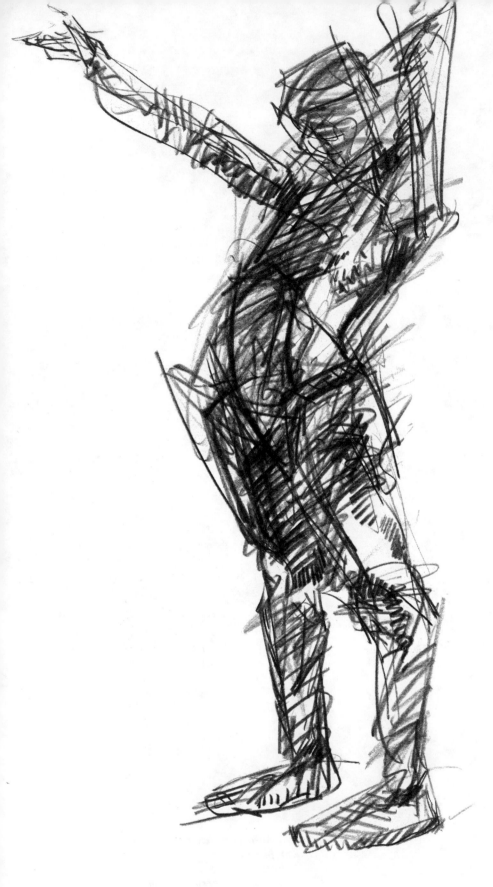

A scribble drawing made after studying the figure as blocks. This new understanding causes the figure to exist solidly in space, and is much more dimensional than the earlier scribble exercises shown in the first chapter.

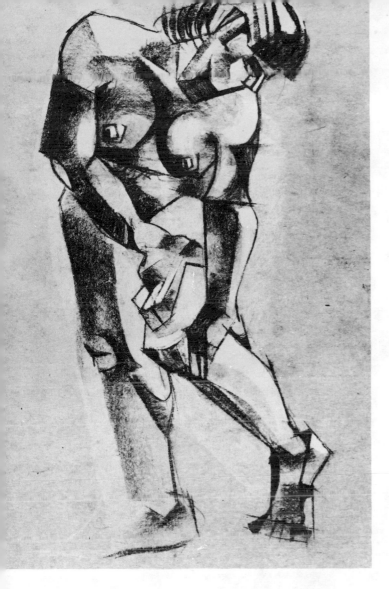

The power of the figure is dramatized by breaking it down into chunky volumes. In areas like the face and arms many small planes have been condensed into one or two and this is continued throughout the figure. These block forms are not set statically, one above the other, but turn in opposing directions: if the front plane of the thigh turns toward us (light), the front plane of the calf turns away (black). Also the movement (to our left) of the top portion of the figure, is opposed by the counter-movement of the bottom half. This kind of reduction of elements can be developed into a structural shorthand, in which each plane is performing in a number of different ways.

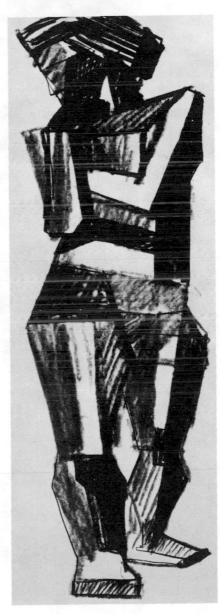

Restricted to two kinds of shapes, the artist has to make the decision as to where each kind of form—curvilinear or rectilinear—is most expressive. He composes the figure so as to emphasize the greatest possible contrast between them.

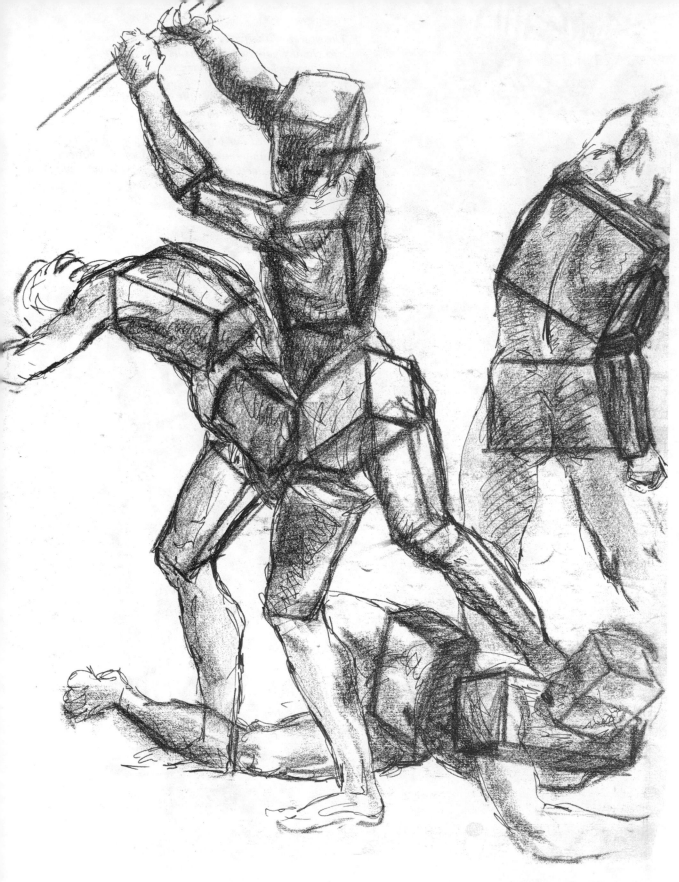

188

A homework assignment was to analyze a masterwork in terms of blocks. This student chose Combat of Nude Men *by Raphael.*

The study of contours (explained in chapter 7) applied to block/figure forms in space and in perspective. First, a composition of blocks is established. Then a series of lines explores the page; each line travels from edge to edge of the paper, moving across the planes of the blocks as it goes.

In this homework assignment, the student imagined two figures in space, one reclining on a plane below eye level, the other floating in the air above eye level. Forms are defined by lines crossing the blocked forms; lines continue across the composition, exploring the space around the figures.

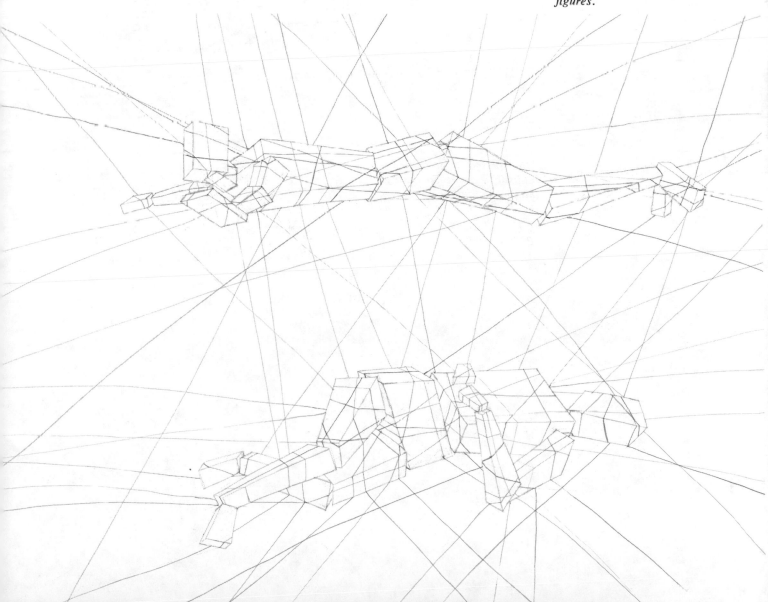

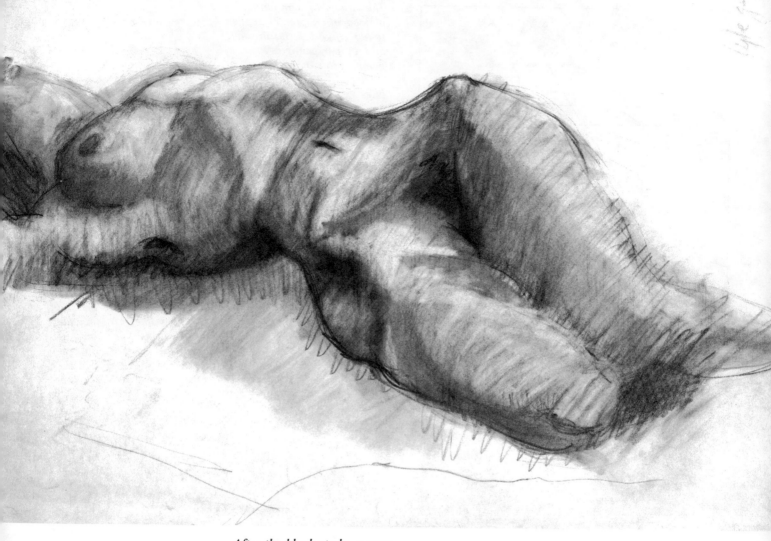

After the block study, a more realistic drawing emphasizes flat planes and the position of the figure in relation to the surface it rests on and the space around it.

190

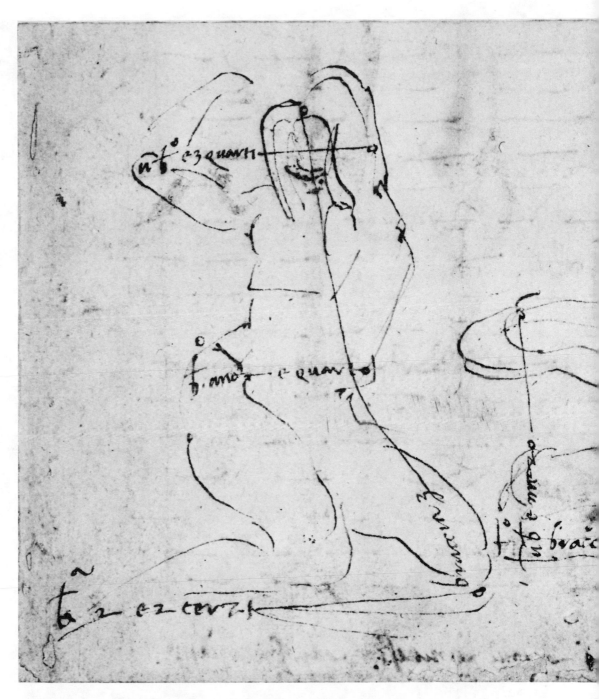

MICHELANGELO: *Sketches For a River God* (detail), c.1525. Courtesy of the Trustees of the British Museum. A great deal of information is given in this quick notation. Lines indicate the planes of hip and chest, showing extreme twisting of the torso. The movement of volumes in space is shown clearly with minimal means; knees in front, the side plane receding to the right hip, left arm and shoulder in front of head, and the right arm is the form farthest back.

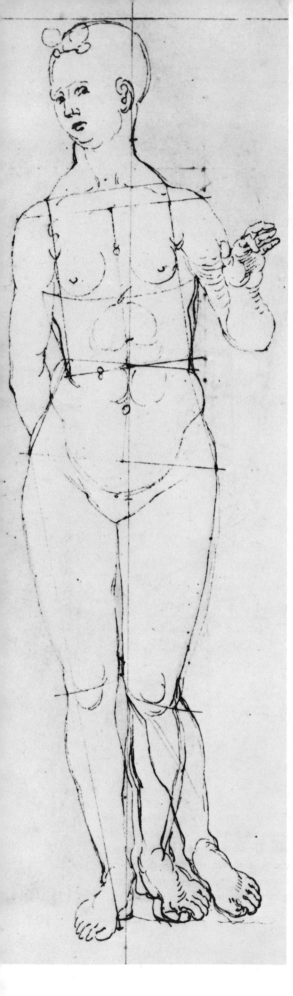

ALBRECHT DÜRER:

Standing Female Nude. Courtesy of the Trustees of the British Museum. Front view of the figure with straight lines emphasizing the tilt of chest and pelvis. Because the weight is entirely on the right foot, the left foot can shift position.

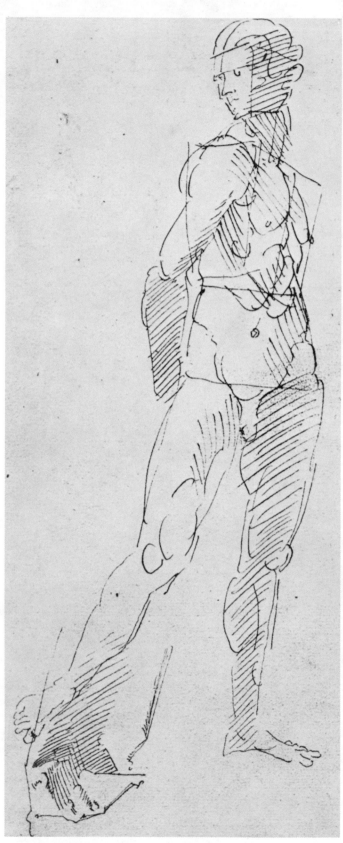

ALBRECHT DÜRER: *Figure*. Head, chest and pelvis are rotated on the spine, and shading is used to emphasize the shift of forms.

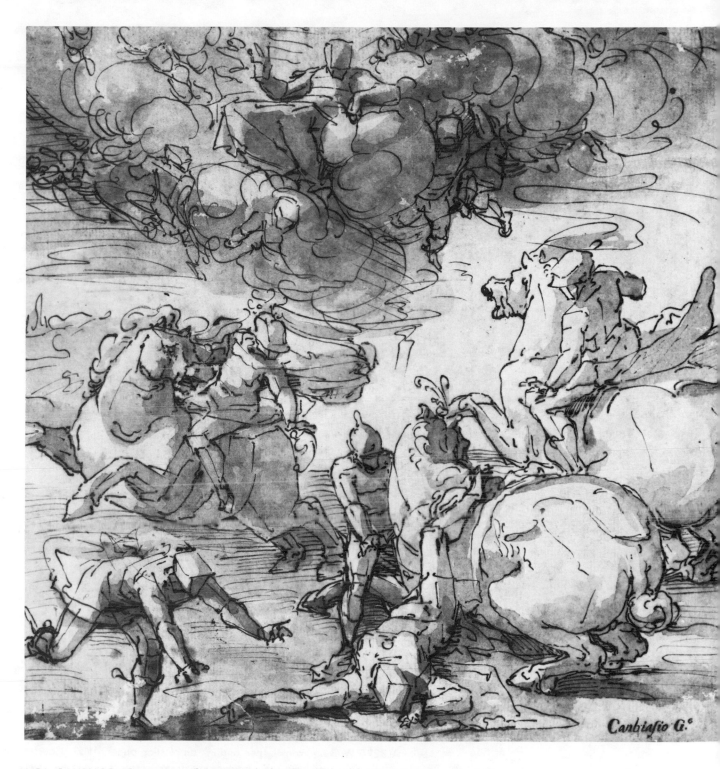

LUCA CAMBIASO: *Conversion of Saint Paul* (detail), pen and brown ink and wash, 16th
century. The Art Museum, Princeton University, bequest of Dan Fellows
Platt. In a preparatory sketch for a painting, the composition is explored
with geometric simplification, clarifying the volumes as to position and
perspective. The use of a single light source, above left, helps greatly to
define the forms.

CALVIN ALBERT: *Walking Woman*, pen and ink on blotting paper, 1952. Courtesy of Ingber Gallery, New York. A figure in extreme perspective with eye level at the right knee. Head, chest and pelvis are seen from below, towering into space. The diagram clarifies the perspective implied in the drawing.

MARISOL: *Picasso,* 1977. Courtesy Sidney Janis Gallery, New York. After carving the head in a realistic style, the sculptor has left the original wood block intact to represent the torso. It sits squarely on a square chair, symmetrical and balanced.

PIERRE PAUL PRUD'HON: *Study For 'La Source'* black and white chalk on blue-gray paper. Sterling and Francine Clark Institute, Williamstown, Massachusetts. Because the artist is far enough away from the subject, there is a minimum of distortion even in the foreshortened legs. A single source of light, above and to the right, emphasizes the solidity of the volumes, and the block-like forms of the setting relate to the solid forms of the figure.

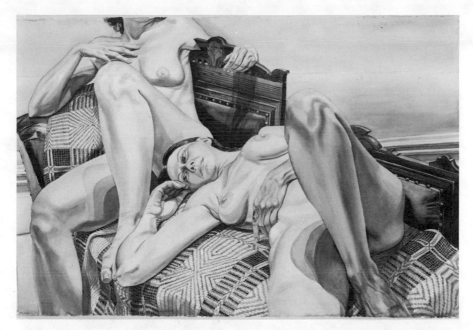

PHILIP PEARLSTEIN: *Two Models on Victorian Sofa and Coverlet*, watercolor, 1983. Courtesy Frumkin Gallery, New York. Pearlstein has moved closer to his subject, purposely causing distortion in the figures as they recede sharply. This distortion and the cropping of the composition suggests photography, although he does not use photographs in his work. Overlapping is another device to place forms in space.

JOAN SEMMEL: *Pink Fingertips*, oil on canvas, 49 × 56 inches, 1977. Courtesy of the artist. This artist is even closer to the subject, as she focuses on her own body. Distortion and the overlapping of forms are so extreme as to create almost an abstract landscape, from the enormous breast in the foreground, receding in stages as far as the foot.

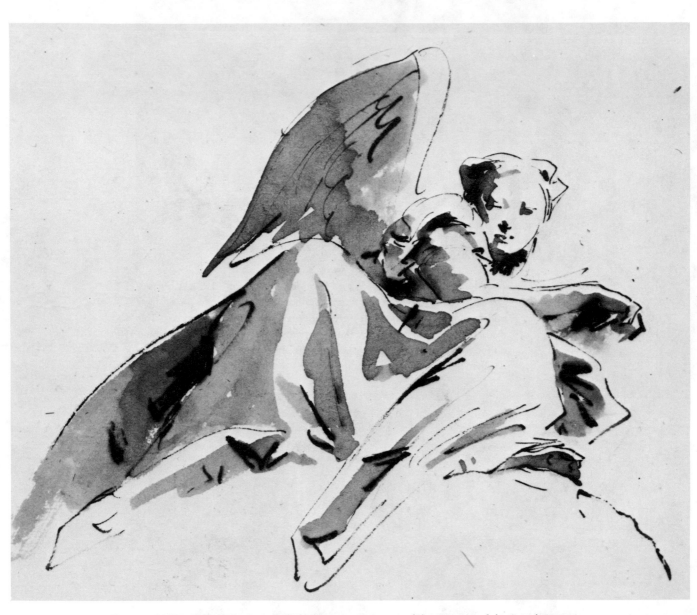

GIAMBATTISTA TIEPOLO: *Angel*, 18th Century. Courtesy of the Trustees of the British Museum.

198

17
Ant's-Eye View

What is the advantage of an ant's-eye view of the subject? Simply the advantage of any point of view that is unfamiliar. As a modern poet said, "it is only in the unfamiliar that we recognize the poetic." Viewed from a hovering helicopter, the half mile that one trudges every day to school or to work becomes fantastic and interesting, revealing another aspect than the humdrum one in every back lot and front yard.

It is not necessary that the point of view be an actual physical one. The startling drawings illustrated were made by people viewing the model from their usual seats while imagining that they adopted the perspective and strangely altered sense of scale of an insect. If they managed to make the physical world of an ant very real in their drawings, it was probably because it was first materialized for them in the word picture below. The inch-by-inch survey of the model underlined the monumentality of the figure and heightened observation of its richly varied "terrain."

Visualization: *"Pretend you are an ant across the street in the park. Picture what things look like to you; a blade of grass is like a tree, wider at the bottom, arching high over your head. Pebbles make great obstacles to walking, twigs are like fallen trees, and we climb over a discarded cigarette that seems like a section of gigantic sewer pipe. We come to the cracked sidewalk; a hot gray surface with deep furrows and craters. The curb presents a perpendicular drop of fifteen stories to the asphalt of the street. In the gutter we find soggy matches to sit on and we crawl under an arch formed by a crumpled piece of white paper. After crossing the street we climb the cement stairs like a series of great cliffs, and then comes a restful elevator ride. Then into the classroom and up onto our chairs, where we are confronted with the great mass of the model, towering far above us, into space."*

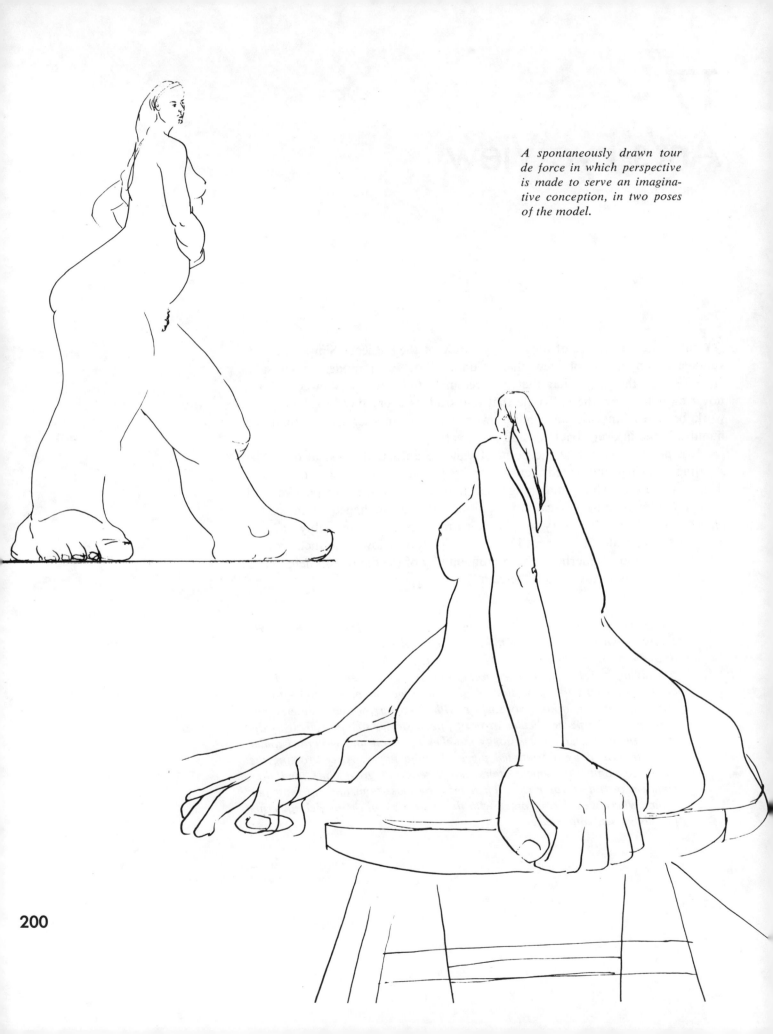

A spontaneously drawn tour de force in which perspective is made to serve an imaginative conception, in two poses of the model.

200

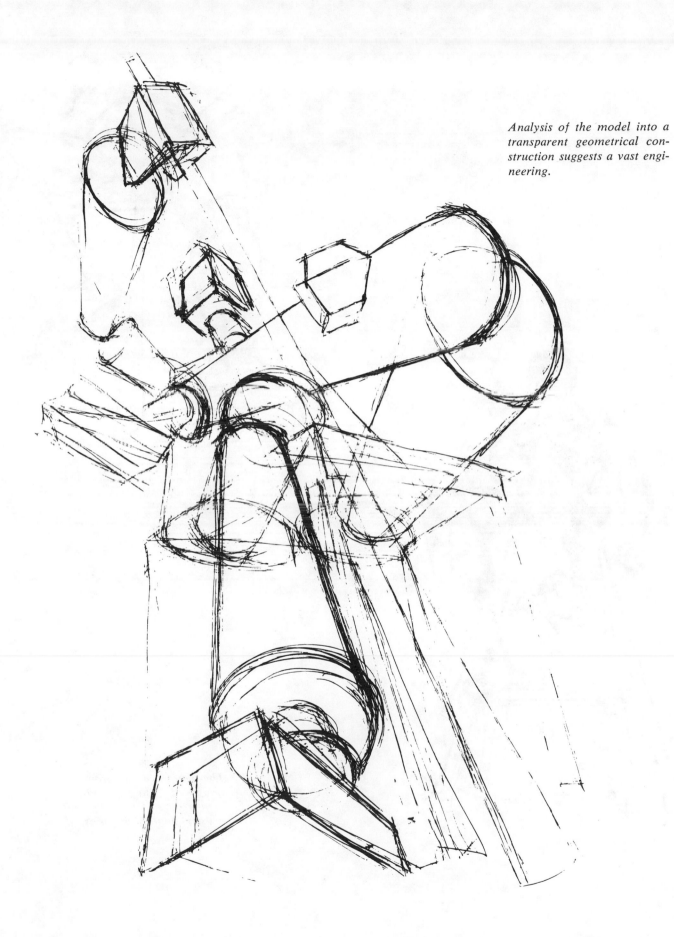

Analysis of the model into a transparent geometrical construction suggests a vast engineering.

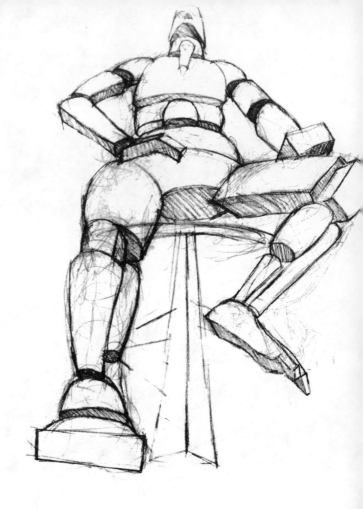

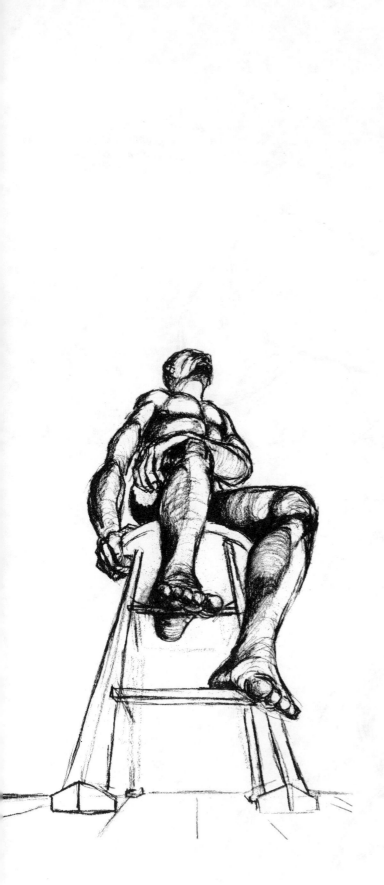

The figure is drawn from the imagined "ant's-eye view" then reconstructed (different artists) into its basic forms.

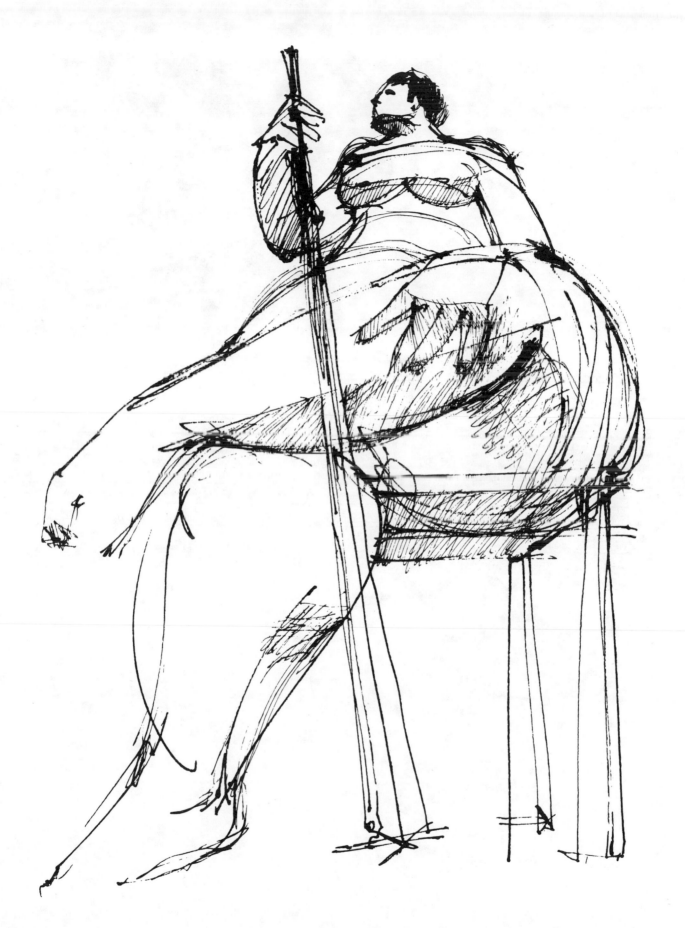

203

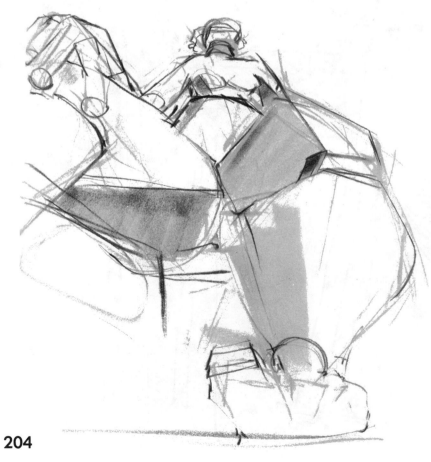

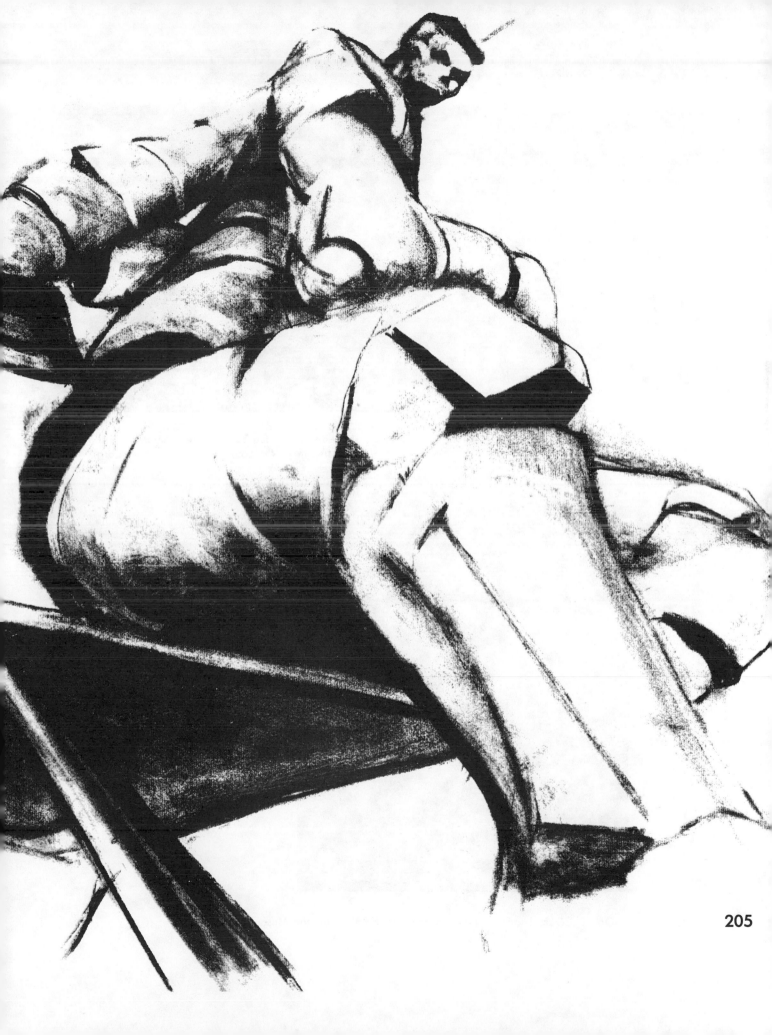

*Examples
of similar techniques*

SALVADOR DALI: *Soft Construction with Boiled Beans;* (premonition of Civil War) 1936.
Philadelphia Museum of Art, Louise and Walter Arensberg Collection.

THOMAS COLE: *Titans' Goblet.* Courtesy of the Metropolitan Museum of Art.

RENÉ MAGRITTE: *The False Mirror*, oil on canvas, 1928. Collection Museum of Modern Art, Purchase Fund.

SAUL STEINBERG: *Drawing on photograph*, illustration for "Built in the U.S.A." article by the artist in Art News, February, 1953. Courtesy of the artist.

Lake Union, Seattle, Wash.

Cl. 1972

CLAES OLDENBURG: *Proposal for a Cathedral in the Form of a Colossal Faucet, Lake Union, Seattle*, watercolor, graphite and colored pencil on paper, 29 × 22⁷/₈ inches, 1972. Collection of the Whitney Museum of American Art, New York. Gift of Knoll International (and purchase). Acq # 80.35.

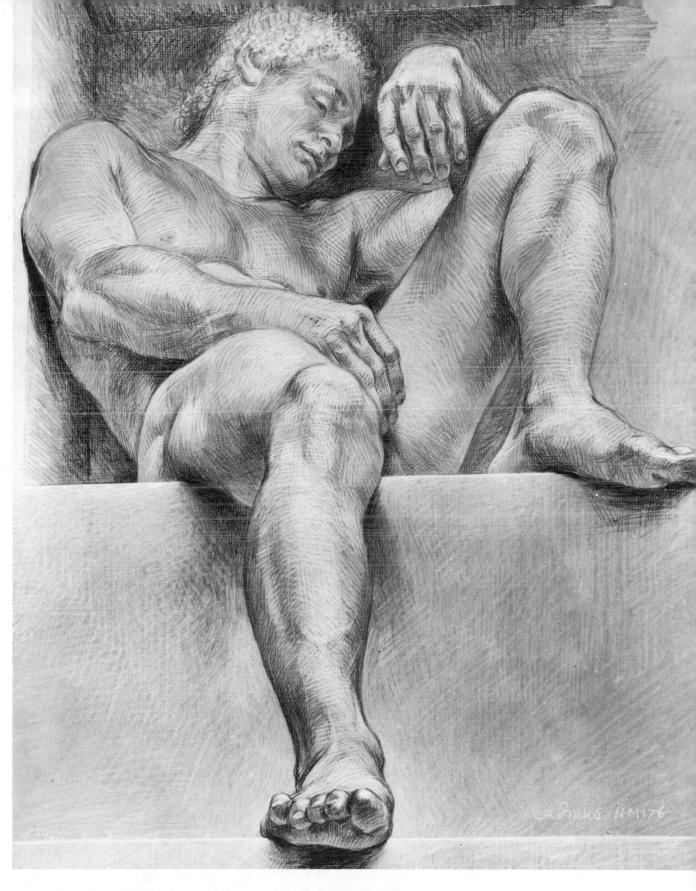

PAUL CADMUS: *Male Nude*, crayons on toned paper, 1983. Private Collection. Courtesy Midtown Galleries, New York. A monumental figure drawn as though carved from stone. The crayon strokes move across surfaces the way chisel marks cross sculptured forms.

209

18
A Case History

Over and over it is demonstrated that the student who is able to depart from literal appearance, to invent, to fantasize, to condense what he sees or intensify it—he is also the one who is most capable of setting down the most carefully observed expression of the model. On the other hand, the individual who is never secure enough to depart at all from a painstaking and literal statement, seldom accomplishes even this limited aim.

The pictorial case history illustrated here traces the development of a student whose first efforts did not seem especially promising. But he was able to take hold of each problem and experiment very freely. In the final work it is clear that this individual, with a vastly enriched vocabulary of forms at his command, can pursue either an inventive vein of fantasy (see his drawings in "Mechanical Man," p. 49) or a more traditional kind of expression.

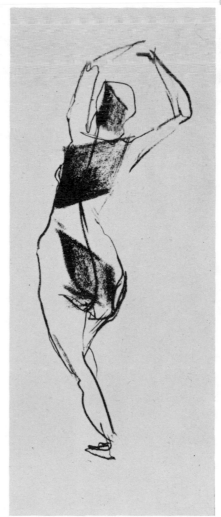

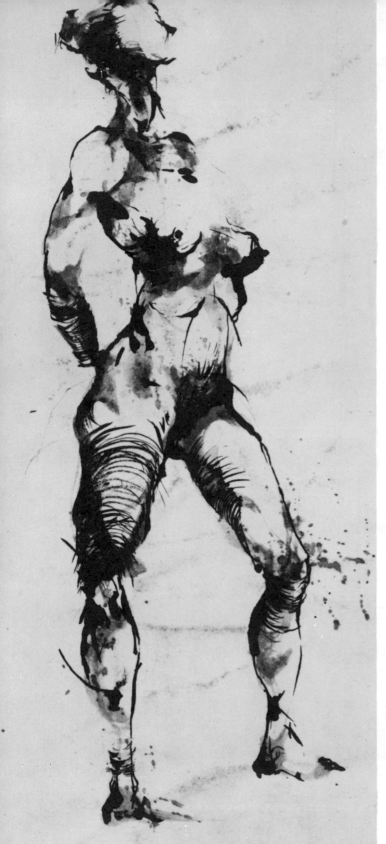

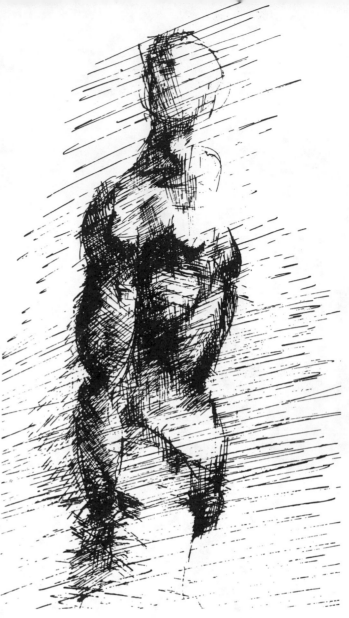

Further examples of the same student's work: left, ink and watercolor; above, pen; and to the right, a charcoal, ink, and wash drawing.

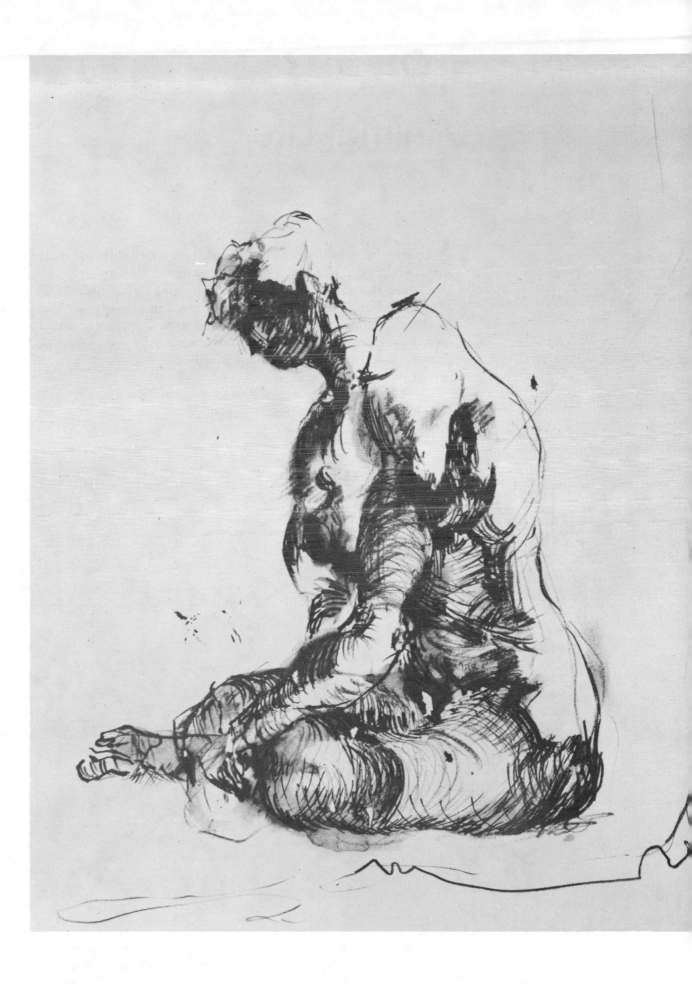

19
Animal Life

A course in animal drawing offered an opportunity to apply to other subjects the principles used in exploring figure drawing.

Before starting the series of chalk drawings, the students made pages of exercises using the side of a piece of chalk in as many ways as possible. In order to bring models into the classroom, chickens and pigeons were rented and domestic pets were borrowed. After spending time in the classroom learning to draw moving birds and animals, the group went on field trips to zoos.

Because these drawings of constantly moving animals must be done so fast, the essence of the subject is distilled.

216

HENRI DE TOULOUSE-LAUTREC: *Page From a Sketchbook* (detail). Collection of the Art
Institute of Chicago.

BETSY LEWIN: *Three Running Hens.* Illustration from *The Strange Thing That Happened to Oliver Wendell Iscovitch,* published by Dodd, Mead & Co.

B. KLIBAN: *Cat With Arab and Guitar.* Copyright © 1978 B. Kliban. Reprinted from *Catcalendar 1979,* published by Workman Publishing Co. Interpretation via a copy. Kliban exchanges his own round-eyed domestic cat for Rousseau's lion in *Sleeping Gypsy,* making a startling change in scale.

MURRAY TINKELMAN: *Drawing,* pen and ink. Courtesy of the artist. A playful robotic extension of a fish.

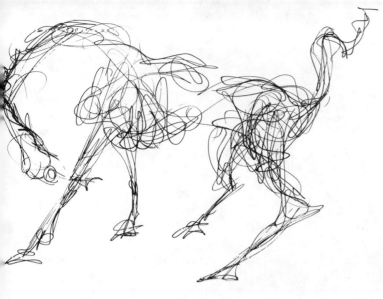

Handwriting the horse

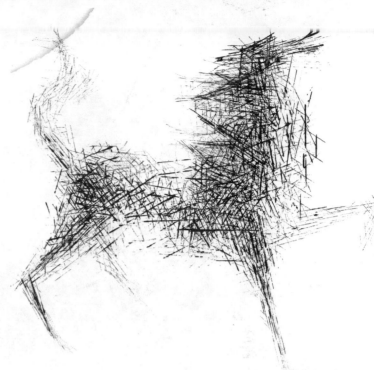

Razor blade dipped in block printing ink

Sculpture: soldered metal rods

CALVIN ALBERT: Three variations on the theme of a horse, 1948.

JOSEPH A. SMITH: *Dream Horse*, 1977–78. Courtesy of the artist. A horse visualized as being assembled of many materials.

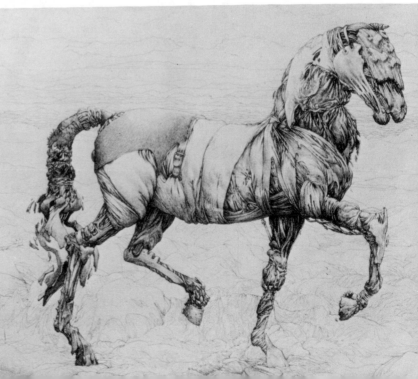

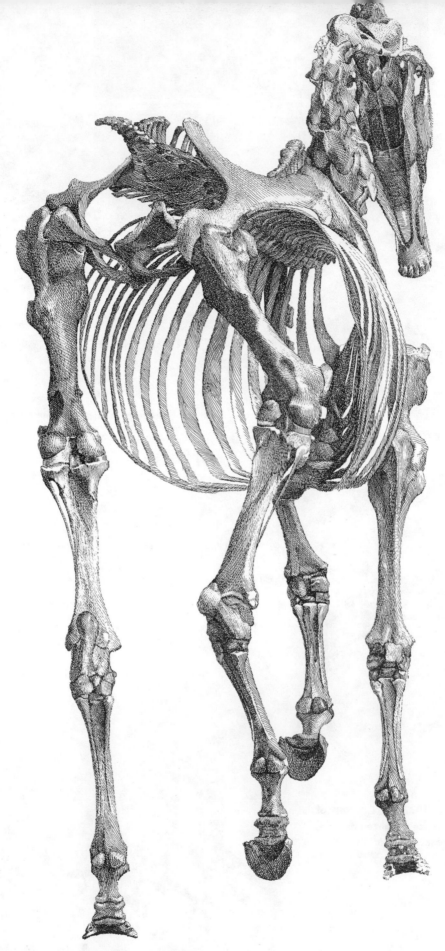

GEORGE STUBBS: *Skeleton of the Horse 1766.* From *Anatomy of the Horse,* reprinted by Dover Publications, Inc., New York, 1976. Volume is emphasized by the foreshortened view.

JOSEPH A. SMITH: *Witch's Familiar*. Courtesy of the artist. Illustration from *Witches*, by Erica Jong, published by Abrams Publishing Co., New York.

CALVIN ALBERT: *Bird*, ink on blotting paper, 1952. Courtesy of the Ingber Gallery. This drawing began with a splash of diluted ink, to be studied like a Rorschach image to see what it suggested. The perceived image was defined with lines and dots.

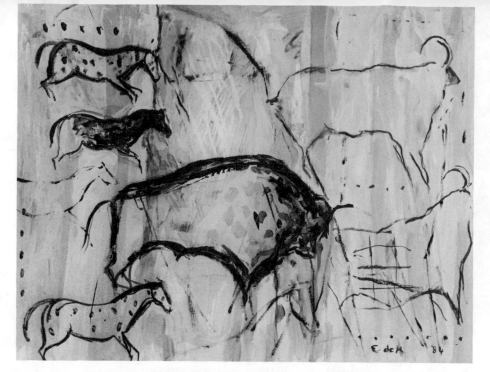

ELAINE de KOONING: *Cave #16,* acrylic on paper. After visiting the Cro-Magnon cave sites in the Dordogne region of France, the artist made a series of paintings in reaction to the prehistoric paintings she saw there.

DOROTHY GEES SECKLER: *Sleeping Cat.* Courtesy of the artist. Traditionally, genre artists have used the form of a sleeping cat to convey a sense of domestic well being and repose. This one was first drawn in line with a marker. The tones indicating fur color on head and sides were brushed in with broad strokes skipping in and out of outlines and leaving some white paper showing. While this was wet the gray tones suggesting the space around the cat were swept in with a wide brush loaded with acrylic wash. A last step was the addition of collage elements which served to suggest the markings of the cat.

Student Credits

Thomas Ackerman 122L
Peter Altman 120BL, 153R
Robert Anders 136B
John C. Andrews 83R, 123R, 124L
Jeannine Apostal 89
Bernard Aptekar 69
Robert Aronowitz 142
Walter W. Baczynsky 45, 50, 136T
Joan-Mary Bassaro 141L
Ronald T. Barrett 128
Camille Bawol 68
Linda Beall 93
Pierre Belliveau 83L, 124R, 127
Peter Bermingham 120BR
Robert E. Berner 152
Philip Bingman 135T
Mary Anne Broughton 134
Richard Budelis 140B
Ronald A. Bushemi 204B, 204T
Henry Butker 121, 123L
John Carocci 122R
Rosemary Cheris 27L
Guy Chirico 204
Frank E. Conner 64L
Sam Cooperstein 69
Tomie Depaola 140T
Walter E. Doerfler, Jr. 156B, 200T

Lyle H. Gerts 158, 190
Donald Giesz 27R, 32T
Chon Gregory 108B
Mary Henry 32B, 91, 102, 104, 106
Gladys Hollander 201
Richard L. Huggins 138TL, 138TR
Charles Jersawitz 126R
Mary Kelly 135B
Norbert Kuypers 173R
Lorraine Launspach 41
Paul Lehr 156TR
Leonard Levitan 138BL
Martin Lipsitt 203
Wally Littman 153T
Terence McKee 92, 101B, 157, 169B
Daniel L. Nevins 52T, 82B
James H. Parsons 137
Gene Paulsen 83L, 202T
Norman Peterson 29
Harry J. Petropoulos 38
Irma Puigdollers 30
Constantine Raitzky 126L
Betsy Reilly 170T
Patricia Reilly 77B, 78R, 172R
Robert T. Renfro 150L, 156BL
Maxine Rosengarten 86
Barry Ross 80L
Mary-Dolores Rost 108T, 173L
Bill Ryan 120T

Charles W. Saito 112
Jan Sand 31
Grant Saylor 107
Alexander Sarkis, Jr. 51, 167, 171
Emanuel Schongut 151L, 151R
Carol Siecke 170B
Florence Sillen 90
Derry Smith 28
Joseph A. Smith 42, 43, 48, 67
James J. Sommer 44B
Virginia M. Soulé 141R
Carl Spangler 80R
Paul Spina 44T
Brian R. Stewart 78L, 79
Cynthia W. Stowell 139
Frances T. Stucin 77T
James William Suddaby 49, 52L, 210–213
Joseph Tulerico 105, 168T
Alfred Tung 168B
D. Duane Unkefer 113
Edward F. Ustilla 101T
Rosetta Valone 125
H. F. Wilson, Jr. 202
Nancy Winberg 81
Edward Yakimowicz 78B
Robert Zakarian 103
Karen Zerner 169T